TENNIS

THE ULTIMATE BOOK

DAS ULTIMATIVE BUCH

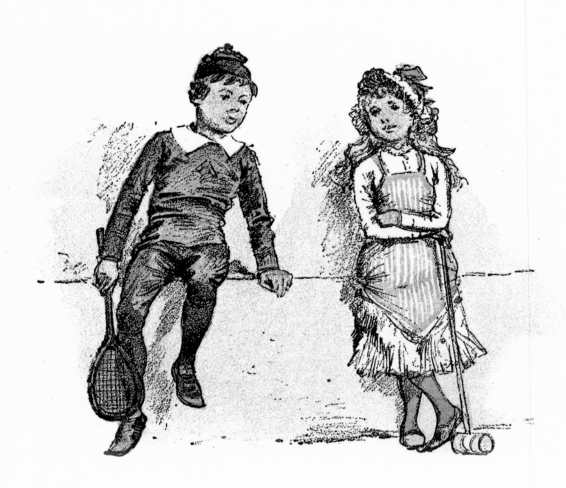

STEFAN MAIWALD · PETER FEIERABEND

TENNIS

THE ULTIMATE BOOK

DAS ULTIMATIVE BUCH

teNeues

CONTENT

← Drawing showing a Victorian boy and girl from West London with tennis racket and croquet set.
Zeichnung eines viktorianischen Jungen und eines Mädchens aus West London mit Tennisschläger und Krocketschläger.

INHALT

Headless Saints and Cramped Ballrooms:
How the Sport Came into Being

. .

Kopflose Heilige und beengte Ballsäle:
Wie der Sport entstand

The origin of the word "tennis" is completely unclear. Adventurous theories circulate, including one that the sport is named after St. Dionysius of Paris (French: *Denis*) who in many paintings holds his severed head like a ball in his hands.

Die Herkunft des Wortes »Tennis« ist völlig unklar. Es kursieren abenteuerliche Theorien, darunter jene, dass der Sport nach dem Heiligen Dionysius von Paris (französisch: *Denis*) benannt ist, der auf vielen Bildern seinen abgeschlagenen

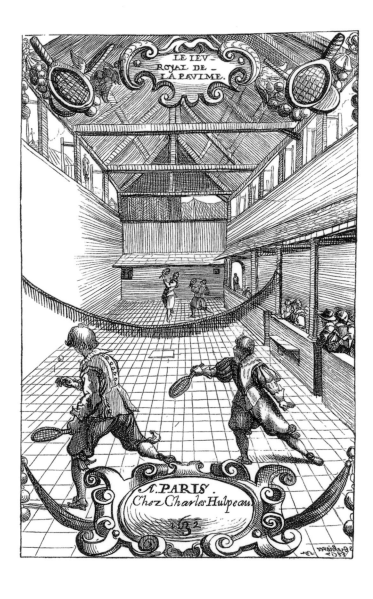

Contemporary engraving of the first Wimbledon Championships in 1877 at Worple Road, London. At that time the net was just over 5 feet high at the posts.
Zeitgenössischer Kupferstich der ersten Wimbledon Championships 1877 in der Worple Road, London. Das Netz war damals mit 5 Fuß an den Pfosten gut 1,5 m hoch.

Or perhaps it has more to do with the French warning cry "Tenez!"? What is certain, however, is form of a much older sport, which in French was called *Jeu de Paume* (*Paume* means "palm"), possibly originated in the early 12th century in monasteries in northern France, and was played almost exclusively indoors – there are said to have been 1800 venues in Paris alone. At first, the ball was hit onto the opponent's field with bare hands, similar to volleyball. Then gloves were used, and later rackets in all kinds of shapes.

The sport is also called "real tennis" because it was played preferentially by aristocrats; Henry VIII and Mary Stuart, for example, were enthusiastic players. At least two French kings even died playing the game: Louis X died of pneumonia in 1316 after a particularly intense match (and a few hastily downed glasses of wine), and

Kopf wie einen Ball in den Händen hält. Oder hat es vielleicht eher mit dem französischen Warnruf *Tenez!* zu tun? Sicher ist aber, dass das heute praktizierte Tennis eine ziemlich neumodische Form eines viel älteren Sports ist, der im Französischen *Jeu de Paume* hieß (*Paume* bedeutet »Handfläche«), möglicherweise im frühen 12. Jahrhundert in nordfranzösischen Klöstern entstand und nahezu ausschließlich in Innenräumen gespielt wurde – allein in Paris soll es 1800 Spielstätten gegeben haben. Zuerst wurde der Ball mit bloßen Händen aufs gegnerische Feld geschlagen, etwa so wie beim Volleyball. Dann kamen Handschuhe zum Einsatz, später Schläger in allerlei Formen.

Der Sport heißt auch »Real Tennis«, weil er bevorzugt von Adligen ausgeübt wurde; beispielsweise waren Heinrich VIII. und Maria Stuart begeisterte Spieler. Mindestens zwei französische

←← "Real tennis" in a 17th century Paris ballroom.
»Echtes Tennis« in einem Pariser Ballhaus im 17. Jahrhundert.

← Sketch of a Lawn Tennis court as first envisaged by inventor Walter Clopton Wingfield in 1874.
Skizze eines Lawn-Tennis-Platzes, wie er zunächst vom Erfinder Walter Clopton Wingfield 1874 vorgesehen wurde.

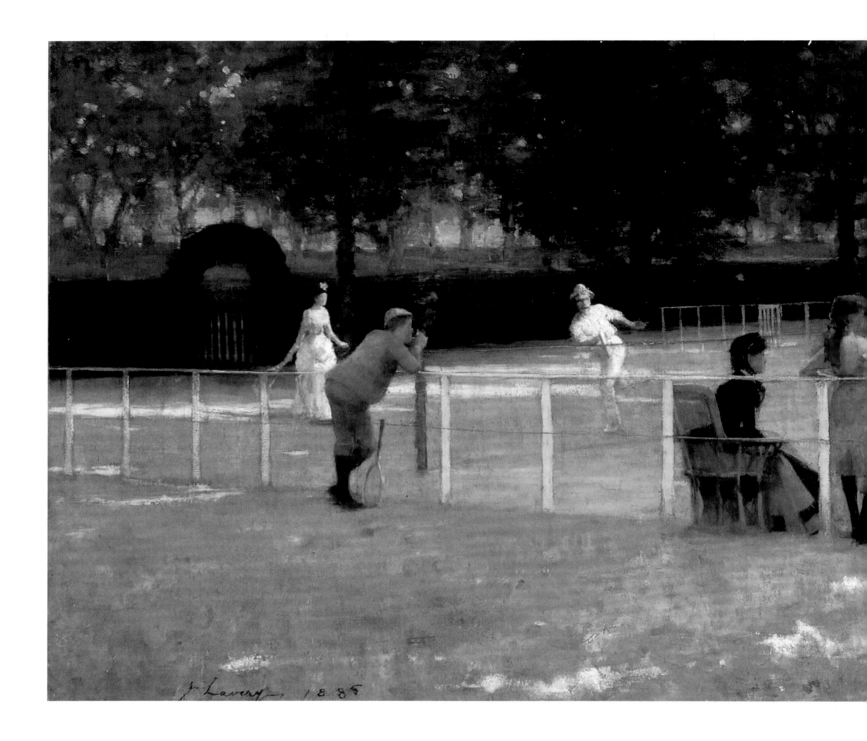

Charles VIII hit his head so hard on a lintel on his way to court in 1498 that he fell into a coma and died nine hours later.

Könige kamen gar beim Spiel ums Leben: Ludwig X. starb 1316 nach einem besonders intensiven Match (und einigen hastig hinuntergestürzten Gläsern Wein) an einer Lungenentzündung, und Karl VIII. schlug sich 1498 auf dem Weg zum Court den Kopf so heftig an einem Türsturz, dass er ins Koma fiel und neun Stunden später starb.

The oil painting "The Tennis Party" (1885) by John Laverty presents the time at the turn of the century.
Das Ölgemälde »The Tennis Party« (1885) von John Laverty porträtiert die Zeit um die Jahrhundertwende.

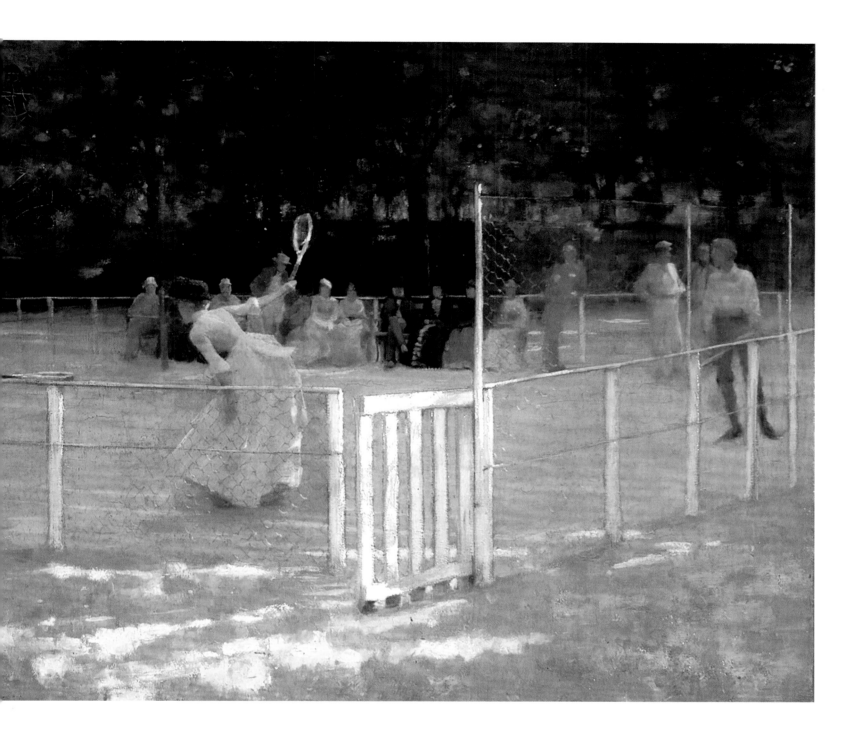

"Lawn tennis" – the sport as we know it today – didn't come into vogue until the late 19th century because fresh air was now considered healthy; people had had enough of cramped buildings and gloomy ballrooms. It is no coincidence that the host of Wimbledon is called All England *Lawn* Tennis and Croquet Club to emphasize its novelty. The old Tennis fell out of fashion; today it is still played by a small group of enthusiasts on about 50 courts worldwide.

Lawn Tennis, »Rasentennis« – der Sport, wie wir ihn heute kennen –, kam erst im späten 19. Jahrhundert in Mode, denn frische Luft galt nun als gesund; man hatte genug von beengten Gebäuden und düsteren Ballsälen. Es ist kein Zufall, dass der Ausrichter von Wimbledon All England *Lawn* Tennis and Croquet Club heißt, um seine Neuartigkeit zu unterstreichen. Das alte Tennis geriet außer Mode; heute wird es noch von einer kleinen Gruppe von Enthusiasten auf etwa 50 Courts weltweit gespielt.

THE 20 BEST MEN OF ALL TIME

DIE 20 BESTEN HERREN ALLER ZEITEN

It has been a privilege to have watched tennis in recent years – because the three best players ever to play the sport were all active and met in epic matches in almost every final.

Es war ein Privileg, in den letzten Jahren Tennis geschaut zu haben – denn die drei besten Spieler, die diesen Sport je ausgeübt haben, waren allesamt aktiv und trafen in beinahe jedem Finale zu epischen Matches aufeinander.

THE ULTIMATE BOOK

Australian Rod Laver receives the Gentlemen's Singles Trophy from Queen Elizabeth II after defeating his compatriot Martin Mulligan in the final of the 1962 Wimbledon Lawn Tennis Championship.

Der Australier Rod Laver erhält von Queen Elizabeth II. die Gentlemen's Singles Trophy, nachdem er seinen Landsmann Martin Mulligan im Endspiel der Wimbledon Lawn Tennis Championship 1962 besiegt hat.

11
Grand Slam singles titles
Grand-Slam-Titel im Einzel

· · · · · · · · · · ·

1

Weeks as number 1
Wochen als Nummer 1

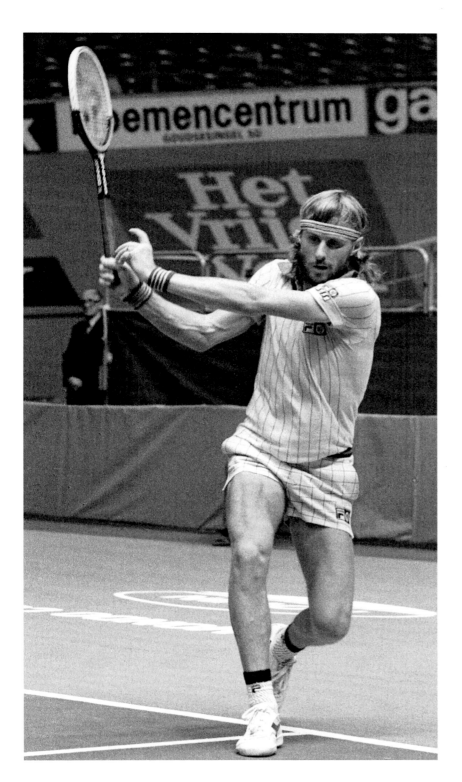

↑ Björn Borg in the final of the ABN tennis tournament
in Rotterdam, 1979.
Björn Borg im Finale des ABN-Tennisturniers in
Rotterdam, 1979.

← Tennis player Björn Borg wins
Wimbledon final again, 1979.
Tennisspieler Björn Borg gewinnt erneut
das Wimbledon-Finale, 1979.

BJÖRN BORG

The stoic Swede provided the sport's most special moments, especially in his duels with the hothead John McEnroe. Wimbledon's Centre Court was his living room, where he won five championships in a row from 1976 to 1980. Several attempts at comebacks (some still with wooden rackets!) failed.

Der stoische Schwede sorgte vor allem in seinen Duellen mit dem Hitzkopf John McEnroe für die ganz besonderen Momente des Sports. Der Center-Court von Wimbledon war sein Wohnzimmer, wo er von 1976 bis 1980 fünf Mal in Folge gewann. Mehrere Versuche von Comebacks (teilweise noch mit Holzschläger!) scheiterten.

↓ Prime Minister van Agt congratulates the winner
Björn Borg, Rotterdam, 1979.
Ministerpräsident van Agt gratuliert dem Sieger
Björn Borg, Rotterdam, 1979.

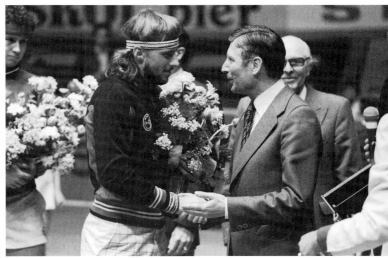

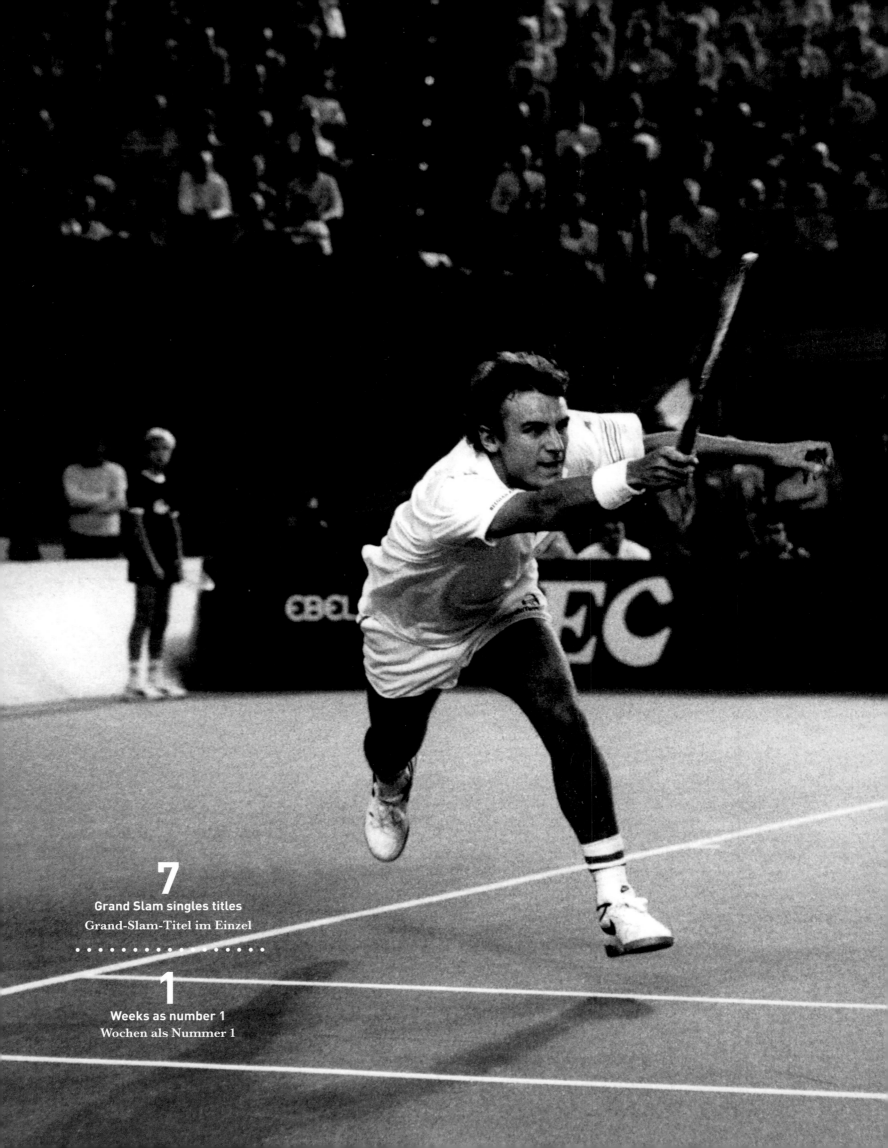

7
Grand Slam singles titles
Grand-Slam-Titel im Einzel

1
Weeks as number 1
Wochen als Nummer 1

MATS WILANDER

His rise began from nowhere: at 17, the Swede won the French Open in 1982 and had his strongest year in 1988, when he won three of the four Grand Slam tournaments. Only Wimbledon is missing from his collection of titles – although he did triumph in doubles there.

Sein Aufstieg begann aus dem Nichts: Mit 17 gewann der Schwede 1982 die French Open und hatte sein stärkstes Jahr 1988, als er drei der vier Grand-Slam-Turniere gewann. Bloß Wimbledon fehlt ihm in seiner Titelsammlung – dort gelang ihm allerdings der Triumph im Doppel.

Mats Wilander during his match against Boris Becker at the Davis Cup, Munich, 1985.
Mats Wilander während seines Spiels gegen Boris Becker beim Davis Cup, München, 1985.

FRED PERRY

His shirts with the symbol of the laurel wreath are still frequently seen on and off the tennis court and have always been a symbol for various youth movements of all political orientations, from skinheads to punks; Perry always resisted any appropriation. The Englishman won Wimbledon three times in the 1930s and once even the world championship in table tennis.

Seine Shirts mit dem Symbol des Lorbeerkranzes sind bis heute häufig dies- und jenseits des Tennisplatzes gesehen und immer wieder Symbol für verschiedene Jugendbewegungen aller politischen Ausrichtungen, von Skinheads bis Punks; Perry wehrte sich stets gegen jede Vereinnahmung. Der Engländer gewann in den 1930er-Jahren drei Mal in Wimbledon und ein Mal sogar die Weltmeisterschaft im Tischtennis.

→ Fred Perry coaching children at Surbiton High School, 1949.
Fred Perry trainiert Kinder der Surbiton High School. London, 1949.

↓ Tennis players Jean Borotra (left) and Fred Perry in 1932.
Die Tennisspieler Jean Borotra (links) und Fred Perry im Jahr 1932.

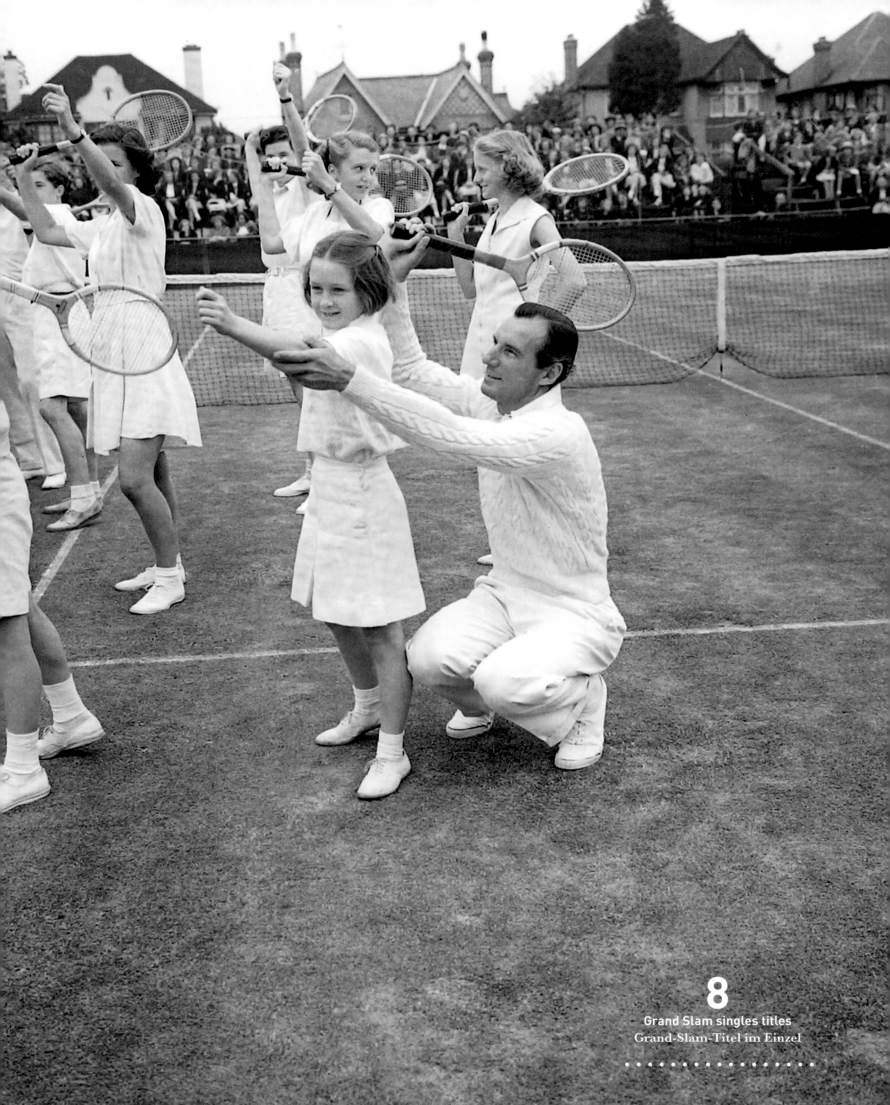

8
Grand Slam singles titles
Grand-Slam-Titel im Einzel

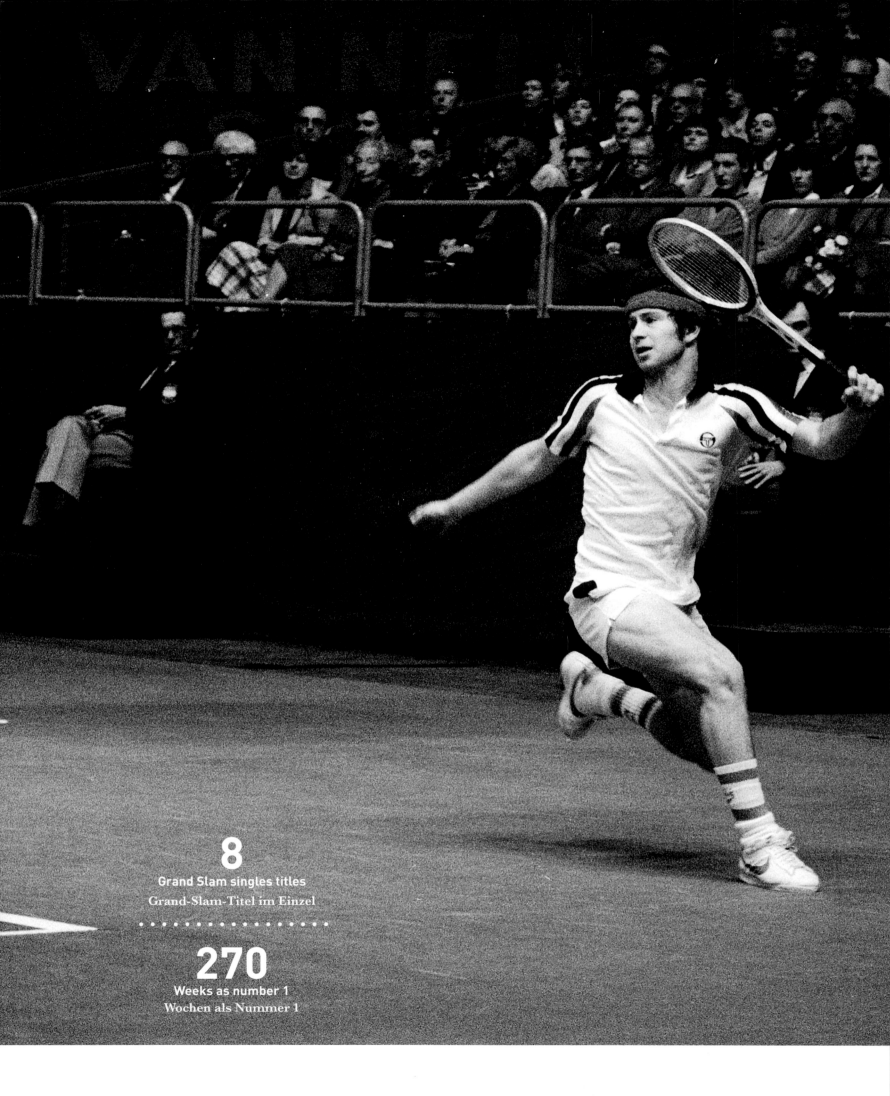

8
Grand Slam singles titles
Grand-Slam-Titel im Einzel

· · · · · · · · · · · · · · · ·

270
Weeks as number 1
Wochen als Nummer 1

John McEnroe at the ABN tennis tournament in Rotterdam, 1979.
John McEnroe beim ABN-Tennisturnier in Rotterdam, 1979.

JOHN MCENROE

He divided audiences with his often disrespectful demeanor, and his saying "You cannot be serious!" which he hurled at a linesman who saw his ball out of bounds is now deeply ingrained in the vernacular (as is the title of his autobiography). But the New Yorker, born in Wiesbaden, Germany, made tennis immensely popular in the US with his passion. Meanwhile, he is a respected TV analyst.

Er spaltete das Publikum mit seinem oft respektlosen Auftreten, und sein Ausspruch »You cannot be serious!«, den er einem Linienrichter entgegenschleuderte, der seinen Ball im Aus sah, ist inzwischen tief in der Umgangssprache verankert (und auch der Titel seiner Autobiografie). Doch der im deutschen Wiesbaden geborene New Yorker machte Tennis mit seiner Leidenschaft in den USA ungeheuer populär. Inzwischen ist er ein angesehener TV-Analyst.

↓ John McEnroe congratulates Björn Borg at the net.
John McEnroe gratuliert Björn Borg am Netz.

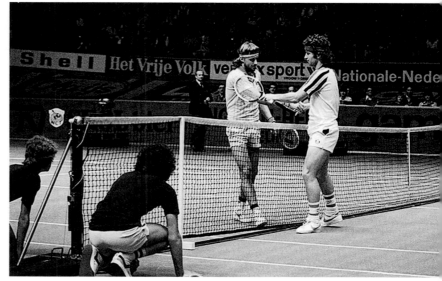

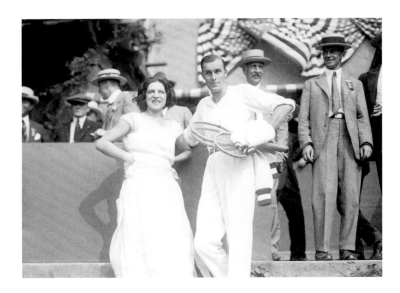

BILL TILDEN

❝❝ Big Bill" dominated the 1920s, yet the man from Philadelphia was a real late bloomer who only became almost invincible at the age of 27. He made no secret of his homosexuality, was sentenced to prison twice in the 1940s, and died ostracized and impoverished.

»Big Bill« dominierte die 1920er-Jahre, dabei war der Mann aus Philadelphia ein echter Spätentwickler, der erst mit 27 Jahren nahezu unbezwingbar wurde. Er machte aus seiner Homosexualität kein Geheimnis, wurde in den 1940er-Jahren zwei Mal zu einer Gefängnisstrafe verurteilt und starb geächtet und verarmt.

↑ Bill Tilden & Suzanne Lenglen, the first idols of tennis, in 1920. By 1922 Wimbledon had built a new Centre Court and grounds on the present site to meet the fans demand for these two superstars.
Bill Tilden und Suzanne Lenglen, die ersten Idole des Tennissports, im Jahr 1920. Bis 1922 baute Wimbledon an der heutigen Stelle einen neuen Center-Court und ein neues Gelände, um die Nachfrage der Fans nach diesen beiden Superstars zu befriedigen.

→ Bill Tilden in action, Wimbledon, 1930.
Bill Tilden in Aktion, Wimbledon, 1930.

11
Grand Slam singles titles
Grand-Slam-Titel im Einzel
.

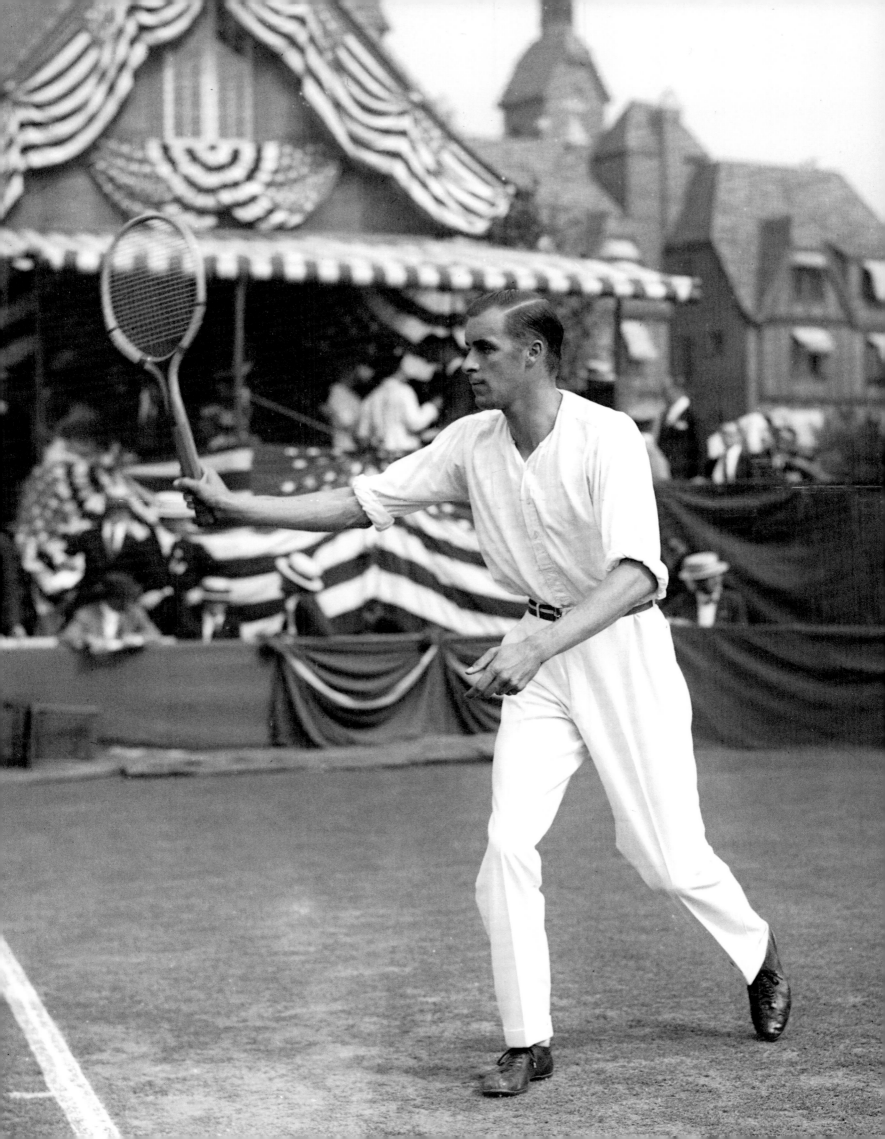

ROY EMERSON

The Australian and great rival of Rod Laver is the only male player to win all Grand Slam titles in singles and also in doubles. He particularly dominated the French Open in doubles, winning six in a row from 1960 to 1965.

Der Australier und große Konkurrent Rod Laver ist der einzige männliche Spieler, der alle Grand-Slam-Titel im Einzel und auch im Doppel gewann. Besonders die French Open dominierte er im Doppel und gewann von 1960 bis 1965 sechs Mal in Folge.

12
Grand Slam singles titles
Grand-Slam-Titel im Einzel

• • • • • • • • • • • • • •

↑ Pierre Darmon and Roy Emerson in the final of the French Open in 1963.
Pierre Darmon und Roy Emerson im Finale der French Open im Jahr 1963.

↑ Roy Emerson in the final of the Dutch International
Tennis Championships against South African Cliff
Drysdale, 1963.

Roy Emerson im Finale der Internationalen
Niederländischen Tennismeisterschaften gegen
den Südafrikaner Cliff Drysdale, 1963.

KEN ROSEWALL

The marathon man, born in Sydney, Australia, was spared injuries during his career and has won tournaments over a period of more than 20 years – he was 43 years old when he won his last major title.

Der Marathonmann, geboren im australischen Sydney, blieb während seiner Karriere von Verletzungen verschont und konnte über eine Zeitspanne von mehr als 20 Jahren Turniere gewinnen – bei seinem letzten großen Titel war er 43 Jahre alt.

↑ Ken Rosewall at an exhibition in Noordwijk, 1956.
Ken Rosewall bei einer Ausstellung in Noordwijk, 1956.

8
Grand Slam singles titles
Grand-Slam-Titel im Einzel

.

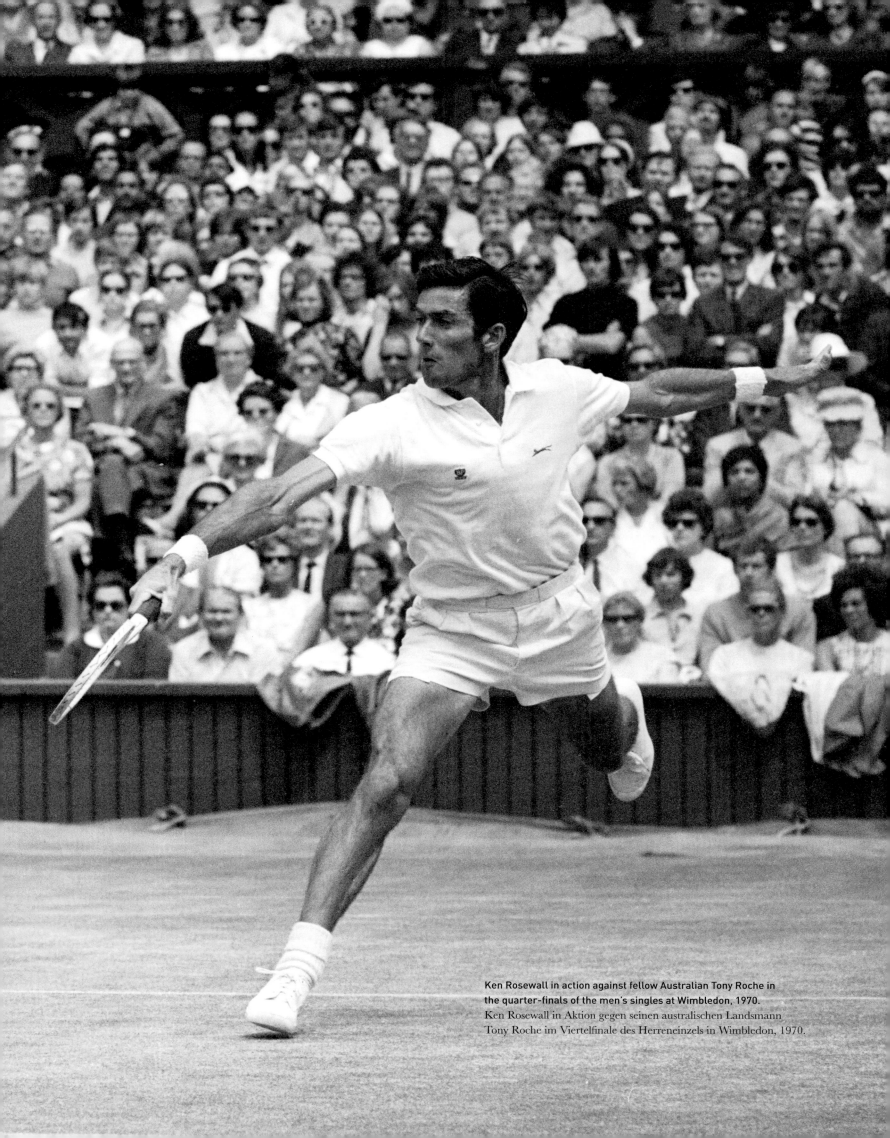

Ken Rosewall in action against fellow Australian Tony Roche in
the quarter-finals of the men's singles at Wimbledon, 1970.
Ken Rosewall in Aktion gegen seinen australischen Landsmann
Tony Roche im Viertelfinale des Herreneinzels in Wimbledon, 1970.

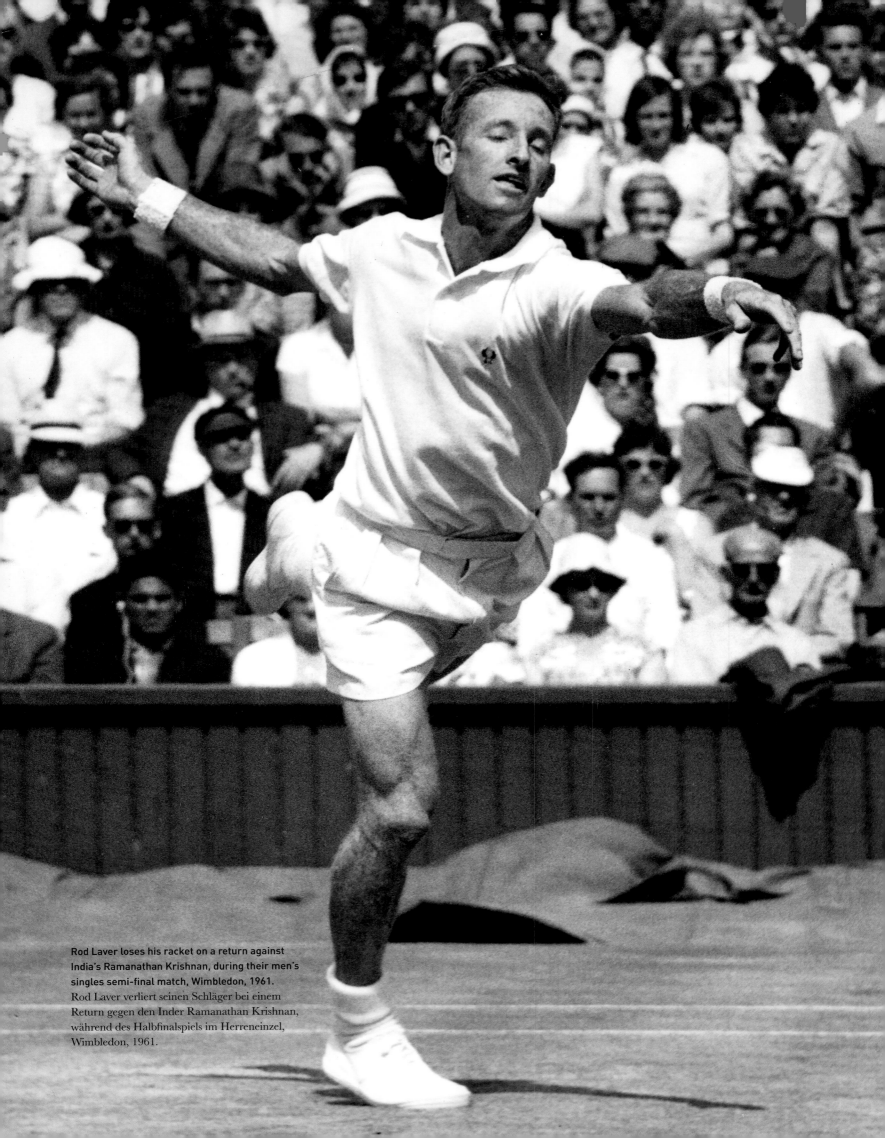

Rod Laver loses his racket on a return against
India's Ramanathan Krishnan, during their men's
singles semi-final match, Wimbledon, 1961.
Rod Laver verliert seinen Schläger bei einem
Return gegen den Inder Ramanathan Krishnan,
während des Halbfinalspiels im Herreneinzel,
Wimbledon, 1961.

ROD LAVER

The Australian achieved his sporting breakthrough by winning the Australian Open in 1960. He is the only player to have won the Grand Slam (i.e. all four major tournaments in one year) twice, in 1962 and 1969. The Centre Court of the Australian Open is named after him.

Der Australier erzielte seinen sportlichen Durchbruch mit dem Gewinn der Australian Open 1960. Er ist der einzige Spieler, der den Grand Slam (also alle vier großen Turniere in einem Jahr) zwei Mal gewinnen konnte, nämlich 1962 und 1969. Der Center-Court der Australian Open ist nach ihm benannt.

↓ Rod Laver with the Gentlemen's Singles Trophy after defeating his compatriot Martin Mulligan in the final, Wimbledon, 1962.
Rod Laver mit der Gentlemen's Singles Trophy nach dem Sieg über seinen Landsmann Martin Mulligan im Finale, Wimbledon, 1962.

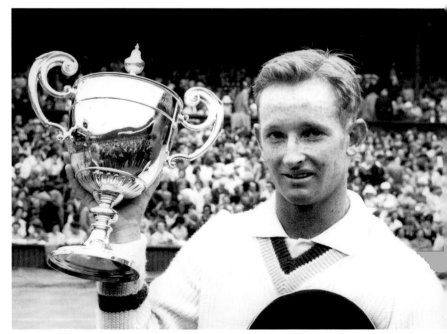

14
Grand Slam singles titles
Grand-Slam-Titel im Einzel

· · · · · · · · · · · · · · · ·

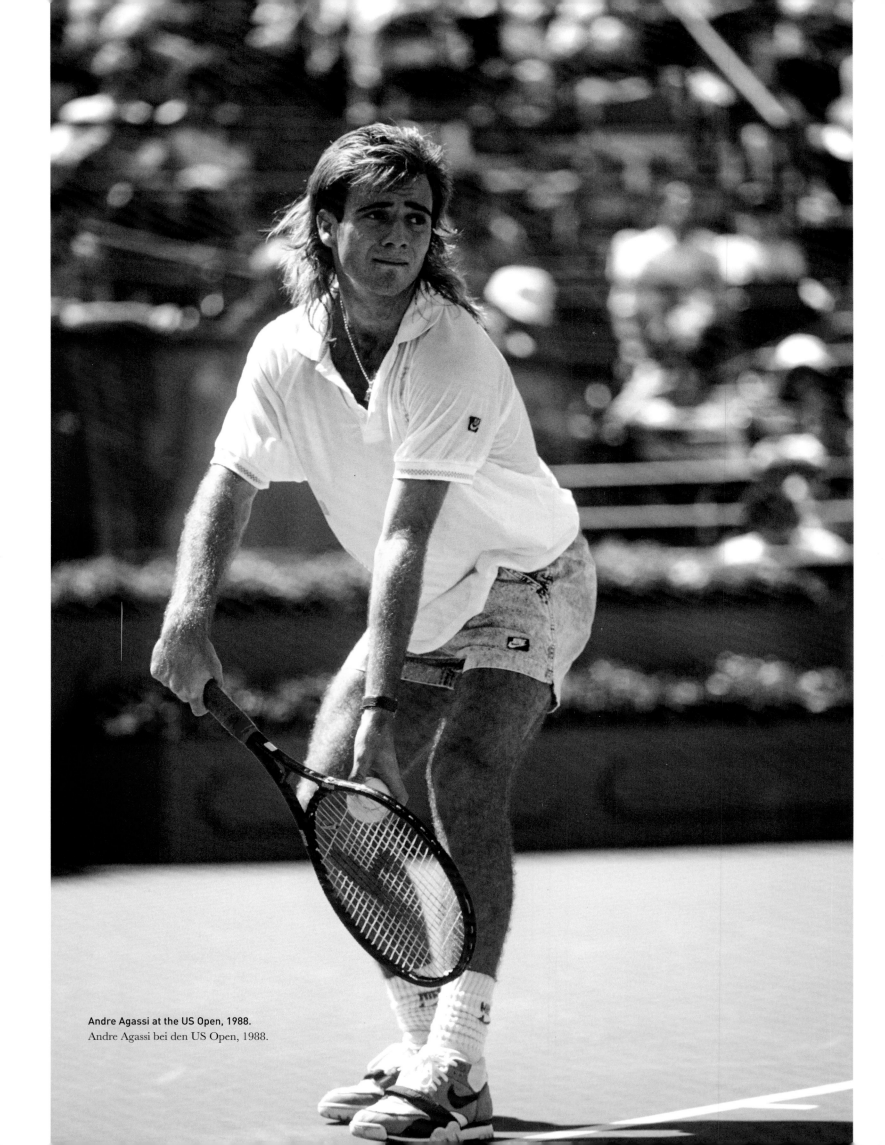

Andre Agassi at the US Open, 1988.
Andre Agassi bei den US Open, 1988.

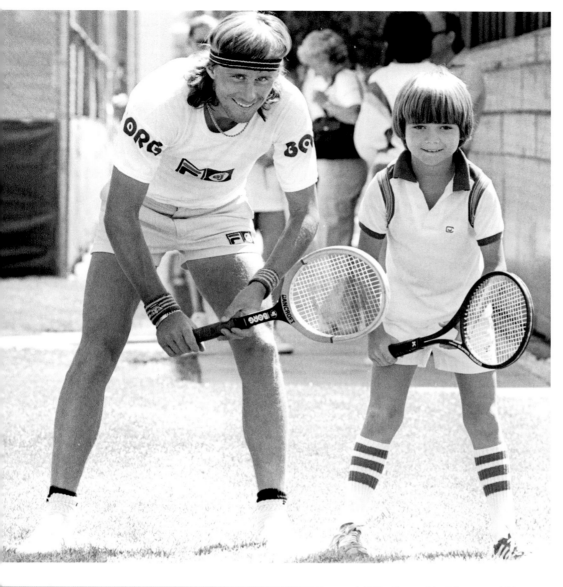

ANDRE AGASSI

Bird of paradise, rebel, icon: In his remarkable autobiography *Open*, the shooting star of the late 1980s from Las Vegas also describes very vividly the darker side of a sportsman's life. His wild mane has long since disappeared, but he is happily married to Steffi Graf.

Paradiesvogel, Rebell, Ikone: In seiner bemerkenswerten Autobiografie *Open: Das Selbstporträt* beschreibt der Shooting-Star der späten 1980er-Jahre aus Las Vegas auch sehr anschaulich die Schattenseiten des Sportlerlebens. Die wilde Mähne ist längst verschwunden, dafür ist er glücklich mit Steffi Graf verheiratet.

↑ Björn Borg with eight-year-old future champion Andre Agassi, Las Vegas, 1978.
Der schwedische Tennisspieler Björn Borg mit dem achtjährigen zukünftigen Champion Andre Agassi, Las Vegas, 1978.

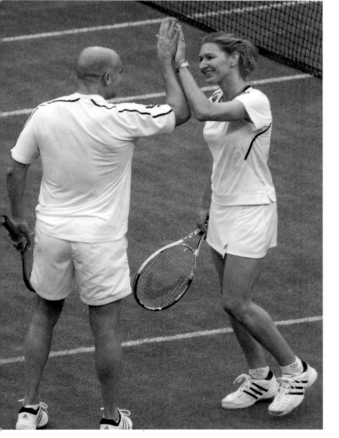

← A tennis love affair. Andre Agassi marries fellow tennis player Steffi Graf on 22 October 2001. They have two children together and live in Las Vegas. Shown here at the charity event "A Centre Court Celebration" playing against Tim Henman and Kim Clijsters.
Eine Tennisliebe. Andre Agassi heiratet am 22.10.2001 seine Tenniskollegin Steffi Graf. Die beiden haben zwei Kinder zusammen und leben in Las Vegas. Hier zu sehen bei der Charity-Veranstaltung »A Center-Court Celebration« beim Spiel gegen Tim Henman und Kim Clijsters.

8
Grand Slam singles titles
Grand-Slam-Titel im Einzel

• • • • • • • • • • • • • • • •

101
Weeks as number 1
Wochen als Nummer 1

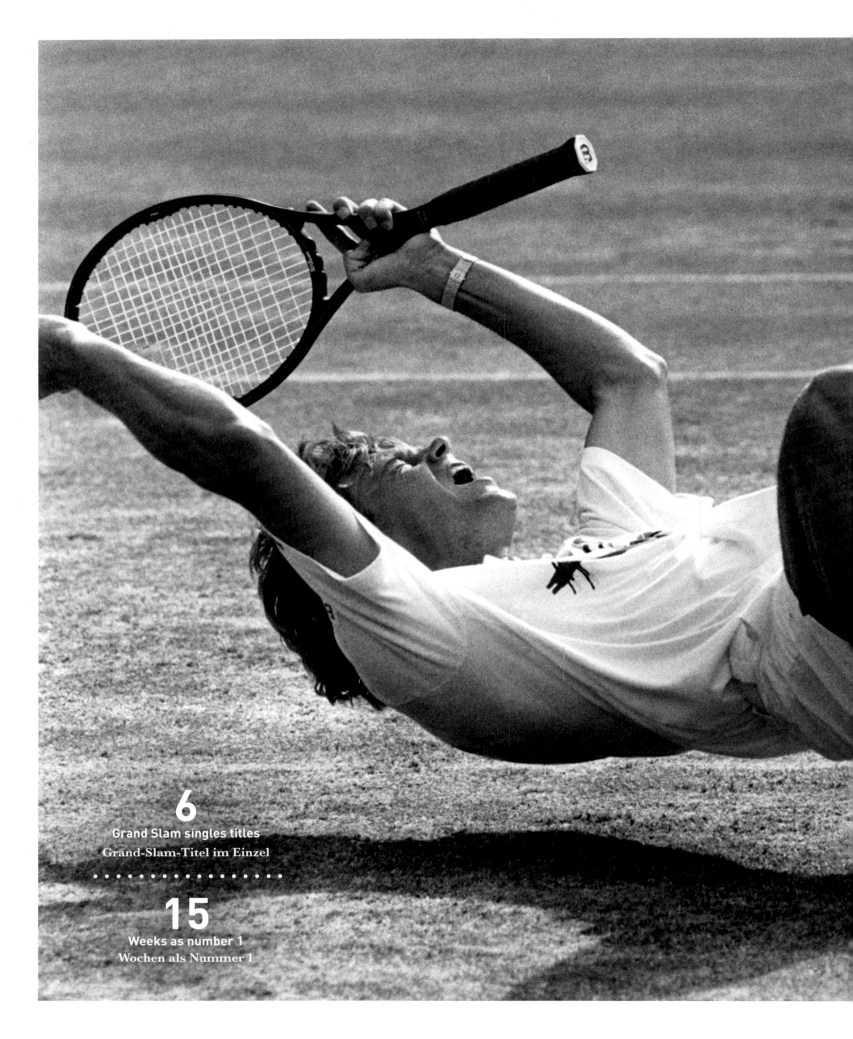

6
Grand Slam singles titles
Grand-Slam-Titel im Einzel

· · · · · · · · · · · · · · · · · ·

15
Weeks as number 1
Wochen als Nummer 1

STEFAN EDBERG

No one perfected the serve-and-volley like he did: practically at the same time as he served, he was already at the net. This made the Swede a power, especially on the fast Wimbledon grass.

Niemand perfektionierte das Serve-and-Volley-Spiel wie er: Praktisch zeitgleich mit seinem Aufschlag stand er schon am Netz. Das machte den Schweden besonders auf dem schnellen Wimbledon-Rasen zu einer Macht.

Stefan Edberg celebrates hilariously after winning at Wimbledon, 1988.
Stefan Edberg feiert ausgelassen nach seinem Sieg in Wimbledon, 1988.

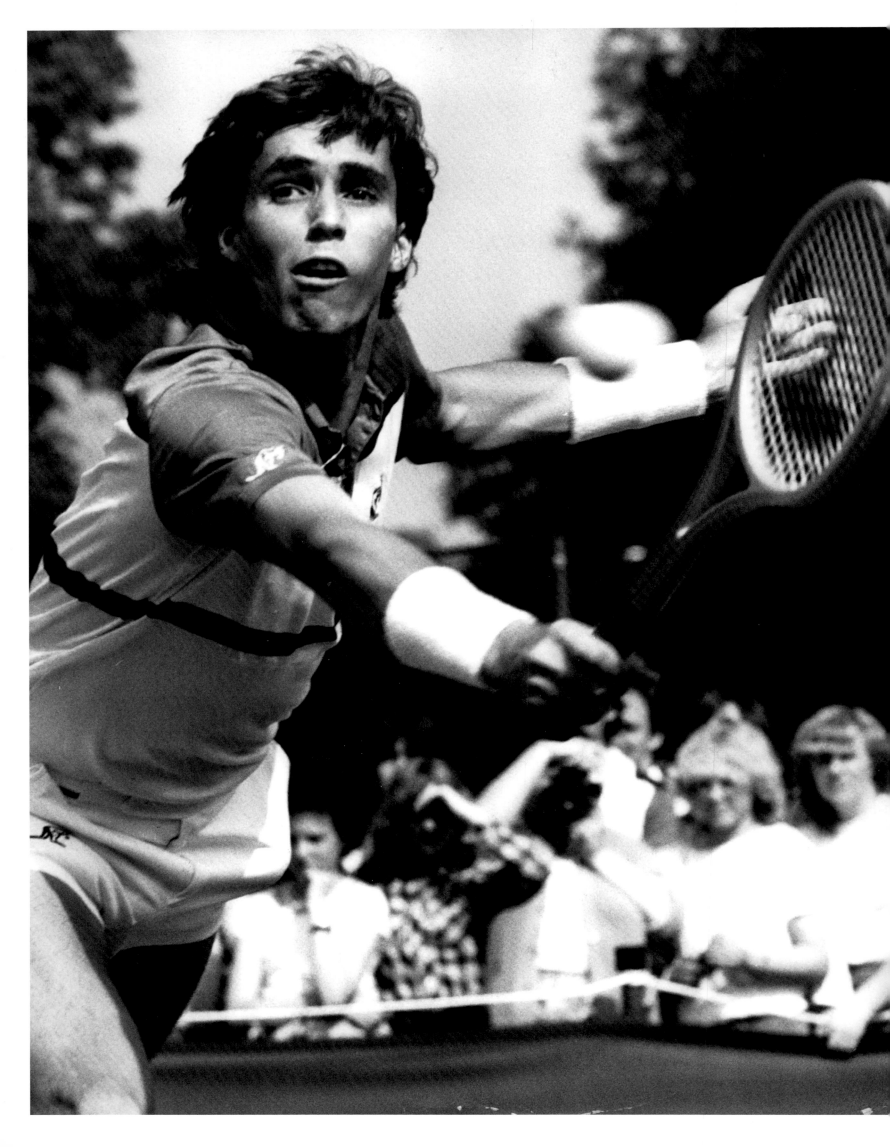

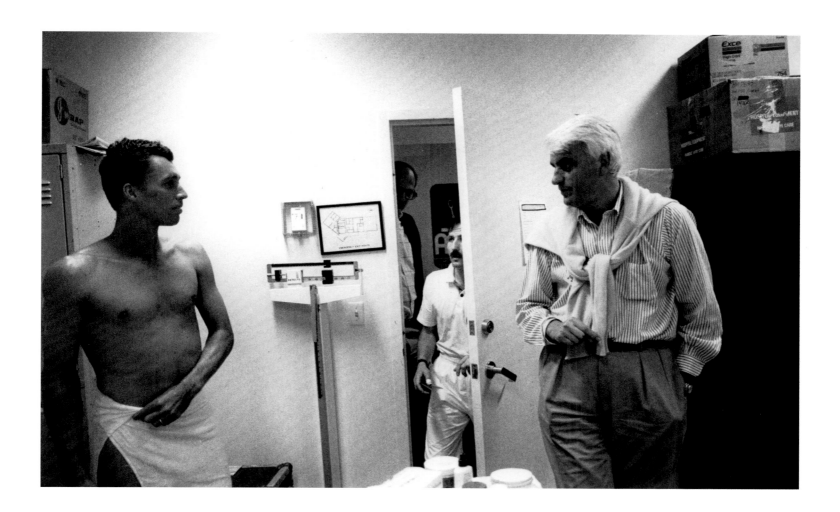

IVAN LENDL

There was always something tragic about his dominance. The Czech, who later became a US citizen, was never able to win at Wimbledon and often suffered unfortunate defeats there. Otherwise, he won on all surfaces with almost tantalizing ease – in total, he has 94 career titles.

Seiner Dominanz haftete immer etwas Tragisches an, konnte der Tscheche, der später US-Bürger wurde, doch nie in Wimbledon gewinnen und erlebte dort oft unglückliche Niederlagen. Ansonsten siegte er auf allen Belägen mit beinahe aufreizender Leichtigkeit – insgesamt kommt er auf 94 Karrieretitel.

8
Grand Slam singles titles
Grand-Slam-Titel im Einzel

· · · · · · · · · · · · · ·

270
Weeks as number 1
Wochen als Nummer 1

← Wimbledon 1981, Ivan Lendl maximally motivated number 4 in the seedings fails to make the final.
Wimbledon 1981, Ivan Lendl ist maximal motiviert als Nummer 4 der Setzliste und schafft es nicht ins Finale.

↑ Czech tennis player Ivan Lendl and his manager Cino Marchesi in the dressing room, ca 1980.
Der tschechische Tennisspieler Ivan Lendl und sein Manager Cino Marchesi in der Umkleidekabine, ca. 1980.

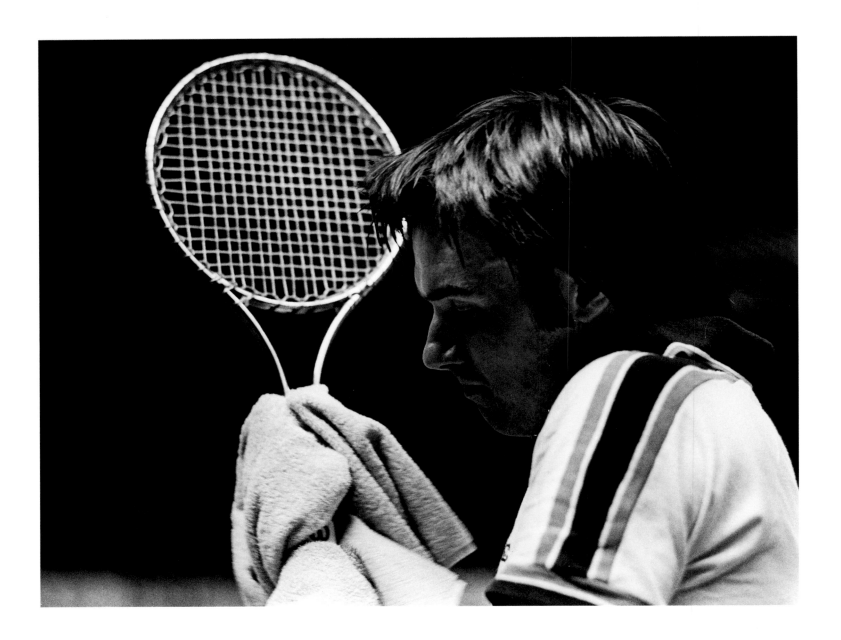

JIMMY CONNORS

The US American from Illinois was exceptionally durable and remained a professional until the age of 43. The left-hander, who won the US Open five times, was briefly involved with Chris Evert. Of the major titles, only the French Open eluded him.

Der US-Amerikaner aus Illinois war außergewöhnlich langlebig und blieb Profi bis ins 43. Lebensjahr. Der Linkshänder, der fünf Mal die US Open gewinnen konnte, war kurzzeitig mit Chris Evert liiert. Von den großen Titeln blieb ihm nur die French Open verwehrt.

↑ In conversation with his tennis racket, a thoughtful Jimmy Connors, 1978.
In Zwiesprache mit seinem Tennisschläger, ein nachdenklicher Jimmy Connors, 1978.

→ Jimmy Connors plays at the Corners ABN tennis tournament in Rotterdam, 1978.
Jimmy Connors spielt beim Corners ABN-Tennisturnier in Rotterdam, 1978.

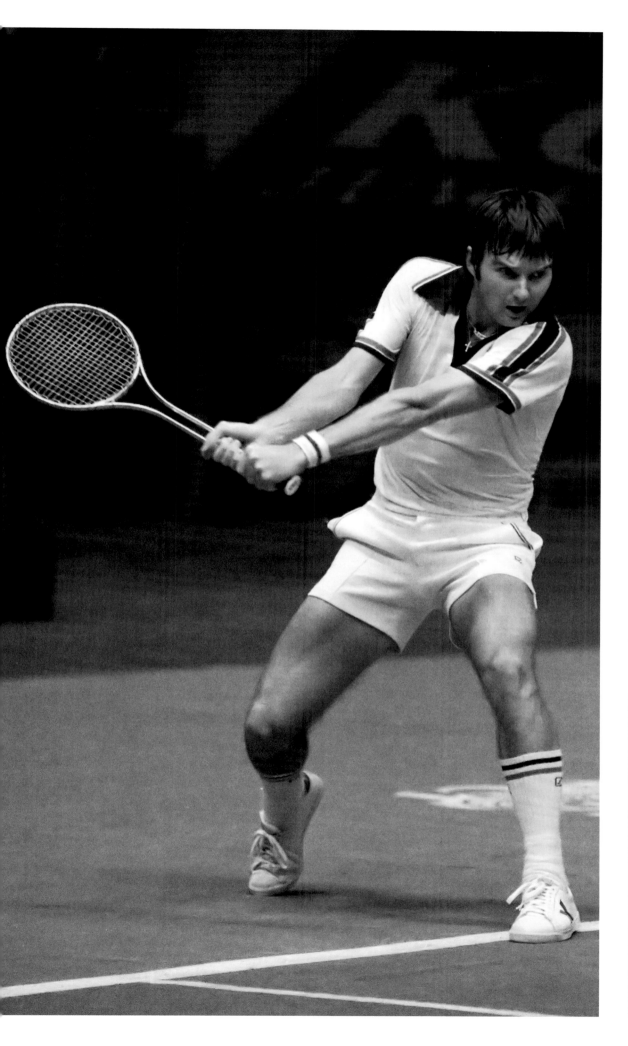

8
Grand Slam singles titles
Grand-Slam-Titel im Einzel

· · · · · · · · · · · · · · · · ·

268
Weeks as number 1
Wochen als Nummer 1

With both hands on the racket, Jimmy Connors plays in exactly the same playing position as 30 years earlier, Miami, 2007.
Mit beiden Händen am Schläger spielt Jimmy Connors in exakt der gleichen Spielhaltung wie 30 Jahre zuvor, Miami, 2007.

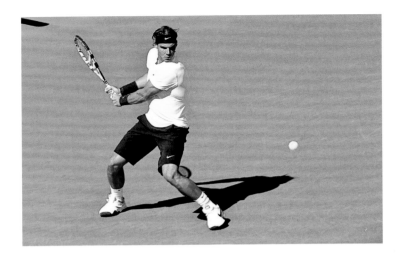

RAFAEL NADAL

Born in Mallorca, "Rafa" is one of the greatest players of all time – and he is definitely the best on clay: he remained undefeated on that surface for almost two years. Incredibly fast and with great stamina, he prefers to play balls from the baseline with a lot of topspin. And he doesn't give up a point without a big fight: his footwork is from another planet.

Geboren auf Mallorca, gehört »Rafa« zu den größten Spielern aller Zeiten – und er ist definitiv der beste auf Sand: Fast zwei Jahre blieb er auf dem Belag unbesiegt. Unfassbar schnell und konditionsstark, spielt er die Bälle von der Grundlinie am liebsten mit viel Topspin. Und er gibt keinen Punkt ohne großen Kampf her: Seine Beinarbeit ist von einem anderen Stern.

↑ Rafael Nadal with his two-handed backhand at the US Open, New York, 2010.
Rafael Nadal bei den US Open mit seiner beidhändigen Rückhand, New York, 2010.

→ Rafael Nadal of Team Europe warms up before the Laver Cup, Geneva, 2019. The Laver Cup pits six players from the rest of the world against their counterparts from Europe.
Rafael Nadal vom Team Europa wärmt sich vor dem Laver Cup auf, Genf, 2019. Beim Laver Cup treten sechs Spieler aus dem Rest der Welt gegen ihre Kollegen aus Europa an.

22
Grand Slam singles titles
Grand-Slam-Titel im Einzel

209
Weeks as number 1
Wochen als Nummer 1

PETE SAMPRAS

The US American with Greek roots was the dominant player of the 1990s. At the age of 19, he already won the US Open; no winner at Flushing Meadows was younger. He was also to win Wimbledon seven times, but early on he repeatedly struggled with injuries. Perhaps even more would have been possible.

Der US-Amerikaner mit griechischen Wurzeln war der dominante Spieler der 1990er-Jahre. Mit 19 Jahren gewann er bereits die US Open, jünger war kein Sieger in Flushing Meadows. Sieben Mal sollte er zudem in Wimbledon gewinnen, doch schon früh hatte er immer wieder mit Verletzungen zu kämpfen. Vielleicht wäre sogar noch mehr möglich gewesen.

14
Grand Slam singles titles
Grand-Slam-Titel im Einzel
.
286
Weeks as number 1
Wochen als Nummer 1

Pete Sampras in flight against Goran Ivanišević,
Wimbledon, 1995.
Pete Sampras in Flughöhe gegen Goran Ivanišević,
Wimbledon, 1995.

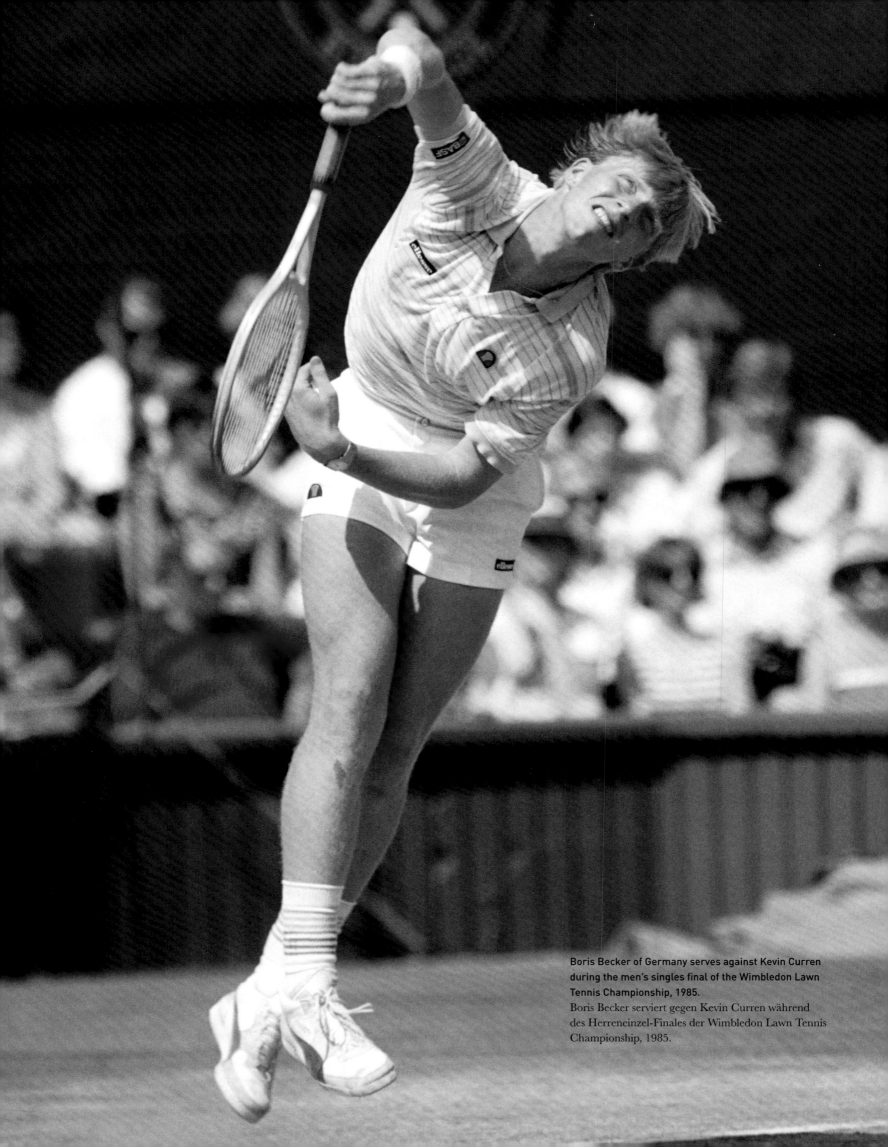

Boris Becker of Germany serves against Kevin Curren during the men's singles final of the Wimbledon Lawn Tennis Championship, 1985.
Boris Becker serviert gegen Kevin Curren während des Herreneinzel-Finales der Wimbledon Lawn Tennis Championship, 1985.

BORIS BECKER

His passionate play electrified fans, and his victories were as dramatic as his defeats. As a 17-year-old, he sensationally won Wimbledon in 1985 – the youngest, first unseeded and first German player to do so. Boris loved and worked tennis; his "Becker dives" became proverbial and remain unmatched.

Sein leidenschaftliches Spiel elektrisierte die Fans, und seine Siege waren so dramatisch wie seine Niederlagen. Als 17-Jähriger gewann er 1985 sensationell in Wimbledon – als jüngster, erster ungesetzter und erster deutscher Spieler. Boris liebte und arbeitete Tennis; seine »Becker-Hechts« wurden sprichwörtlich und bleiben unerreicht.

6
Grand Slam singles titles
Grand-Slam-Titel im Einzel

· · · · · · · · · · · · · · · · ·

12
Weeks as number 1
Wochen als Nummer 1

↓ The famous Becker dive. Germany's Boris Becker dives to play a return against Goran Ivanišević, Wimbledon, 1994.
Die berühmte Beckerrolle. Boris Becker taucht ab, um einen Return gegen Goran Ivanišević zu spielen, Wimbledon, 1994.

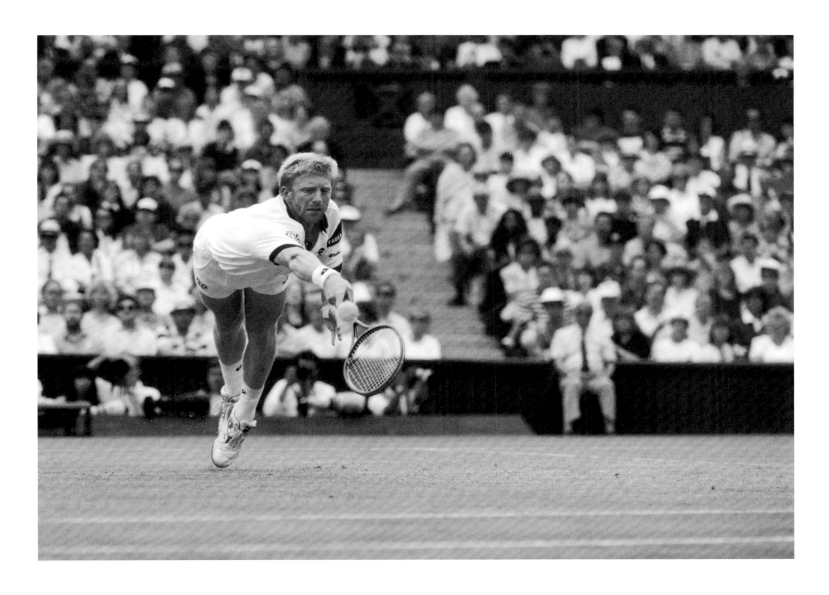

JOHN NEWCOMBE

The Australian with the moustache was one of the wildest players in the tennis world, so aggressive in his pursuit of points that he often hit an ace with his second serve. He was one of a handful of professionals to top the world rankings in both singles and doubles.

Der Australier mit dem Schnauzbart war einer der wildesten Spieler der Tenniswelt, der so aggressiv auf Punktejagd ging, dass er oft auch noch mit seinem zweiten Aufschlag ein Ass schlug. Als einer von wenigen Profis führte er sowohl im Einzel als auch im Doppel die Weltrangliste an.

An energetic John Newcombe in action, Scheveningen, 1969.
Ein energischer John Newcombe in Aktion, Scheveningen, 1969.

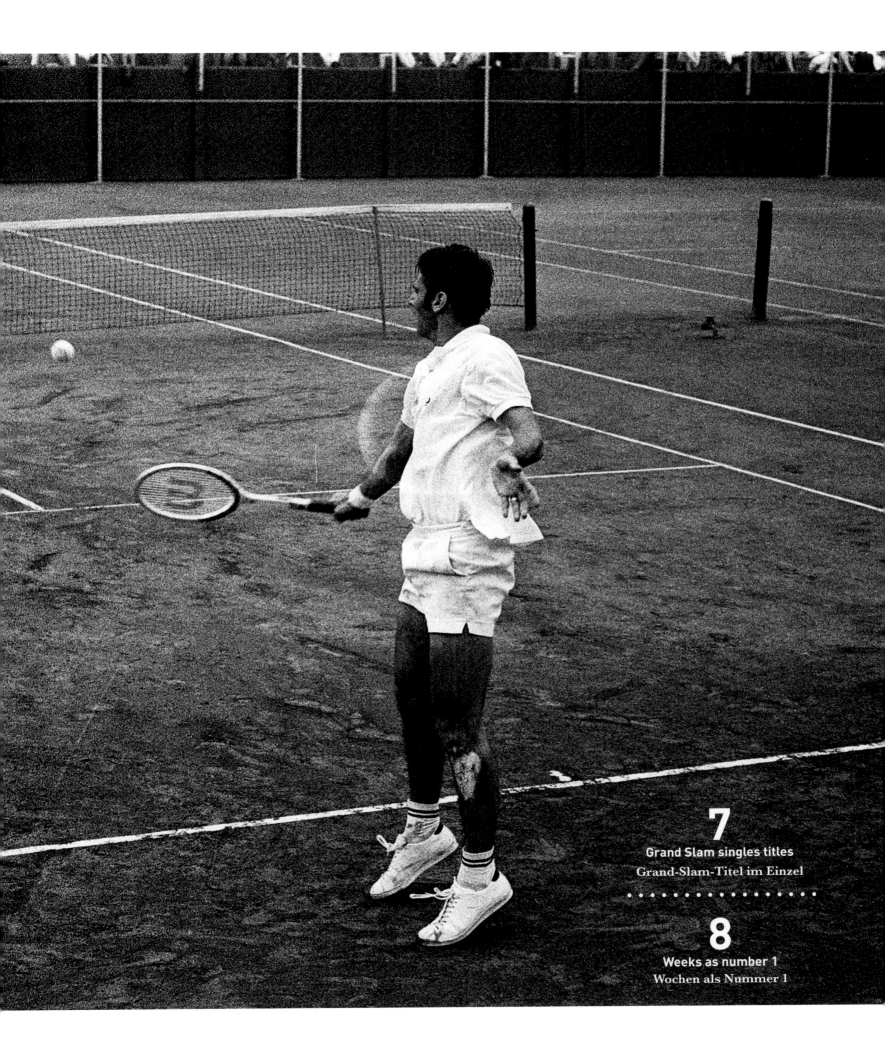

7
Grand Slam singles titles
Grand-Slam-Titel im Einzel

· · · · · · · · · · · · · · · · · ·

8
Weeks as number 1
Wochen als Nummer 1

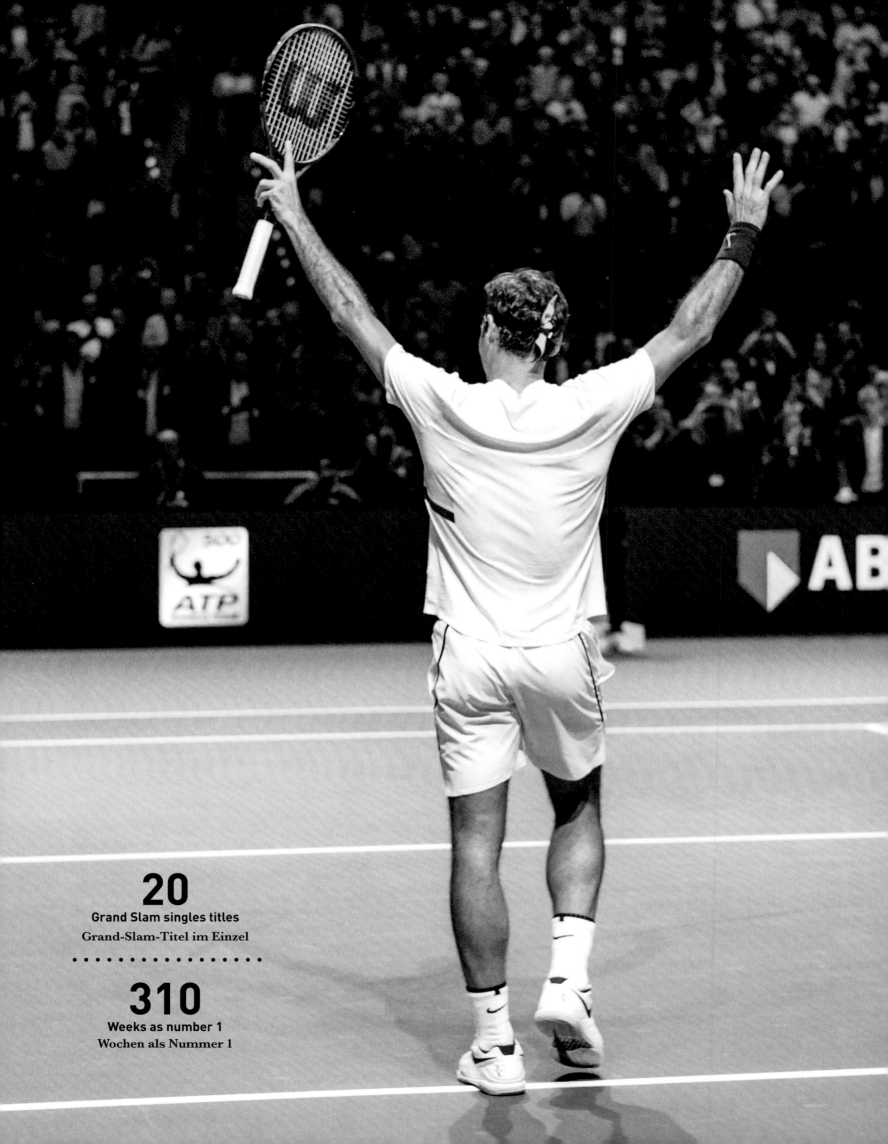

20
Grand Slam singles titles
Grand-Slam-Titel im Einzel
· · · · · · · · · · · · · · · · · ·
310
Weeks as number 1
Wochen als Nummer 1

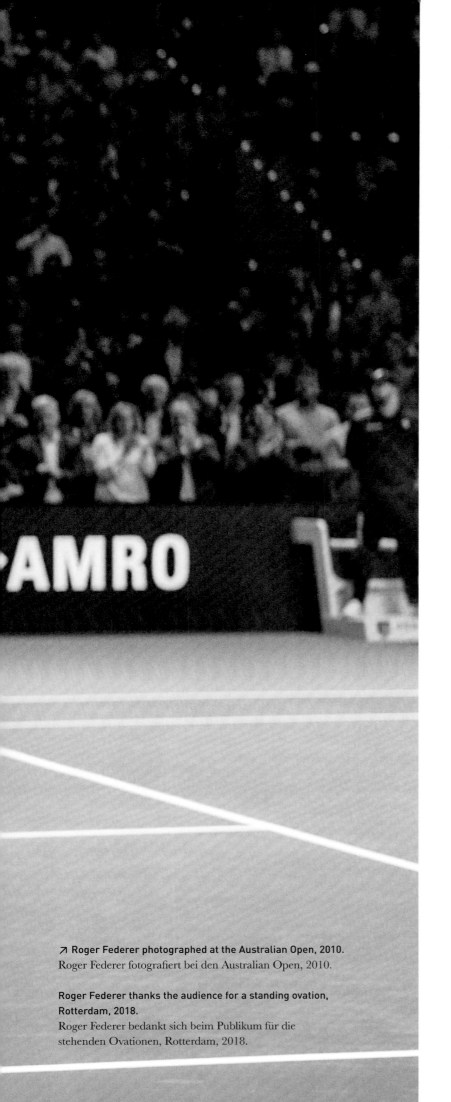

ROGER FEDERER

No one had more talent than him, no one played tennis so elegantly, with so much variation, so light-heartedly – indeed, almost good-humoredly, even under extreme pressure. The Swiss was regarded as a player without any weaknesses and also had extremely strong nerves. A true gentleman off the court as well, his retirement from professional tennis in September 2022 brought even his competitors to tears.

Niemand hatte mehr Talent als er, niemand spielte Tennis so elegant, so variantenreich, so unbeschwert – ja, beinahe gutgelaunt, auch unter extremem Druck. Der Schweizer galt als Spieler ohne jede Schwäche und war zudem extrem nervenstark. Ein echter Gentleman auch jenseits des Platzes, brachte sein Rücktritt vom Profitennis im September 2022 selbst die Konkurrenten zum Weinen.

↗ **Roger Federer photographed at the Australian Open, 2010.**
Roger Federer fotografiert bei den Australian Open, 2010.

Roger Federer thanks the audience for a standing ovation, Rotterdam, 2018.
Roger Federer bedankt sich beim Publikum für die stehenden Ovationen, Rotterdam, 2018.

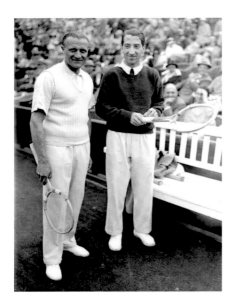

RENÉ LACOSTE

I n 1919, at the age of 15, young René finally managed to persuade his father to give tennis a try. The father agreed – but only if he would make it to the top of the world within five years. The son obeyed. His nickname "Crocodile" resulted from a bet on a suitcase from crocodile leather – and made his fashion company world famous to this day.

Im Jahr 1919, mit 15 Jahren, schaffte es der junge René endlich, seinen Vater zu überreden, es einmal mit Tennis zu probieren. Der Vater war einverstanden – aber nur, wenn er es innerhalb von fünf Jahren in die Weltspitze schaffen würde. Der Sohn gehorchte. Sein Spitzname »Krokodil« resultierte aus einer Wette um einen Koffer aus Krokodilleder – und machte seine Modefirma bis heute weltberühmt.

↑ René Lacoste (right) together with Otto Froitzheim at a match in Berlin, 1929.
René Lacoste (re.) zusammen mit Otto Froitzheim bei einem Match in Berlin, 1929.

→ Roehampton 1925, Suzanne Lenglen and René Lacoste wildly playing a mixed doubles match.
Roehampton 1925, Suzanne Lenglen und René Lacoste spielen wild ein gemischtes Doppel.

7
Grand Slam singles titles
Grand-Slam-Titel im Einzel

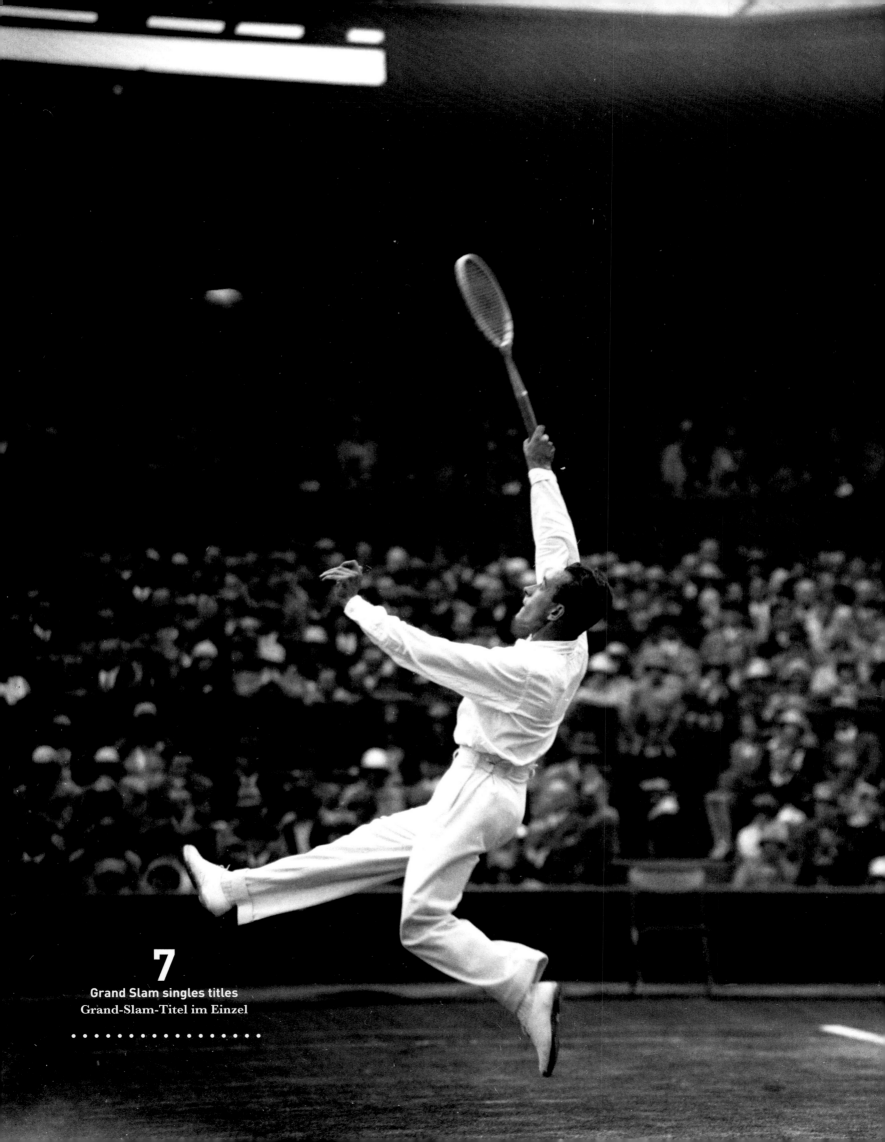

7
Grand Slam singles titles
Grand-Slam-Titel im Einzel

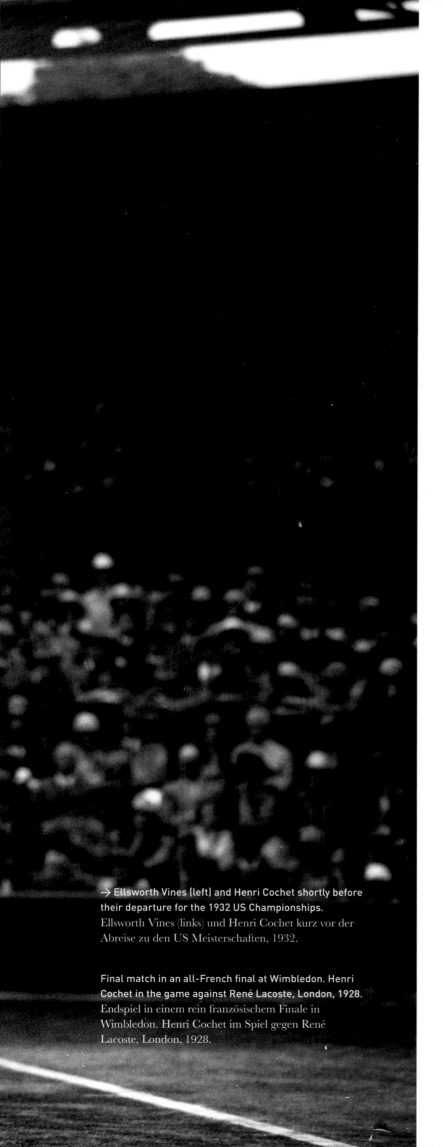

→ Ellsworth Vines (left) and Henri Cochet shortly before their departure for the 1932 US Championships.
Ellsworth Vines (links) und Henri Cochet kurz vor der Abreise zu den US Meisterschaften, 1932.

Final match in an all-French final at Wimbledon. Henri Cochet in the game against René Lacoste, London, 1928.
Endspiel in einem rein französischem Finale in Wimbledon. Henri Cochet im Spiel gegen René Lacoste, London, 1928.

HENRI COCHET

Lacoste's contemporary formed the virtually invincible "Four Musketeers" with the "Crocodile" plus Jean Borotra and Jacques Brugnon, who won the Davis Cup six times in a row for France. He distracted himself from the stress of tournament play with an unusual hobby: he was an excellent ice hockey player.

Der Zeitgenosse von Lacoste bildete mit dem »Krokodil« sowie Jean Borotra und Jacques Brugnon die nahezu unbesiegbaren »Vier Musketiere«, die sechs Mal hintereinander für Frankreich den Davis Cup gewannen. Vom Stress des Turnierbetriebs lenkte er sich mit einem ungewöhnlichen Hobby ab: Er war ein exzellenter Eishockeyspieler.

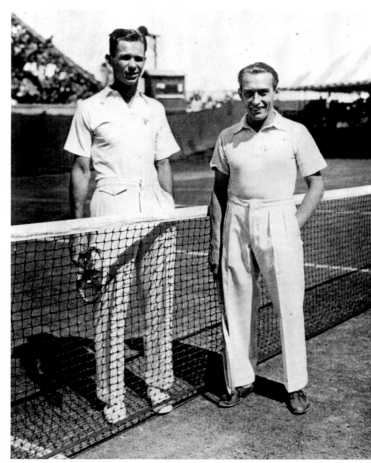

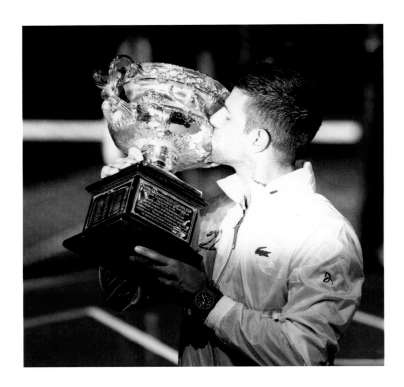

NOVAK DJOKOVIC

The Serb's favorite tournament is the Australian Open, which he has won nine times. He grew up in Belgrade and played tennis every day from the age of four. He later attended the tennis academy in Munich before turning professional at 16 and storming inexorably to the top of the world. His game intelligence is considered unique – he has, it is said, not only a Plan A in every match and for every point win, but also a Plan B, C and D.

Das Lieblingsturnier des Serben ist die Australian Open, die er zehn Mal gewinnen konnte. Er wuchs in Belgrad auf und spielte bereits mit vier Jahren täglich Tennis. Später besuchte er die Tennisakademie in München, bevor er mit 16 Jahren Profi wurde und unaufhaltsam an die Weltspitze stürmte. Seine Spielintelligenz gilt als einmalig – er hat, heißt es, in jedem Match und für jeden Punktgewinn nicht nur einen Plan A, sondern auch einen Plan B, C und D.

↖ Novak Djokovic celebrates his 22nd Grand Slam title with the trophy after the men's final at the Australian Open, Melbourne, 2023.
Novak Djokovic feiert seinen 22. Grand-Slam-Titel mit der Trophäe nach dem Finale der Herren bei den Australian Open, Melbourne, 2023.

A focused Novak Djokovic in action at the Barclays ATP World Finals, O2 Arena, 2013.
Ein konzentrierter Novak Djokovic in Aktion bei den Barclays ATP World Finals, O2 Arena, 2013.

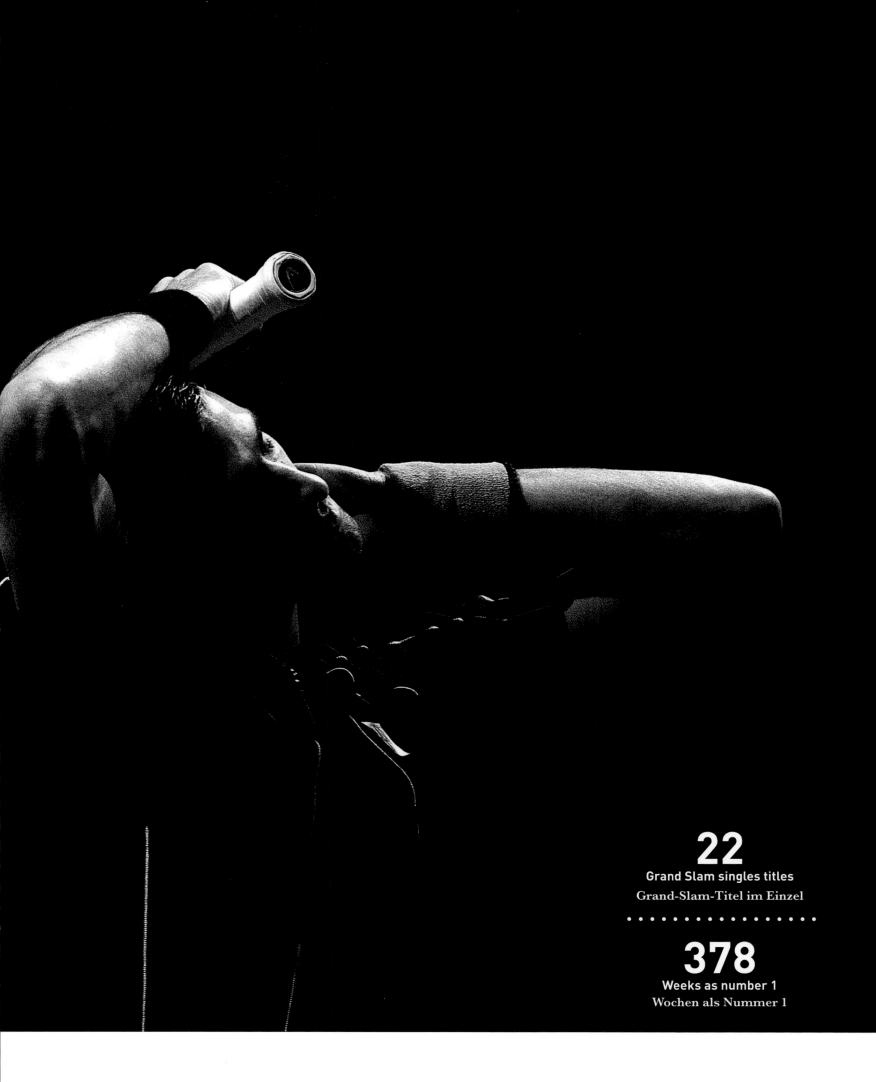

22
Grand Slam singles titles
Grand-Slam-Titel im Einzel

· · · · · · · · · · · · · · · · ·

378
Weeks as number 1
Wochen als Nummer 1

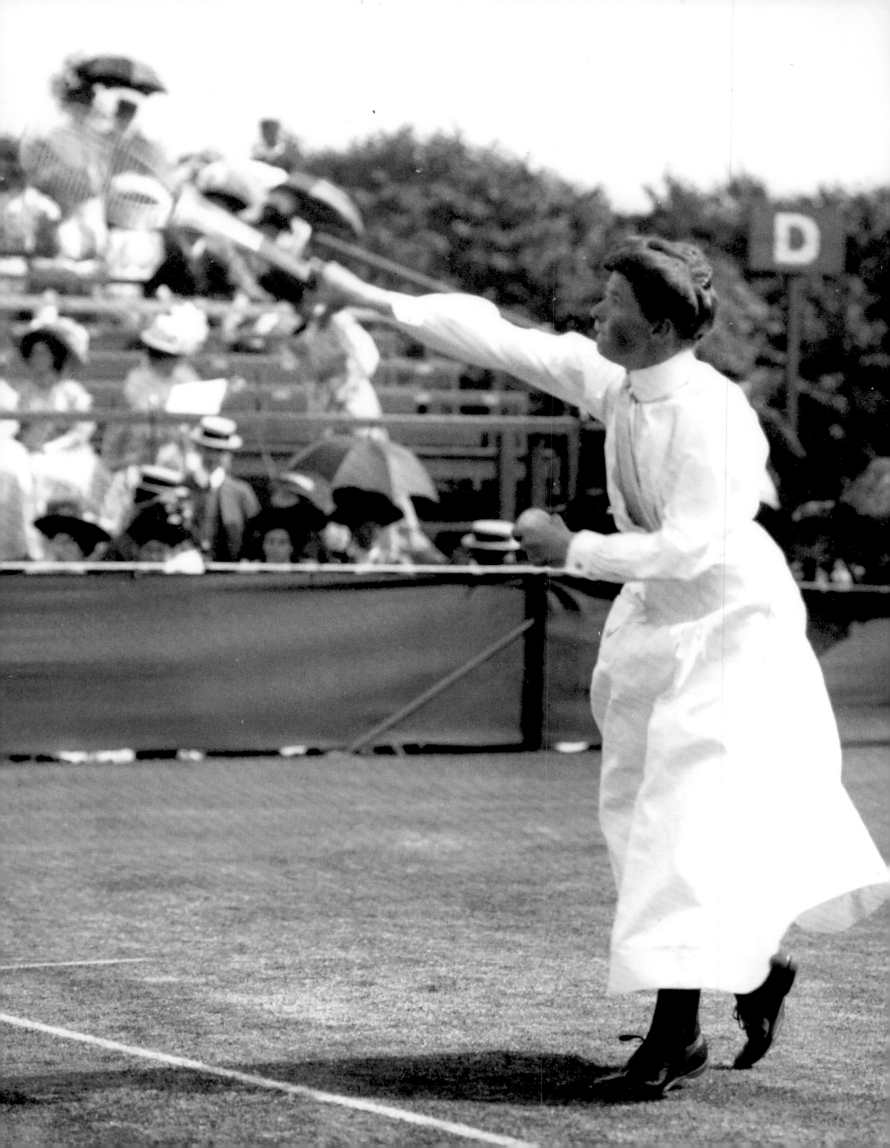

THE 20 BEST WOMEN OF ALL TIME

DIE 20 BESTEN DAMEN ALLER ZEITEN

Unlike in men's tennis, a triumvirate of winning players has been missing in recent years – the most successful women are fairly distributed across all eras.

Anders als bei den Herren fehlte in den letzten Jahren ein Triumvirat aus Siegspielerinnen – die erfolgreichsten Damen sind gerecht über alle Epochen verteilt.

THE ULTIMATE BOOK

British tennis player Charlotte Sterry (née Cooper), winner of the Wimbledon women's singles title in 1895, 1896, 1898, 1901 and 1908, Wimbledon.
Die britische Tennisspielerin Charlotte Sterry (geborene Cooper), Gewinnerin des Wimbledon-Titels im Dameneinzel in den Jahren 1895, 1896, 1898, 1901 und 1908.

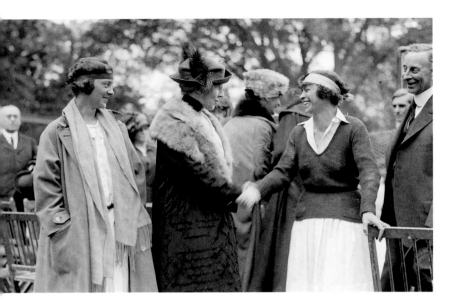

MOLLA MALLORY

Born in Norway, she won a bronze medal at the 1912 Stockholm Olympics and moved to New York in 1915 to work as a masseuse. More for fun than anything else, she competed in the US Indoor Championships, reached the final and beat favorite Marie Wagner – a sign to take the sport seriously after all. Molla won all her Grand Slam titles at the US Open.

Die gebürtige Norwegerin holte 1912 die Bronzemedaille bei den Olympischen Spielen in Stockholm und zog 1915 nach New York, um als Masseurin zu arbeiten. Eher aus Spaß trat sie bei den US Indoor Championships an, erreichte das Finale und schlug die Favoritin Marie Wagner – ein Zeichen, den Sport doch noch einmal ernst zu nehmen. Alle Grand-Slam-Titel gewann Molla bei der US Open.

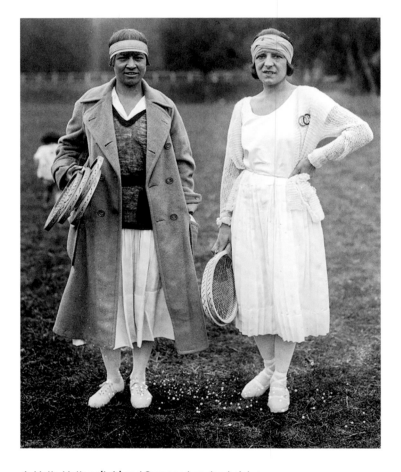

↑ Molla Mallory (left) und Suzanne Lenglen bei den Hartplatz-Weltmeisterschaften, 1921.
Molla Mallory (links) und Suzanne Lenglen bei den Hartplatz-Weltmeisterschaften, 1921.

→ Molla Mallory concentrating in crouched position, 1922.
Molla Mallory konzentriert in geduckter Haltung, 1922.

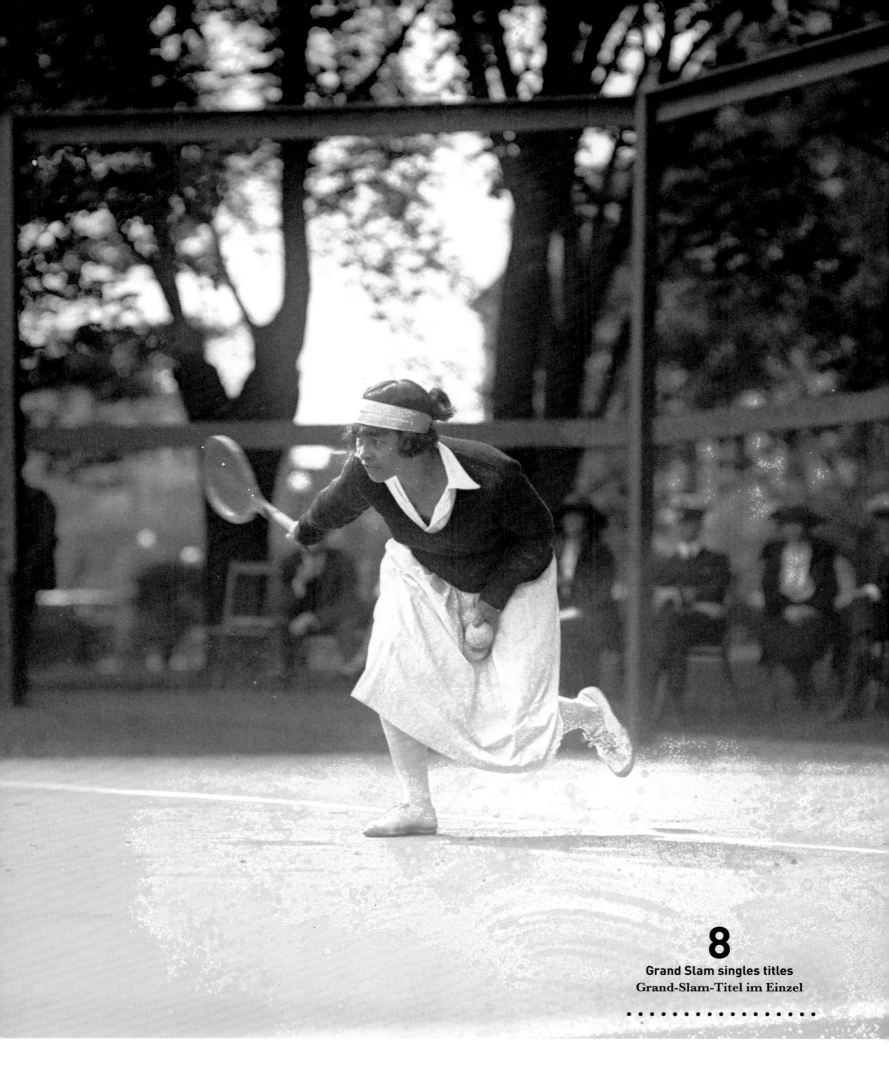

8
Grand Slam singles titles
Grand-Slam-Titel im Einzel
· · · · · · · · · · · · · · · · · ·

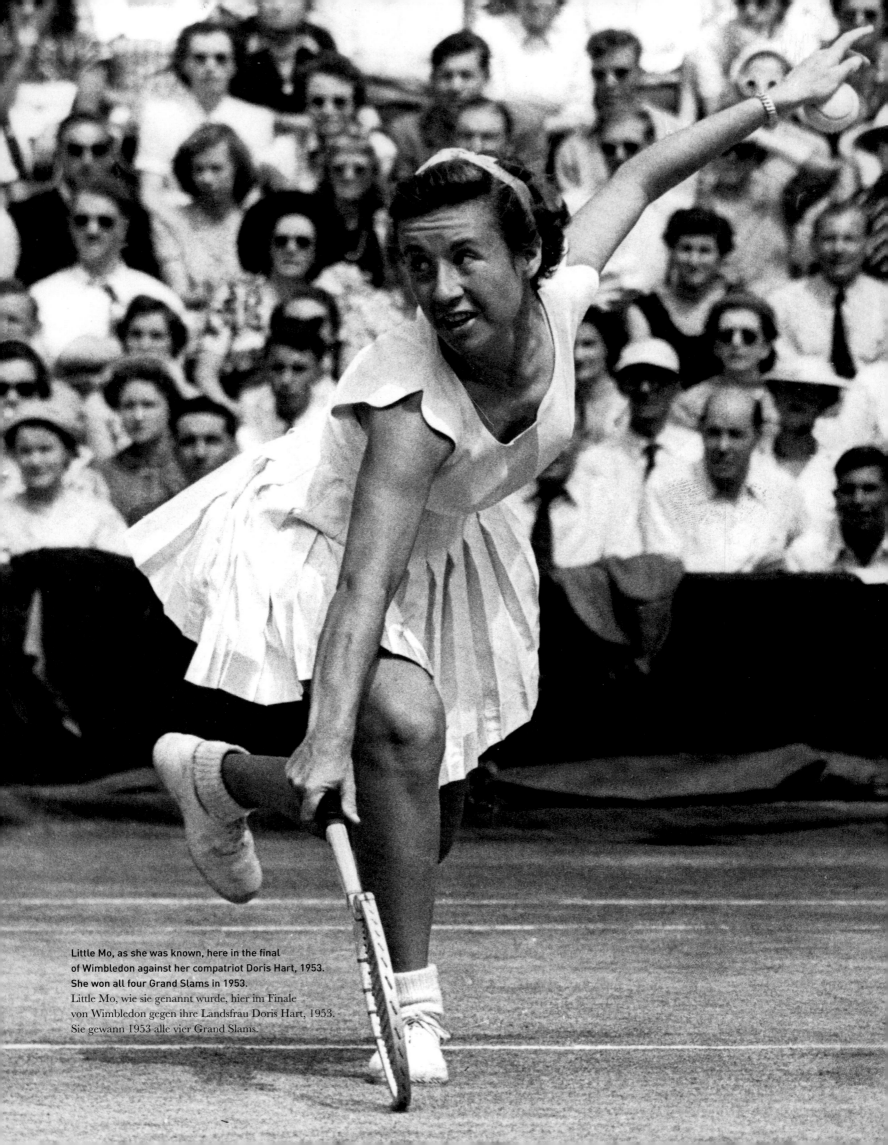

Little Mo, as she was known, here in the final
of Wimbledon against her compatriot Doris Hart, 1953.
She won all four Grand Slams in 1953.
Little Mo, wie sie genannt wurde, hier im Finale
von Wimbledon gegen ihre Landsfrau Doris Hart, 1953.
Sie gewann 1953 alle vier Grand Slams.

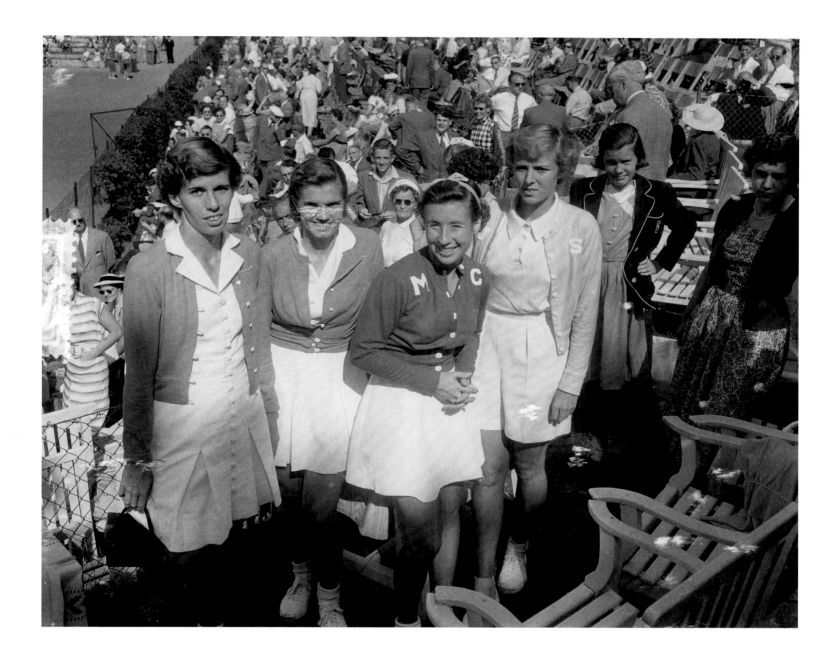

MAUREEN CONNOLLY

What a tragic career: In 1953, the US player became the first female player to win the Grand Slam, all four major tournaments in one calendar year. But after a riding accident, "Little Mo", just 19 years old, had to end her career; she died of cancer at the age of 34.

Was für eine tragische Karriere: Im Jahr 1953 wurde die US-Amerikanerin die erste Spielerin, die den Grand Slam gewann, alle vier großen Turniere in einem Kalenderjahr. Doch nach einem Reitunfall musste »Little Mo«, gerade 19-jährig, ihre Karriere beenden; sie starb mit 34 Jahren an Krebs.

7
Grand Slam singles titles
Grand-Slam-Titel im Einzel

• • • • • • • • • • • • • • • •

↑ Noordwijk, 1953, from left the American ladies Doris Hart, Shirley Fry and Wimbledon winner Maureen Connolly.
Noordwijk, 1953, von links die amerikanischen Damen Doris Hart, Shirley Fry und Wimbledon-Siegerin Maureen Connolly.

MONICA SELES

The Yugoslavian won the French Open in 1990 at the age of 16 and went on to win another seven Grand Slam titles. She played both forehand and backhand two-handed with tremendous power from the baseline. In 1993, she was stabbed by a mentally deranged fan of Steffi Graf and, shocked, retired from tennis for two years. After her comeback, she was unable to match her best performances.

Die Jugoslawin gewann 1990 mit 16 Jahren die French Open und gewann weitere sieben Grand-Slam-Titel. Sie spielte Vorhand wie Rückhand beidhändig mit ungeheurer Kraft von der Grundlinie. 1993 wurde sie von einem geistig verwirrten Steffi-Graf-Fan niedergestochen und zog sich geschockt zwei Jahre vom Tennissport zurück. Nach ihrem Comeback konnte sie nicht mehr an ihre Bestleistungen anknüpfen.

↖ Monica Seles at a charity event in 2007, playing against Martina Navratilova, New Orleans.
Monica Seles bei einer Wohltätigkeitsveranstaltung im Jahr 2007, sie spielt gegen Martina Navratilova, New Orleans.

Monica Seles in almost dogged action during her victory over Kim Clijsters, 2001.
Monica Seles in fast verbissener Aktion bei ihrem Sieg über Kim Clijsters, 2001.

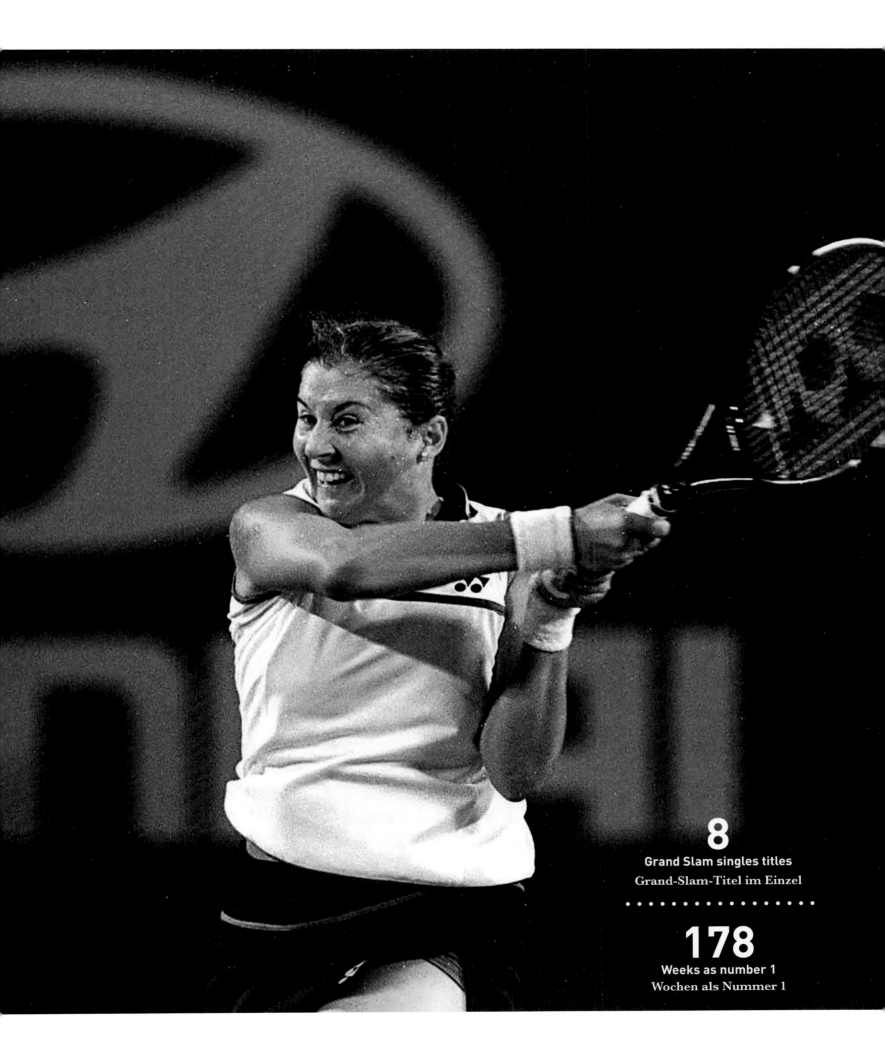

8
Grand Slam singles titles
Grand-Slam-Titel im Einzel

· · · · · · · · · · · · · · · · · ·

178
Weeks as number 1
Wochen als Nummer 1

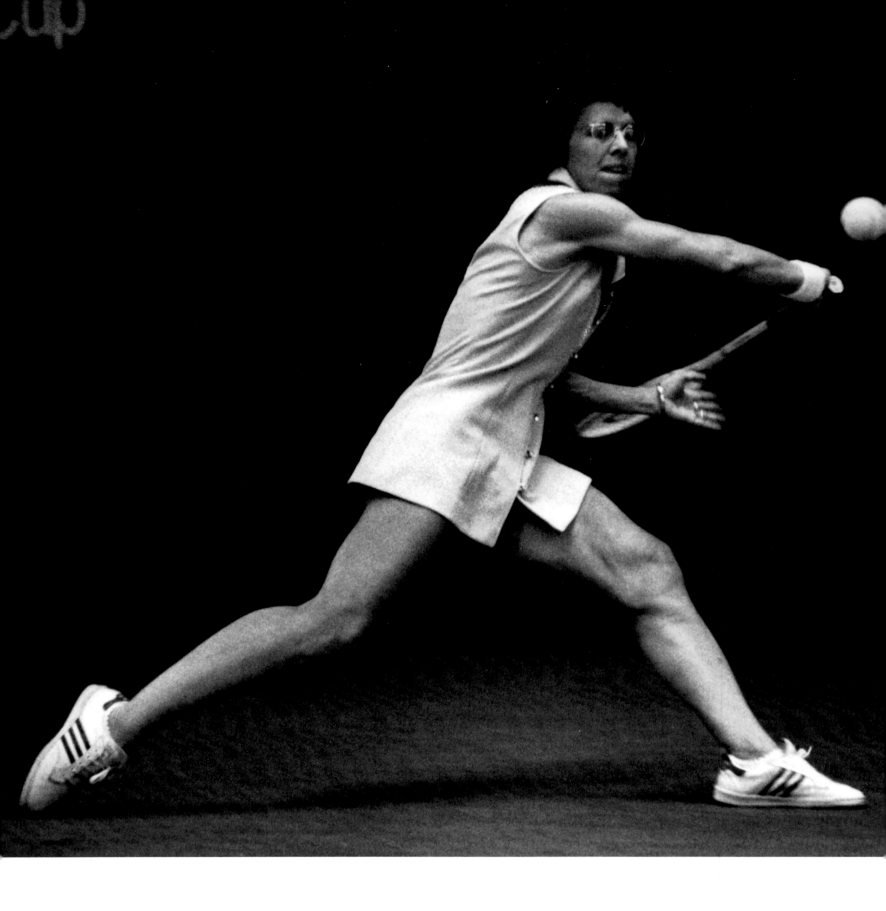

12
Grand Slam singles titles
Grand-Slam-Titel im Einzel

· · · · · · · · · · · · · · · ·

BILLIE JEAN KING

She campaigned for gender equality, founded the Women's Tennis Association and remains politically active to this day. The California native felt most at home at Wimbledon, where she won six singles, ten doubles and four mixed titles. The Federation Cup, the female equivalent of the Davis Cup, has been called the Billie Jean King Cup since 2020.

Sie setzte sich für Geschlechtergleichheit ein, gründete die Women's Tennis Association und bleibt bis heute politisch aktiv. Am wohlsten fühlte sich die gebürtige Kalifornierin in Wimbledon, wo sie sechs Einzel-, zehn Doppel- und vier Mixed-Titel gewann. Der Federation Cup, das weibliche Pendant zum Davis Cup, heißt seit 2020 Billie Jean King Cup.

↑ Billie Jean King in the locker room, New York, 1978.
Billie Jean King in der Umkleidekabine, New York, 1978.

← Billie Jean King hits the ball during a match in the 1970s.
Billie Jean King schlägt den Ball während eines Matches in den 1970er-Jahren.

→ Billie beats her doubles partner Rosie Casals, as usual, and jokes with the trophy, 1969.
Billie schlägt wie fast üblich ihre Doppelpartnerin Rosie Casals und macht Scherze mit der Trophäe, 1969.

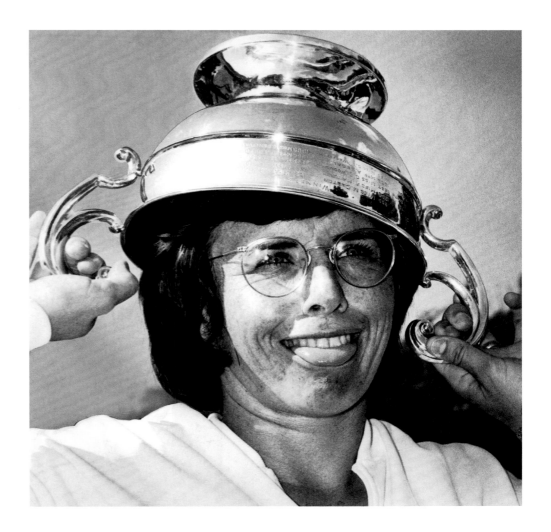

CHRIS EVERT

The clay court queen (she won the French Open seven times) reached 34 Grand Slam finals – a record that still stands today. For 13 years, the US American won at least one major title per season, another unmatched record.

Die Sandplatzkönigin (die French Open gewann sie sieben Mal) erreichte 34 Grand-Slam-Finals – ein Rekord, der bis heute besteht. 13 Jahre lang gewann die US-Amerikanerin mindestens einen Major-Titel pro Saison, auch das ist eine unerreichte Bestleistung.

↑ Chris Evert, Freestyle Skiing Champion Suzy Chaffee, White House Photographer David Hume Kennerly, and other Guests seated in the Red Room during a State Dinner, White House, 1976.
Chris Evert, Freestyle-Skiing-Champion Suzy Chaffee, der Fotograf des Weißen Hauses, David Hume Kennerly, und andere Gäste, die während eines Staatsdinners im Roten Saal sitzen, Weißes Haus, 1976.

→ The women's singles final, 1978. Chris Evert versus winner Martina Navratilova, Wimbledon.
Das Dameneinzel-Finale 1978. Chris Evert gegen Siegerin Martina Navratilova, Wimbledon.

18
Grand Slam singles titles
Grand-Slam-Titel im Einzel

· · · · · · · · · · · · · · · · ·

260
Weeks as number 1
Wochen als Nummer 1

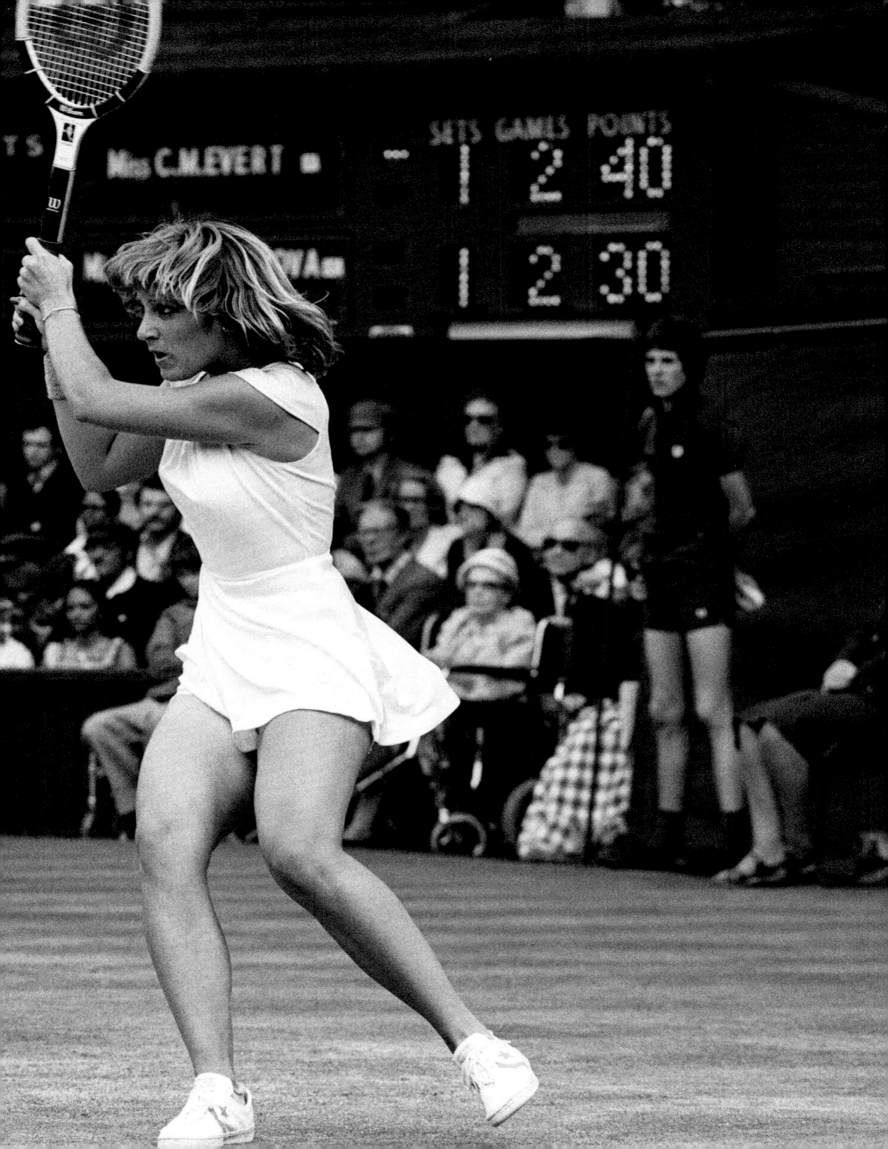

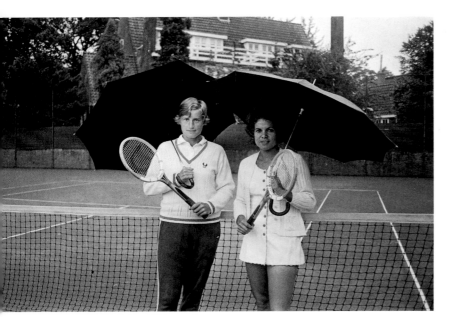

← Trudy Walhof and Evonne Goolagong (right) under an umbrella in Hilversum, 1971.
Trudy Walhof und Evonne Goolagong (rechts) unter einem Regenschirm in Hilversum, 1971.

EVONNE GOOLAGONG CAWLEY

Voted "Australian of the Year" in 1971, she is considered a role model for many indigenous Australians. She has won the Australian Open four times; the only thing missing from her career Grand Slam is the title at the US Open, where she lost four times in the finals.

1971 wurde sie zur »Australierin des Jahres« gewählt, gilt sie doch als Vorbild für viele indigene Australier. Vier Mal konnte sie die Australian Open gewinnen; zum Karriere-Grand-Slam fehlt ihr lediglich der Titel bei der US Open, wo sie gleich vier Mal im Finale scheiterte.

7
Grand Slam singles titles
Grand-Slam-Titel im Einzel

• • • • • • • • • • • • • •

↑ Evonne Goolagong wins the International Tennis Championships, Hilversum, 1971.
Evonne Goolagong siegt bei den internationalen Tennismeisterschaften, Hilversum, 1971.

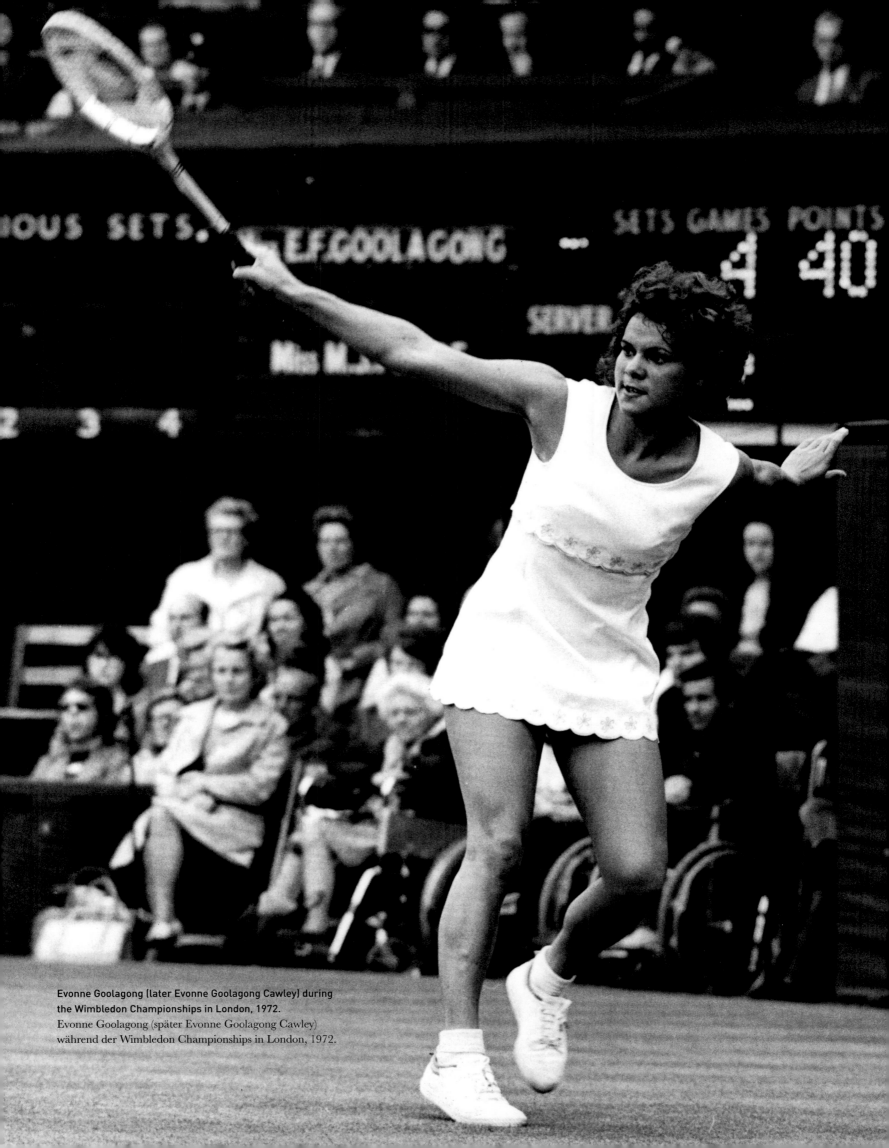

Evonne Goolagong (later Evonne Goolagong Cawley) during
the Wimbledon Championships in London, 1972.
Evonne Goolagong (später Evonne Goolagong Cawley)
während der Wimbledon Championships in London, 1972.

JUSTINE HENIN

What a career and what a remarkable end: as world number one, the Belgian declared her retirement from professional tennis in 2008 in complete surprise – she had "achieved everything". Her favorite surface was clay: she won 35 sets in a row at the French Open. Later, she did return for a few tournaments, but was unable to make it again to the top of the world rankings.

Was für eine Karriere und was für ein bemerkenswertes Ende: Als Nummer eins der Weltrangliste erklärte die Belgierin völlig überraschend 2008 ihren Rücktritt vom Profitennis – sie habe »alles erreicht«. Ihr Lieblingsbelag war Sand: Bei der French Open gewann sie 35 Sätze in Folge. Später kam sie doch noch einmal für ein paar Turniere zurück, konnte aber nicht mehr in die Weltspitze vordringen.

Wimbledon 2007, Justine Henin in acrobatic action against Jorgelina Cravero.
Wimbledon 2007, Justine Henin in akrobatischer Aktion gegen Jorgelina Cravero.

7
Grand Slam singles titles
Grand-Slam-Titel im Einzel

· · · · · · · · · · · · · · · · ·

117
Weeks as number 1
Wochen als Nummer 1

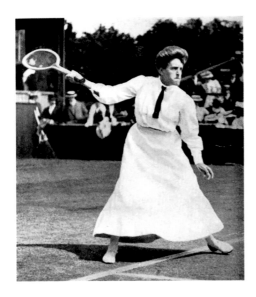

DOROTHY LAMBERT CHAMBERS

In 1903, she lost in the second round on her debut at Wimbledon after a walk-through, but that was not to happen to her again from then on – the London native won her home tournament seven times until Suzanne Lenglen stopped the winning streak in an epic match in the final in 1919. Dorothy later wrote the first tennis textbook specifically for women.

1903 verlor sie bei ihrem Debüt in Wimbledon nach einem Freilos gleich in der zweiten Runde, doch das sollte ihr fortan nicht mehr passieren – sieben Mal gewann die gebürtige Londonerin ihr Heimatturnier, bis Suzanne Lenglen 1919 die Siegesserie in einem epischen Match im Finale stoppte. Dorothy schrieb später das erste Tennislehrbuch speziell für Frauen.

↑ English tennis champion Dorothea Lambert Chambers in a forehand stroke.
Die englische Tennismeisterin Dorothea Lambert Chambers bei einem Vorhandschlag.

→ Dorothea Lambert Chambers plays Dora Boothby in the women's singles Challenge Round, Wimbledon, 1910.
Im Dameneinzel der Challenge Round spielt Dorothea Lambert Chambers gegen Dora Boothby, Wimbledon, 1910.

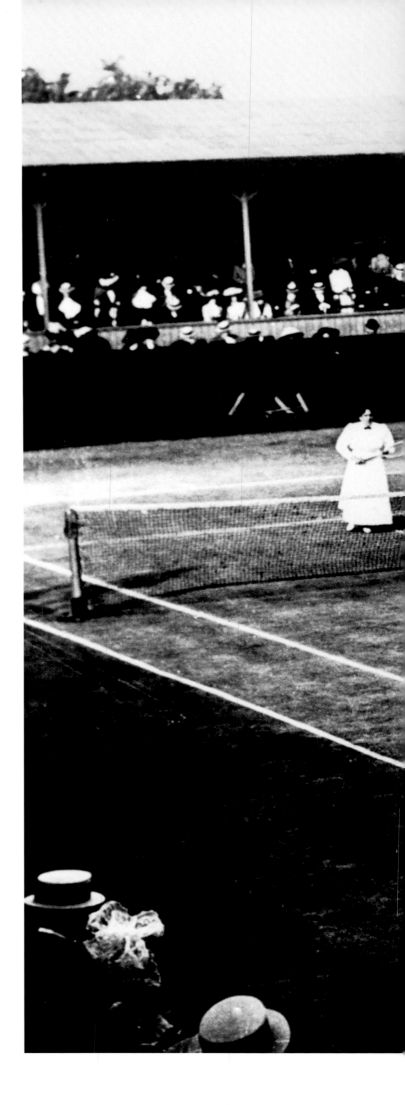

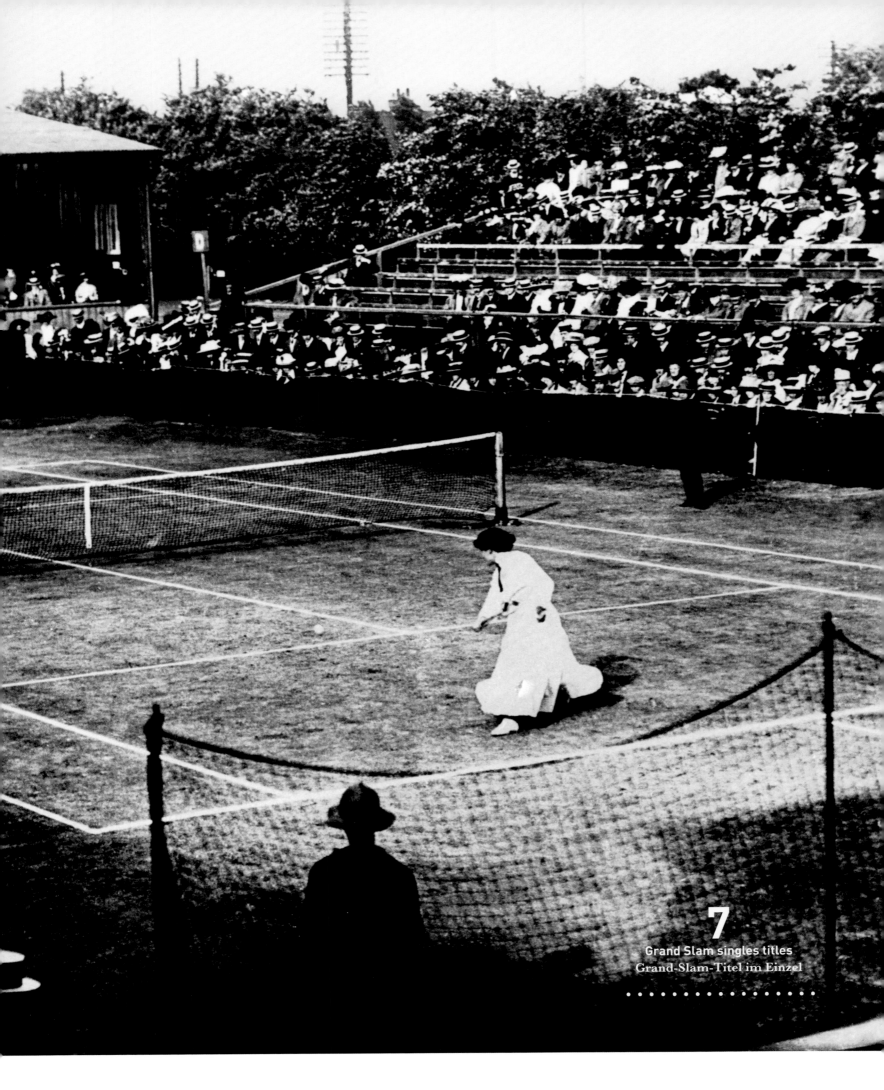

7
Grand Slam singles titles
Grand-Slam-Titel im Einzel

· · · · · · · · · · · · · ·

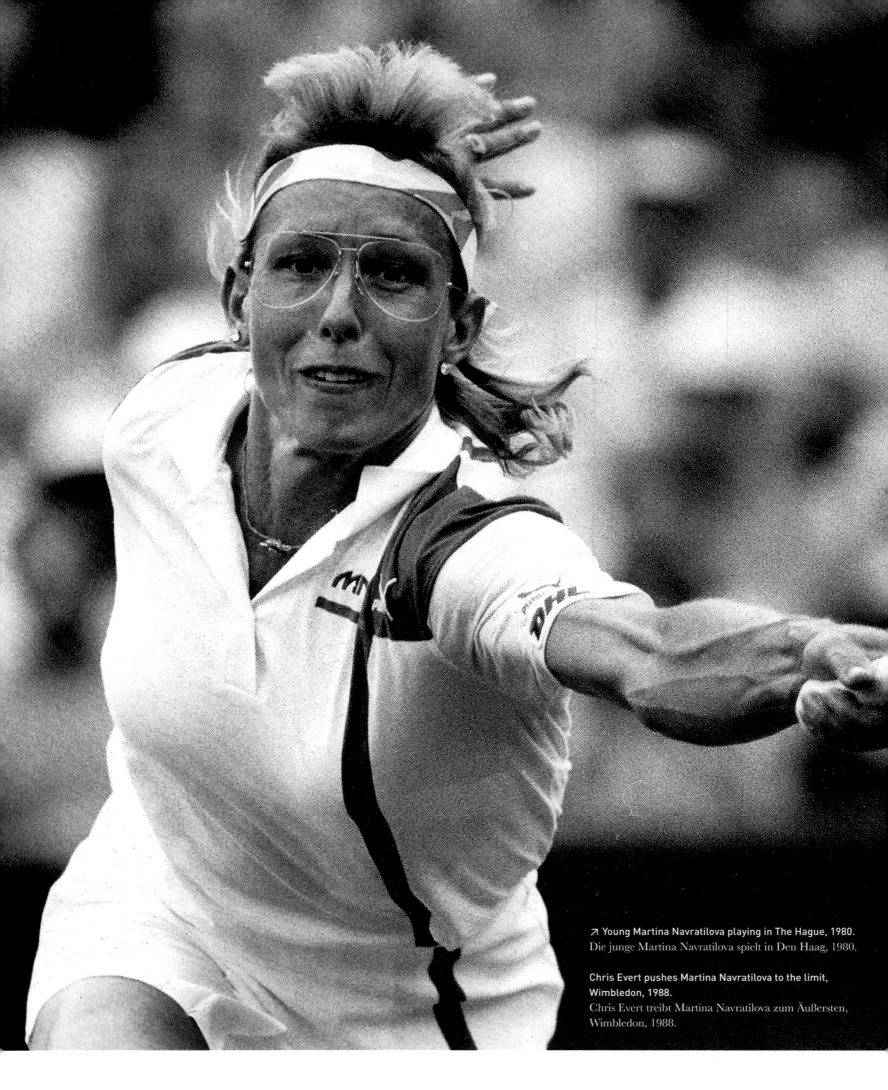

↗ Young Martina Navratilova playing in The Hague, 1980.
Die junge Martina Navratilova spielt in Den Haag, 1980.

Chris Evert pushes Martina Navratilova to the limit,
Wimbledon, 1988.
Chris Evert treibt Martina Navratilova zum Äußersten,
Wimbledon, 1988.

18
Grand Slam singles titles
Grand-Slam-Titel im Einzel

.

332
Weeks as number 1
Wochen als Nummer 1

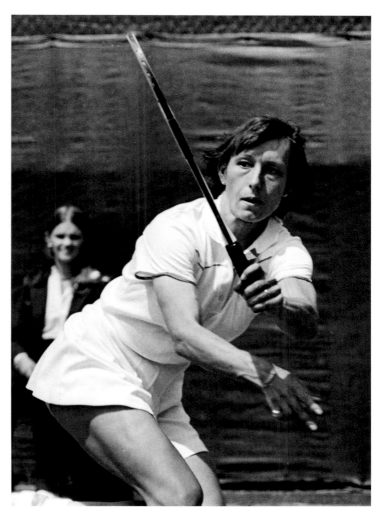

MARTINA NAVRATILOVA

The left-hander dominated women's tennis in the 1970s and 1980s, together with her great rival Chris Evert – the two faced each other ten times in Grand Slam finals alone. The Czech-born player, who later became a US citizen, was known for her exceptionally aggressive play.

Die Linkshänderin dominierte das Damentennis der 1970er- und 1980er-Jahre, gemeinsam mit ihrer großen Konkurrentin Chris Evert – allein zehn Mal standen sich die beiden in Grand-Slam-Finals gegenüber. Die gebürtige Tschechin, die später die US-amerikanische Staatsbürgerschaft annahm, war bekannt für ihr außergewöhnlich aggressives Spiel.

DORIS HART

At the beginning of her career, the US American had to put up with a lot: from 1942 to 1946, she lost seven Grand Slam finals until she finally won her first title at Wimbledon in 1947. Her greatest triumph, however, is that despite limited mobility – her right leg was barely able to bear weight after an infection in childhood – she was one of the best players of her era. Another amazing fact: In 1951 there were long rain interruptions at Wimbledon. Doris had to play three finals in one day (singles, doubles, mixed) and won all three.

Zu Beginn ihrer Karriere musste die US-Amerikanerin einiges einstecken: Von 1942 bis 1946 verlor sie sieben Grand-Slam-Finals, bis ihr 1947 endlich in Wimbledon der erste Titel glückte. Ihr größter Triumph ist aber, dass sie trotz eingeschränkter Beweglichkeit – ihr rechtes Bein war nach einer Infektion in der Kindheit kaum belastbar – zu den besten Spielerinnen ihrer Ära zählte. Noch ein erstaunlicher Fakt: 1951 kam es in Wimbledon zu langen Regenunterbrechungen. Doris musste drei Finals an einem Tag spielen (Einzel, Doppel, Mixed) und gewann alle drei.

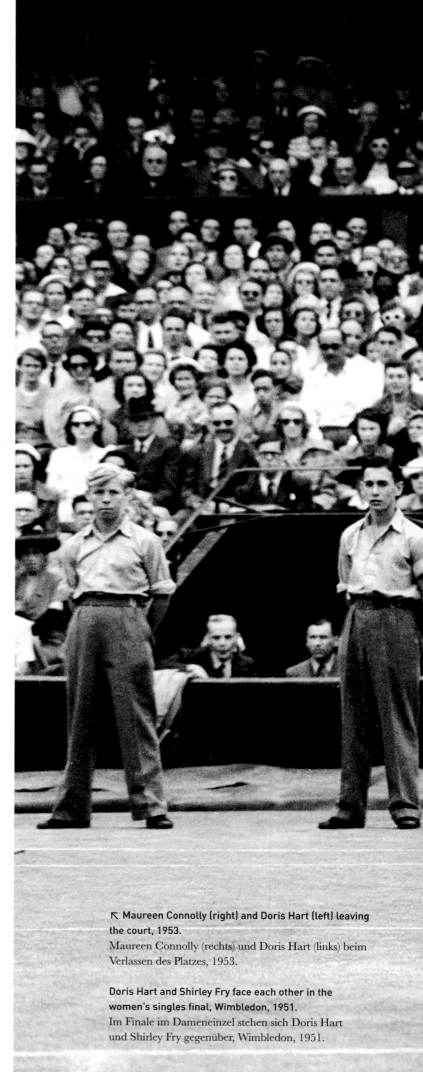

↖ Maureen Connolly (right) and Doris Hart (left) leaving the court, 1953.
Maureen Connolly (rechts) und Doris Hart (links) beim Verlassen des Platzes, 1953.

Doris Hart and Shirley Fry face each other in the women's singles final, Wimbledon, 1951.
Im Finale im Dameneinzel stehen sich Doris Hart und Shirley Fry gegenüber, Wimbledon, 1951.

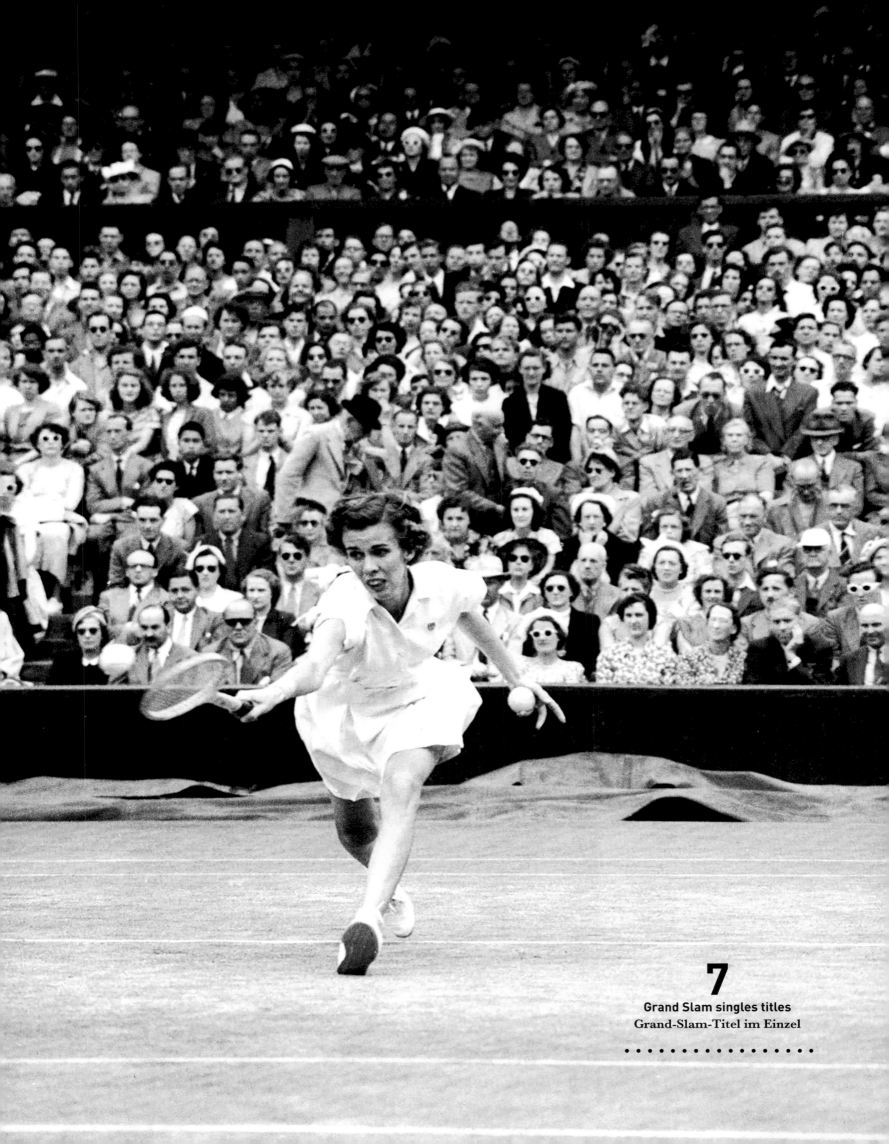

7
Grand Slam singles titles
Grand-Slam-Titel im Einzel
.

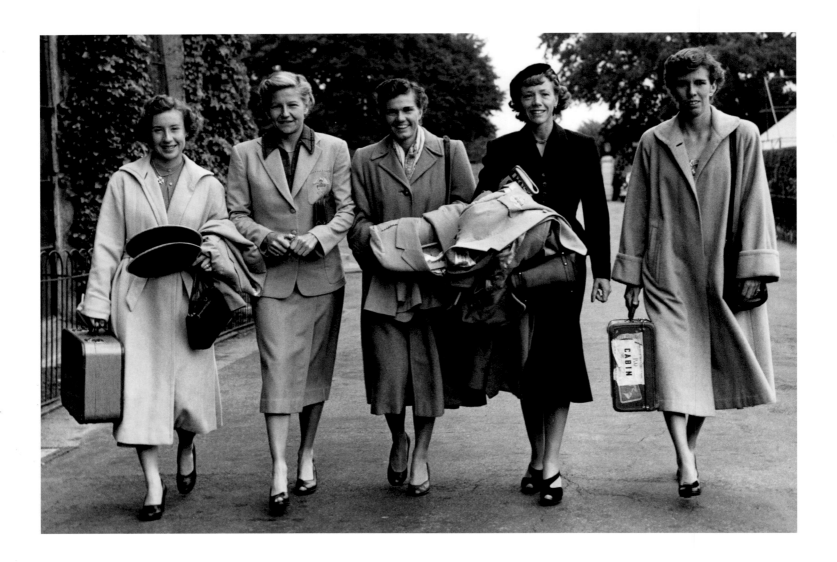

LOUISE BROUGH

She was a volley specialist, had an excellent backhand and served with a powerful spin – with the high bouncing ball, the US American brought her opponents to despair in the 1940s and 1950s. Her strengths came to the fore particularly on the fast grass of Wimbledon; between 1946 and 1955 she reached the singles finals seven times and the doubles finals ten times. After her career, she worked as a tennis teacher.

Sie war Volley-Spezialistin, hatte eine hervorragende Rückhand und servierte mit mächtigem Spin – mit dem hoch abspringenden Ball brachte die US-Amerikanerin in den 1940er- und 1950er-Jahren ihre Gegnerinnen zur Verzweiflung. Besonders auf dem schnellen Rasen von Wimbledon kamen ihre Stärken zum Tragen; zwischen 1946 und 1955 stand sie sieben Mal in den Einzel-Finals und zehn Mal in den Doppel-Finals. Nach ihrer Karriere arbeitete sie als Tennislehrerin.

6
Grand Slam singles titles
Grand-Slam-Titel im Einzel

• • • • • • • • • • • • • • •

↑ Maureen Connolly, Louise Brough, Shirley Fry, non-playing captain Marjorie Gladman and Doris Hart (left to right) arrive for the 23rd edition of the Wightman Cup women's tennis competition between the United States and Great Britain, Wimbledon, 1952.
Maureen Connolly, Louise Brough, Shirley Fry, die nicht spielende Kapitänin Marjorie Gladman und Doris Hart (von links nach rechts) treffen zur 23. Auflage des Wightman-Cup-Damentenniswettbewerbs zwischen den Vereinigten Staaten und Großbritannien ein, Wimbledon, 1952.

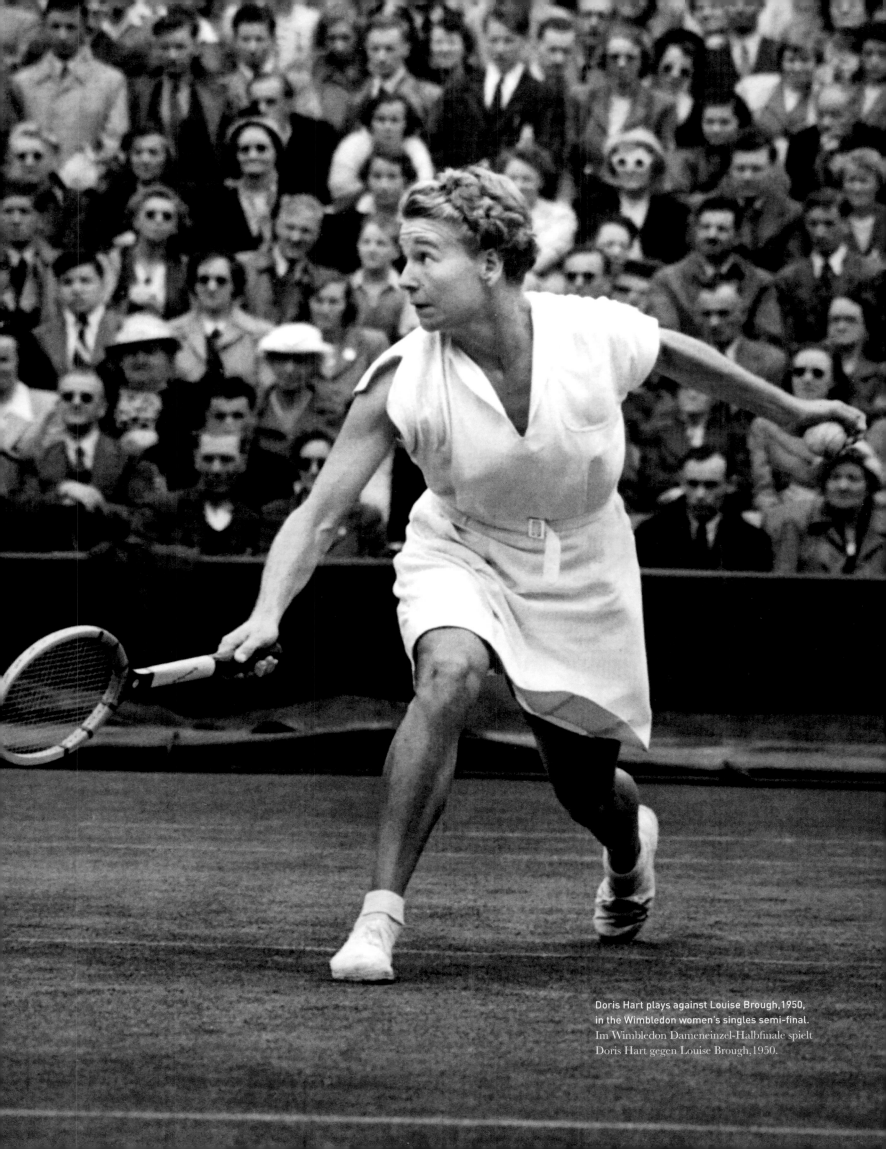

Doris Hart plays against Louise Brough, 1950,
in the Wimbledon women's singles semi-final.
Im Wimbledon Dameneinzel-Halbfinale spielt
Doris Hart gegen Louise Brough, 1950.

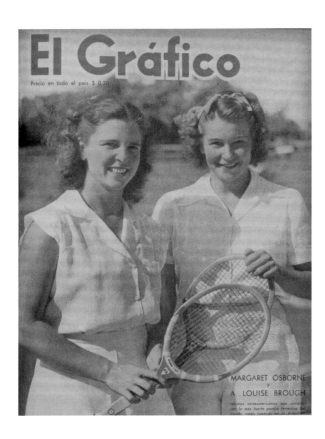

MARGARET OSBORNE DUPONT

Marriage to William duPont, the heir to the chemical company, helped the Oregon farmer's daughter's career: for she was able to train on nine different tennis courts and all surfaces (hard court, grass, clay) on the family estate. In 1947, the year of her wedding, Margaret won Wimbledon for the first time against Doris Hart, whom she also beat in the finals of the US Open in 1949 and 1950.

Die Ehe mit William duPont, dem Erben des Chemiekonzerns, half der Karriere der Farmerstochter aus Oregon: Denn sie konnte auf dem Familiensitz auf neun verschiedenen Tennisplätzen und allen Belägen (Hartplatz, Rasen, Sand) trainieren. 1947, im Jahr ihrer Hochzeit, gewann Margaret zum ersten Mal in Wimbledon gegen Doris Hart, die sie auch 1949 und 1950 im Finale der US Open besiegen konnte.

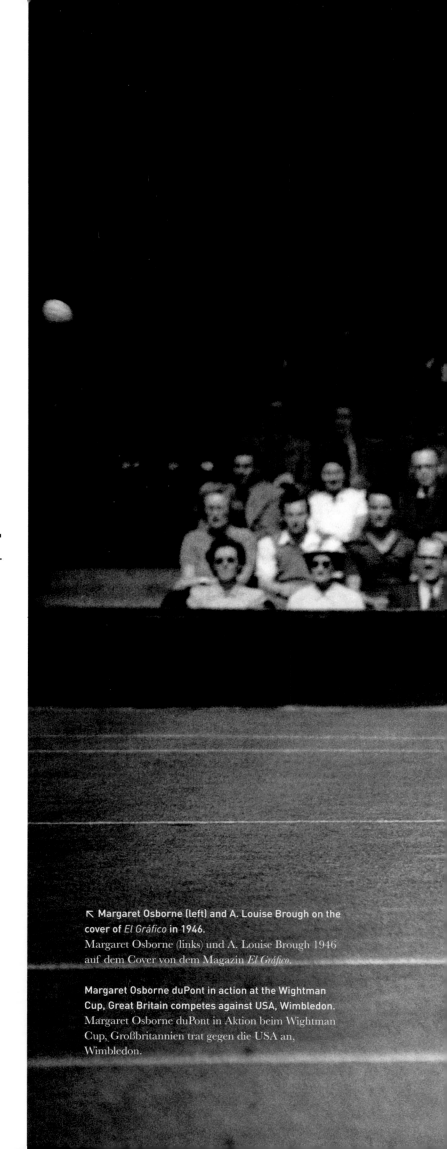

↖ Margaret Osborne (left) and A. Louise Brough on the cover of *El Gráfico* in 1946.
Margaret Osborne (links) und A. Louise Brough 1946 auf dem Cover von dem Magazin *El Gráfico*.

Margaret Osborne duPont in action at the Wightman Cup, Great Britain competes against USA, Wimbledon.
Margaret Osborne duPont in Aktion beim Wightman Cup, Großbritannien trat gegen die USA an, Wimbledon.

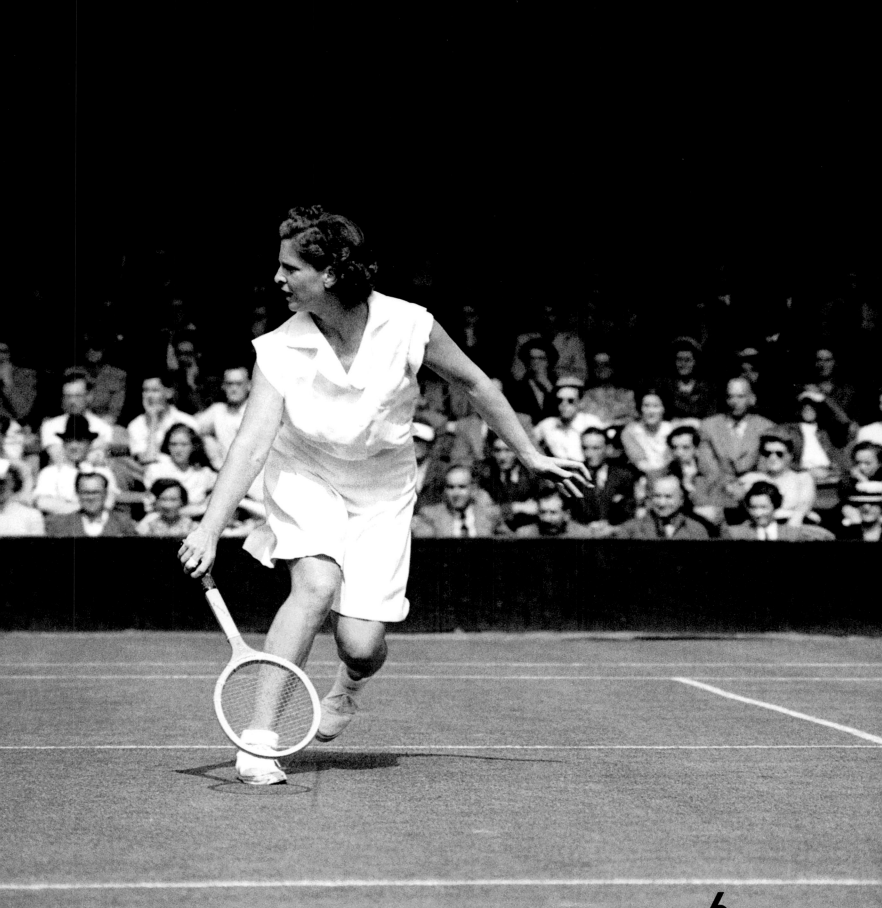

6
Grand Slam singles titles
Grand-Slam-Titel im Einzel

.

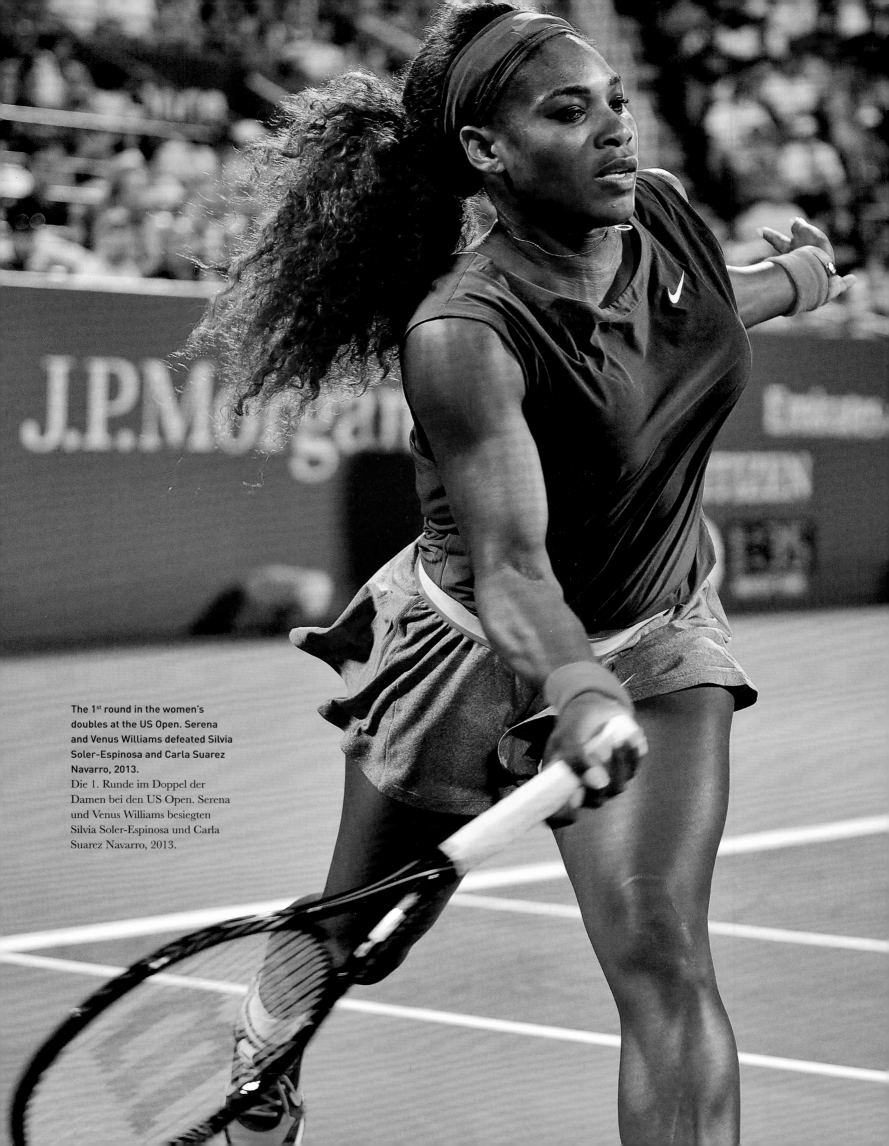

The 1ˢᵗ round in the women's doubles at the US Open. Serena and Venus Williams defeated Silvia Soler-Espinosa and Carla Suarez Navarro, 2013.
Die 1. Runde im Doppel der Damen bei den US Open. Serena und Venus Williams besiegten Silvia Soler-Espinosa und Carla Suarez Navarro, 2013.

22
Grand Slam singles titles
Grand-Slam-Titel im Einzel

· · · · · · · · · · · · · · · · ·

319
Weeks as number 1
Wochen als Nummer 1

SERENA WILLIAMS

She brought a new quality to women's tennis – together with her sister Venus, the game became faster, more powerful and more athletic. Father Richard coached the two from an early age and instilled in them an unshakable strength of nerve. Serena is the highest-earning female athlete of all time, winning nearly $95 million in prize money alone.

Sie brachte eine neue Qualität ins Damentennis – gemeinsam mit ihrer Schwester Venus wurde das Spiel schneller, kraftvoller und athletischer. Vater Richard coachte die beiden von klein auf und impfte ihnen eine unerschütterliche Nervenstärke ein. Serena ist die bestverdienende Sportlerin aller Zeiten und gewann allein an Preisgeldern knapp 95 Millionen Dollar.

↓ The Williams Sisters at a young age, 1993.
Die Williams Schwestern als junge Mädchen, 1993.

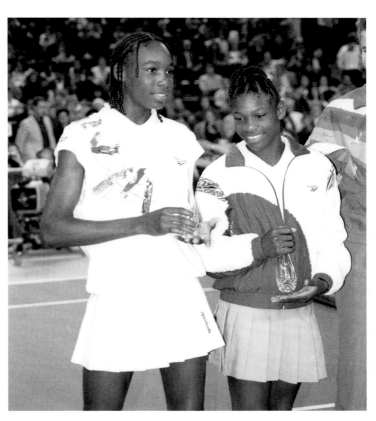

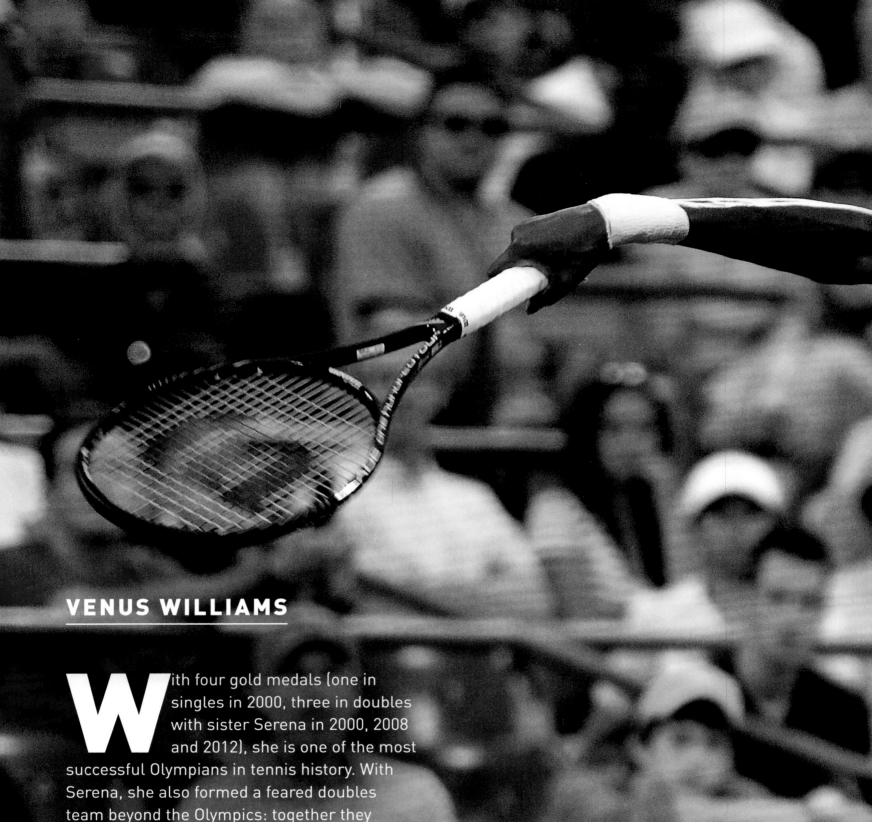

VENUS WILLIAMS

With four gold medals (one in singles in 2000, three in doubles with sister Serena in 2000, 2008 and 2012), she is one of the most successful Olympians in tennis history. With Serena, she also formed a feared doubles team beyond the Olympics: together they won 14 Grand Slam tournaments.

Sie gehört mit vier Goldmedaillen (eine im Einzel 2000, drei im Doppel mit Schwester Serena 2000, 2008 und 2012) zu den erfolgreichsten Olympionikinnen der Tennisgeschichte. Mit Serena bildete sie auch jenseits von Olympia ein gefürchtetes Doppel: Gemeinsam gewannen sie 14 Grand-Slam-Turniere.

Venus Williams stretches out in doubles against Silvia Soler-Espinosa and Carla Suarez Navarro, 2013, New York.
Venus Williams streckt sich im Doppel gegen Silvia Soler-Espinosa und Carla Suarez Navarro, 2013, New York.

7
Grand Slam singles titles
Grand-Slam-Titel im Einzel

11
Weeks as number 1
Wochen als Nummer 1

MARIA BUENO

A fairy-tale rise: She won her first major tournament at the age of 12 without any real tennis training and became Brazilian champion at 14. At 19, she reached the Wimbledon final for the first time in 1959, winning outright in two sets. Who knows how many more finals she would have won had she not had to play again and again against the almost indomitable Margaret Court, who denied her success at the Australian Open and the French Open, among others.

Ein Märchenaufstieg: Mit 12 Jahren gewann sie ohne jegliches echtes Tennistraining ihr erstes großes Turnier, mit 14 wurde sie brasilianische Meisterin. Mit 19 stand sie 1959 zum ersten Mal im Wimbledon-Finale und gewann glatt in zwei Sätzen. Wer weiß, wie viel mehr Finals sie gewonnen hätte, hätte sie nicht wieder und wieder gegen die nahezu unbezwingbare Margaret Court antreten müssen, die ihr unter anderem die Erfolge bei der Australian Open und der French Open verwehrte.

↑ Tennis final in Hilversum, Margaret Smith Court on the left, Maria Bueno on the right, 1964.
Tennis-Finale in Hilversum, links Margaret Smith-Court, rechts Maria Bueno, 1964.

7

Grand Slam singles titles
Grand-Slam-Titel im Einzel

.

→ Maria Bueno parries the ball in 1957, she was number 1 in 1959, 1960, 1964 and 1966.
Maria Bueno pariert den Ball im Jahr 1957, sie war die Nummer 1 in den Jahren 1959, 1960, 1964 und 1966.

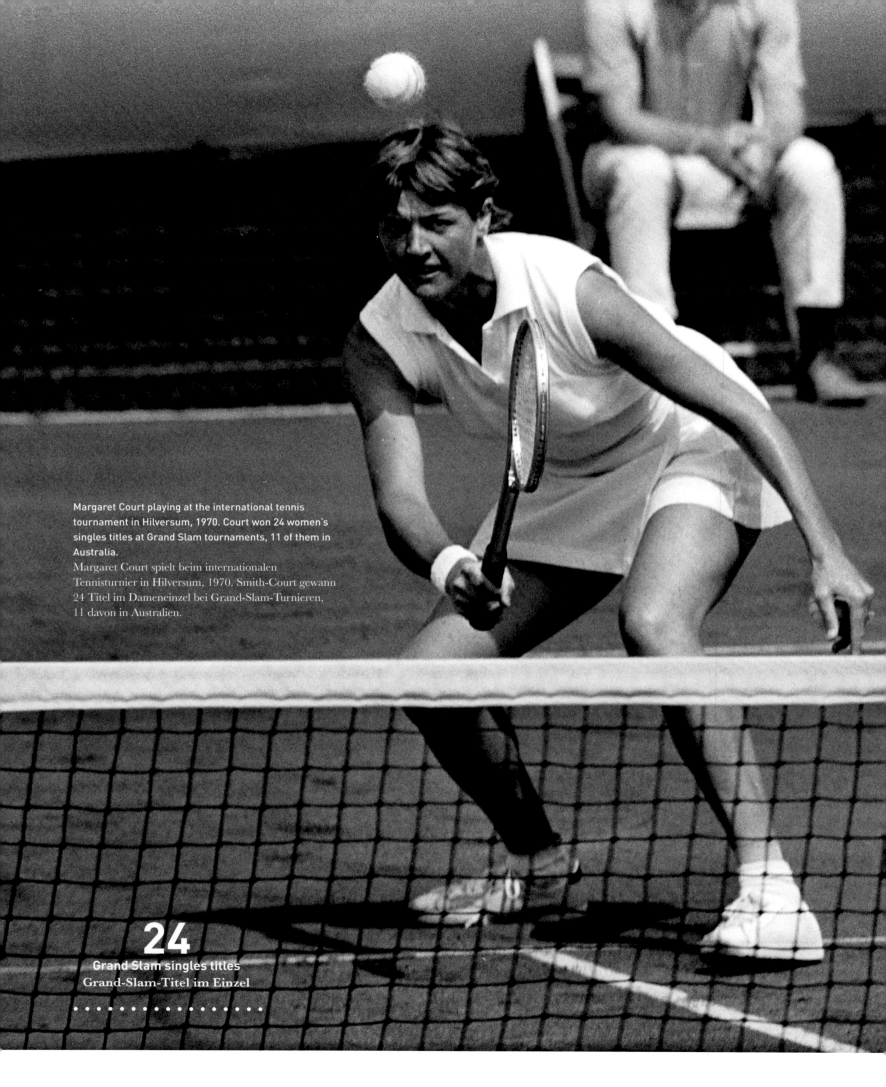

Margaret Court playing at the international tennis tournament in Hilversum, 1970. Court won 24 women's singles titles at Grand Slam tournaments, 11 of them in Australia.

Margaret Court spielt beim internationalen Tennisturnier in Hilversum, 1970. Smith-Court gewann 24 Titel im Dameneinzel bei Grand-Slam-Turnieren, 11 davon in Australien.

24
Grand Slam singles titles
Grand-Slam-Titel im Einzel

· · · · · · · · · · · · · · ·

MARGARET COURT

The Australian set records for eternity: In 1960, she won the Australian Open as a 16-year-old, and in 1963 she completed her Grand Slam at the age of 21 when she won Wimbledon. Her winning percentage is unrivaled at 91.74 percent of all matches. Margaret, who is listed in many winners' lists under her maiden name Smith, was relatively tall, yet extremely agile and very strong, so she often appeared at the net and won the point with a powerful volley.

Die Australierin setzte Bestmarken für die Ewigkeit: Im Jahr 1960 gewann sie als 16-Jährige die Australian Open, 1963 komplettierte sie mit 21 Jahren ihren Grand Slam, als sie in Wimbledon gewann. Ihre Siegquote ist mit 91,74 Prozent aller Matches unerreicht. Margaret, die in vielen Siegerlisten unter ihrem Mädchennamen Smith geführt ist, war relativ groß gewachsen, dabei extrem beweglich und sehr kräftig, sodass sie oft am Netz auftauchte und den Punkt mit einem wuchtigen Volley für sich entschied.

↓ Margaret Court (nee Smith), Robbin Ebbern, Lesley Turner (l.t.r.) sitting relaxed in a restaurant in Hilversum, 1970.
Margaret Smith-Court, Robbin Ebbern und Lesley Turner (von links nach rechts) sitzen entspannt in Hilversum im Restaurant, 1970.

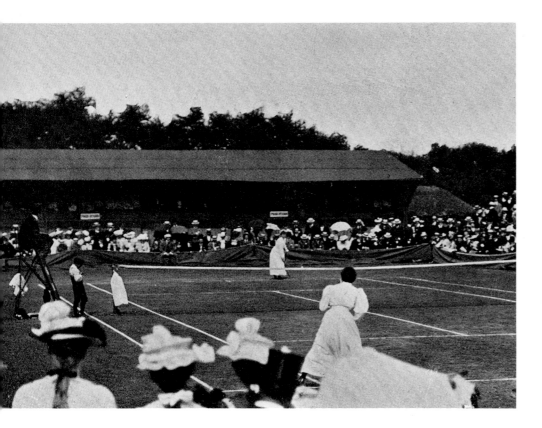

← Blanche Bingley Hillyard (front) against Charlotte Cooper Sterry in the final of Wimbledon, 1901.
Blanche Bingley Hillyard (vorne) gegen Charlotte Cooper Sterry im Endspiel von Wimbledon, 1901.

BLANCHE BINGLEY

The daughter of a wealthy English clothing manufacturer, she was, along with Charlotte Dod, the first dominant female tennis player of the modern era; she won six Wimbledon tournaments from 1886 to 1900. Top fit, she still competed at Wimbledon in 1913 at the age of 49 before retiring.

Die Tochter eines wohlhabenden englischen Bekleidungsherstellers war gemeinsam mit Charlotte Dod die erste dominierende Tennisspielerin der modernen Ära; von 1886 bis 1900 gewann sie sechs Wimbledon-Turniere. Topfit trat sie noch mit 49 Jahren 1913 in Wimbledon an, bevor sie sich zur Ruhe setzte.

↑ Blanche Bingley Hillyard and her husband at Thrope Satchville, England, before 1912.
Blanche Bingley Hillyard mit ihrem Ehemann in Thrope Satchville, England, vor 1912.

6
Grand Slam singles titles
Grand-Slam-Titel im Einzel

• • • • • • • • • • • • • • • •

→ Blanche Bingley Hillyard, photographed around 1900, was a six-time Wimbledon winner.
Blanche Bingley Hillyard, fotografiert um 1900, war sechsmalige Wimbledon-Siegerin.

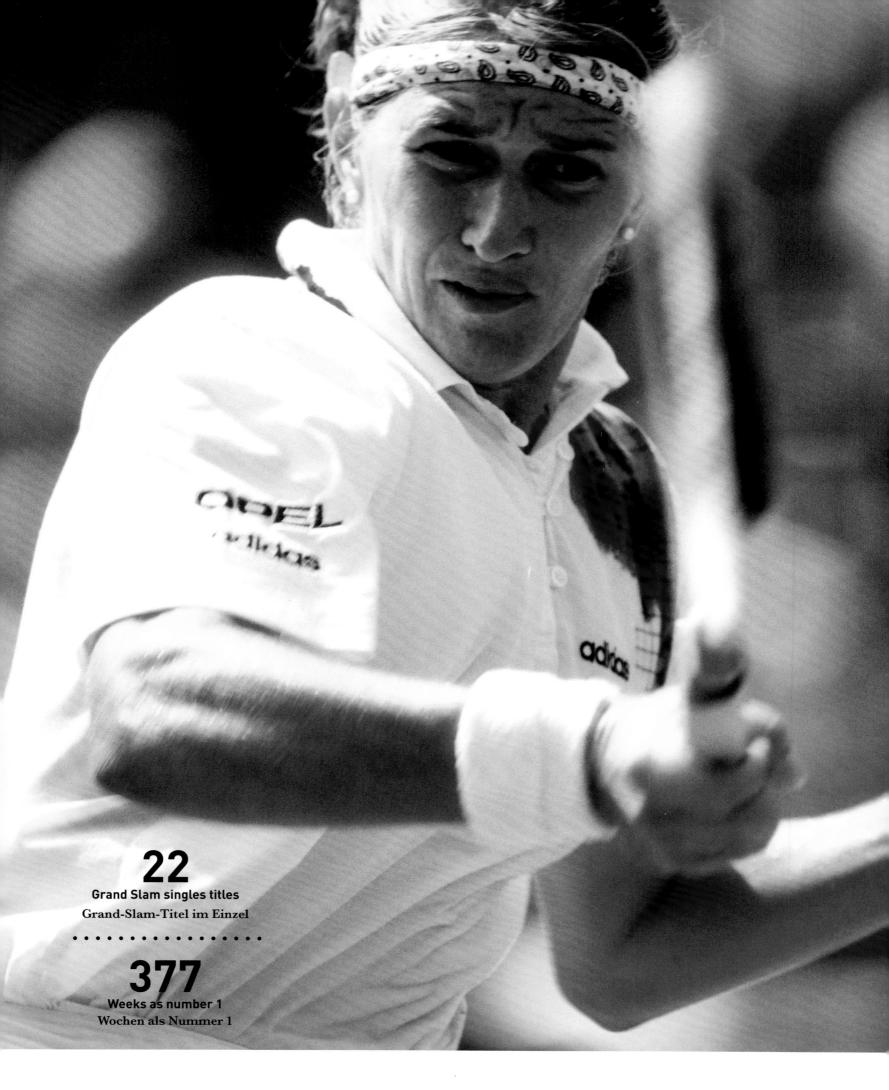

22
Grand Slam singles titles
Grand-Slam-Titel im Einzel

· · · · · · · · · · · · · · · · ·

377
Weeks as number 1
Wochen als Nummer 1

Steffi Graf in a defensive stance at the US Open, 1995.
Steffi Graf in Abwehrhaltung bei den US Open, 1995.

↑ Steffi Graf, who was known for her strong forehand, during an exhibition match at Wimbledon, 2009.
Steffi Graf, die für ihre starke Vorhand bekannt war, bei einem Schaukampf in Wimbledon, 2009.

STEFFI GRAF

No one hit the forehand harder than she did: the German, who was already considered a child prodigy at the age of eleven and entered the pros at 13, was the only player to date to achieve the "Golden Slam" in 1988 – winning all four major tournaments as well as the Olympic gold medal. No one was number one in the world longer than she was.

Härter als sie schlug niemand die Vorhand: Der Deutschen, die schon mit elf Jahren als Wunderkind galt und mit 13 bei den Profis antrat, gelang 1988 als bislang einziger Spielerin der »Golden Slam« – der Gewinn aller vier Major-Turniere sowie der Olympischen Goldmedaille. Niemand war länger die Nummer eins der Welt als sie.

← Lenglen and Wills pictured at the Match of the Century, 1926.
Suzanne Lenglen und Helen Wills beim »Match of the Century«, 1926.

↑ Vincent Richards and Helen Wills at the Racing Club de France, 1926.
Vincent Richards und Helen Wills im Racing Club de France, 1926.

HELEN WILLS

She looked like a movie star and was idolized by actors and other celebrities. Completely unusual at the time, the US American trained almost exclusively with male partners. She won Wimbledon eight times – a record that stood until 1990, when Martina Navratilova won there for the ninth time. She also won the Olympic gold medals in singles and doubles in 1924.

Sie sah aus wie ein Filmstar und wurde von Schauspielern und anderen Berühmtheiten umschwärmt. Damals völlig unüblich, trainierte die US-Amerikanerin fast ausschließlich mit männlichen Partnern. Acht Mal gewann sie in Wimbledon – ein Rekord, der bis 1990 hielt, als Martina Navratilova dort zum neunten Mal gewann. Zumal holte sie sich 1924 die Olympischen Goldmedaillen im Einzel und im Doppel.

→ Helen Wills, shown here in 1924, won a total of 31 Grand Slam titles in singles, doubles and mixed.
Helen Wills, fotografiert 1924, gewann insgesamt 31 Grand-Slam-Titel in Einzel, Doppel und Mixed.

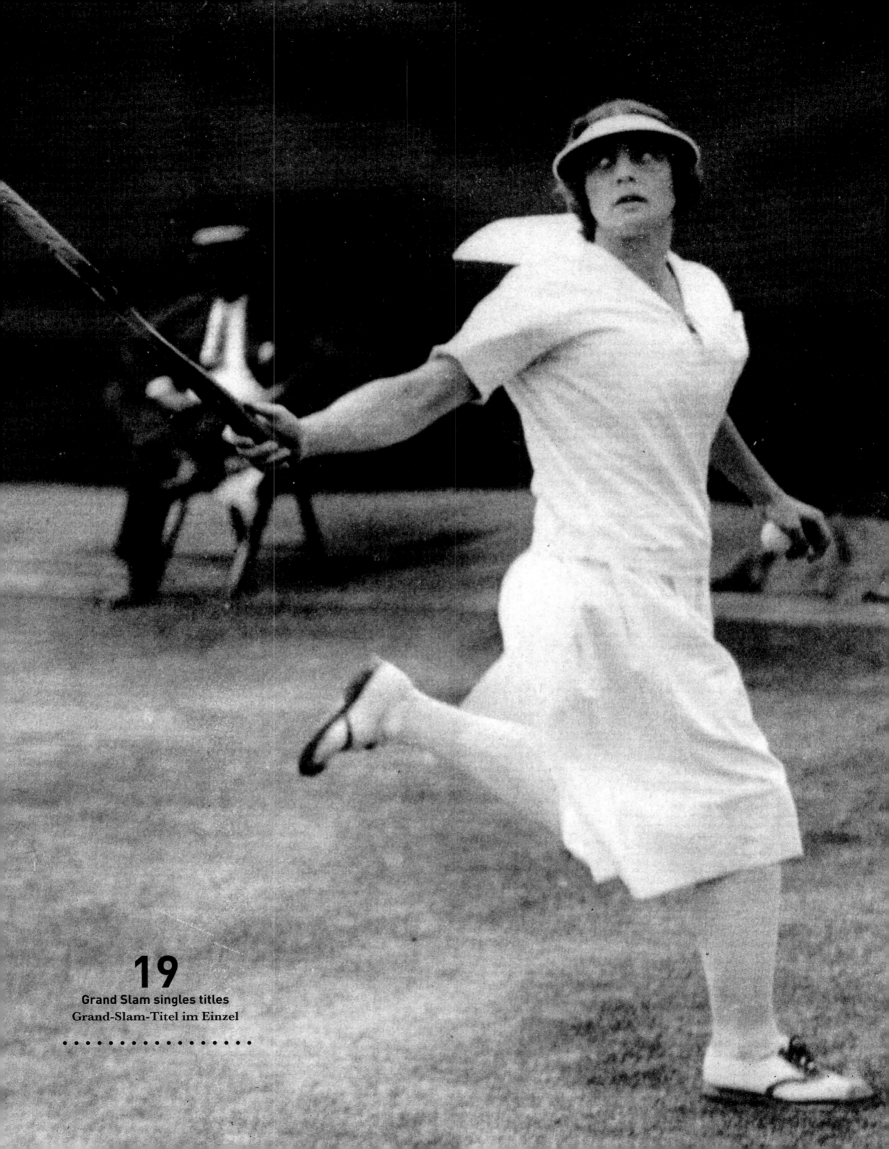

19
Grand Slam singles titles
Grand-Slam-Titel im Einzel

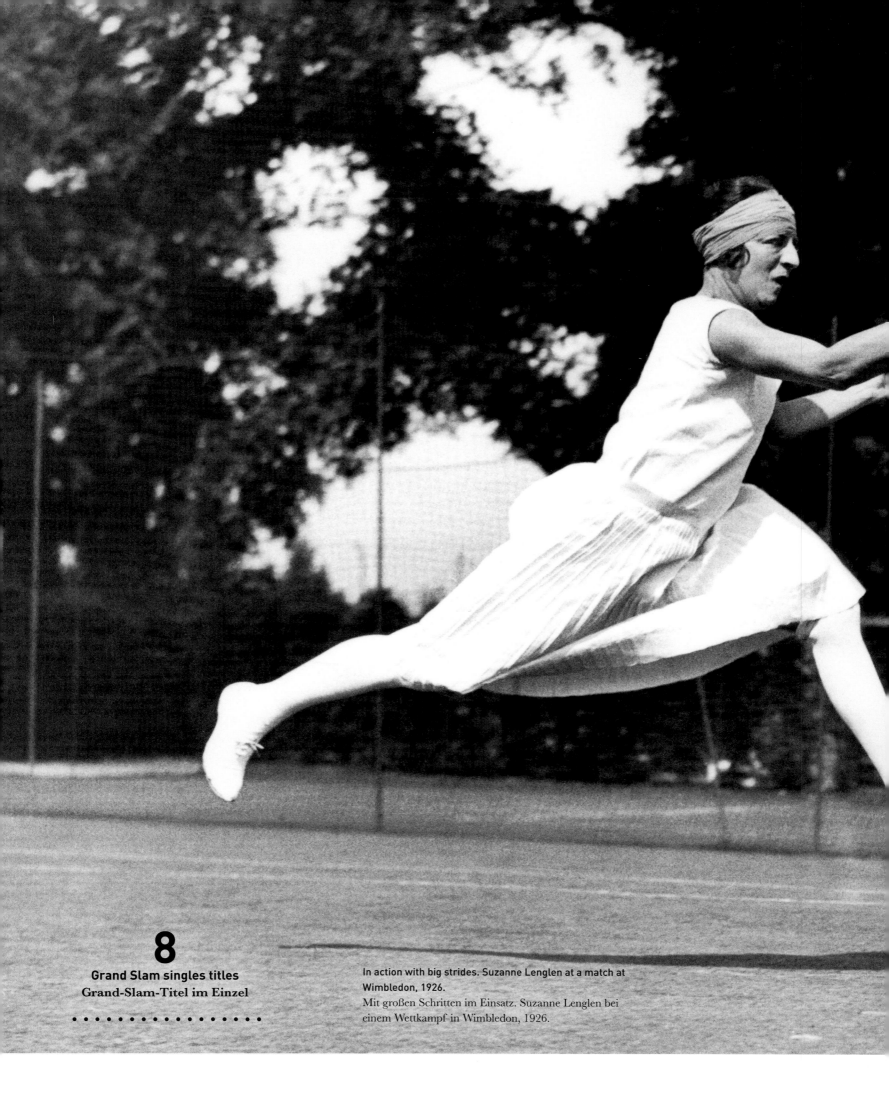

8
Grand Slam singles titles
Grand-Slam-Titel im Einzel
· · · · · · · · · · · · · · · · ·

In action with big strides. Suzanne Lenglen at a match at Wimbledon, 1926.
Mit großen Schritten im Einsatz. Suzanne Lenglen bei einem Wettkampf in Wimbledon, 1926.

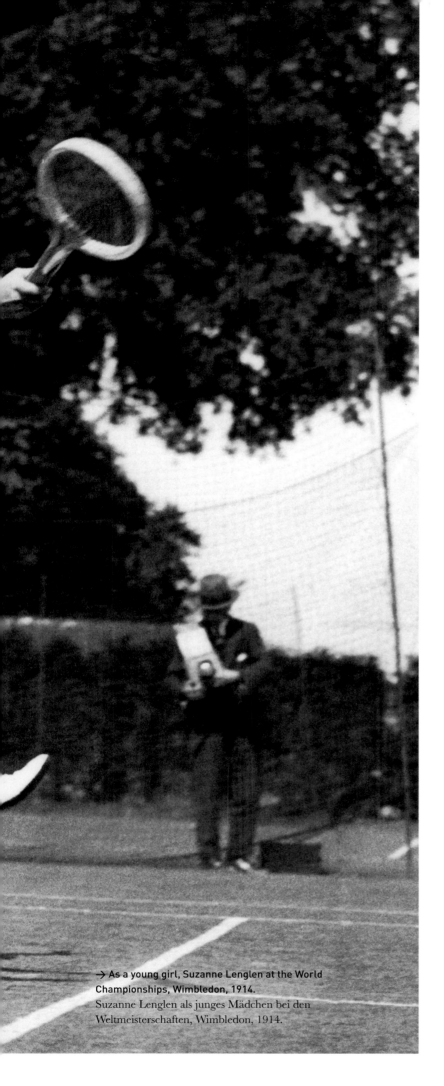

SUZANNE LENGLEN

With her headband and fur coat, the French style icon was a perfect match for the Golden 1920s and ensured that women's tennis is just as popular today as men's tennis – other sports can learn from it. She was a world star far beyond the tennis courts and is considered the "first female influencer".

Die französische Stilikone passte mit Stirnband und Pelzmantel perfekt zu den goldenen 1920er-Jahren und sorgte dafür, dass Damentennis heute genauso populär ist wie Herrentennis – andere Sportarten können davon lernen. Sie war weit über die Tenniscourts hinaus ein Weltstar und gilt als »erste Influencerin«.

→ As a young girl, Suzanne Lenglen at the World Championships, Wimbledon, 1914.
Suzanne Lenglen als junges Mädchen bei den Weltmeisterschaften, Wimbledon, 1914.

The Coach: the Father of Success

Der Coach: der Vater des Erfolgs

They are almost as famous as the players – and just as wealthy: the best coaches are booked out for years to come and sometimes have to turn down requests from the world's top players. What's more, they can command high four-digit daily rates, plus travel and airfare expenses. The most famous tennis coach is Nick Bollettieri, who trained Andre Agassi, Monica Seles, Jim Courier and Maria Sharapova, among others, at his academy in Florida.

Sie sind fast so berühmt wie die Spieler – und ebenso wohlhabend: Die besten Coaches sind auf Jahre hinaus ausgebucht und müssen mitunter auch Anfragen aus der Weltspitze ablehnen. Darüber hinaus können sie hohe vierstellige Tagessätze aufrufen, plus Reise- und Flugspesen. Der berühmteste Tennislehrer ist Nick Bollettieri, der in seiner Akademie in Florida unter anderem Andre Agassi, Monica Seles, Jim Courier und Maria Sharapova ausbildete.

The academy is highly sought after and employs dozens of coaches, only the crème de la crème were taken care of by Nick Bolletieri himself in his last years. He died in 2022. The amazing thing: Nick Bolletieri was self-taught; he only began playing tennis after his time with the U.S. Paratroopers. His academy in Bradenton, Florida, encompasses 162,000 square feet and 56 tennis courts. Parents who dream of a professional career for their children have to shell out about $80,000 a year.

Toni Nadal is also a man in demand. He coached his nephew Rafael since his childhood and turned the Mallorcan into one of the most dominant

Die Akademie ist hochbegehrt und beschäftigt Dutzende Trainer, nur um die Crème de la Crème kümmerte sich der 2022 verstorbene Nick Bolletieri selbst. Das Erstaunliche: Nick Bolletieri war Autodidakt, er begann erst nach seiner Zeit bei den US-Fallschirmjägern mit dem Tennis. Seine Akademie in Bradenton, Florida, umfasst 162.000 Quadratmeter und 56 Tennisplätze. Eltern, die von einer Profikarriere für ihre Kinder träumen, müssen pro Jahr etwa 80.000 Dollar berappen.

Toni Nadal ist ebenfalls ein gefragter Mann. Er coachte seinen Neffen Rafael seit dessen Kindheit und machte den Mallorquiner zu einem der

← Tennis coach Nick Bollettieri gives instructions to young Russian Anna Kournikova at his tennis academy in Florida.
Tennistrainer Nick Bollettieri gibt der jungen Russin Anna Kournikova Anweisungen in seiner Tennisakademie in Florida.

↓ It's hot in Florida. Andre Agassi sits shirtless with his coach Nick Bollettieri, 1990.
Es ist heiß in Florida. Andre Agassi sitzt ohne Hemd mit seinem Trainer Nick Bollettieri zusammen, 1990.

players in tennis history. Brad Gilbert, the former world number four, looks after Andy Murray and is famous for his analytical approach to the sport. He wrote the book *Winning Ugly – Mental Warfare in Tennis* and claims of himself not to have had as much talent as others, but to have reached the top of the world thanks to clever tactics and strategies. Australian Bob Brett, who died in 2021, coached Boris Becker and Goran Ivanišević – his tennis academy in San Remo, Italy, is probably the most famous performance center in Europe.

dominantesten Spieler der Tennisgeschichte. Brad Gilbert, die einstige Nummer vier der Welt, kümmert sich um Andy Murray und ist berühmt für seine analytische Herangehensweise an den Sport. Er schrieb das Buch *Winning Ugly – Mentale Kriegsführung im Tennis* und behauptet von sich selbst, gar nicht so viel Talent gehabt zu haben wie andere, aber dank kluger Taktiken und Strategien bis an die Weltspitze vorgedrungen zu sein. Der 2021 verstorbene Australier Bob Brett trainierte Boris Becker und Goran Ivanišević –

↓ Toni Nadal coaches Rafael Nadal during practice at the Queens Club Aegon Championships in London, 2015.
Toni Nadal coacht Rafael Nadal während des Trainings bei den Queens Club Aegon Championships in London, 2015.

↑ Boris Becker coaches Novak Djokovic during practice on Court No. 4 at Wimbledon, 2014.
Boris Becker coacht Novak Djokovic beim Training auf Court Nr. 4 in Wimbledon, 2014.

→ Bob Brett as tennis coach of the Japanese Davis Cup team, 2007.
Bob Brett als Tennistrainer des japanischen Davis-Cup-Teams, 2007.

↑ Andy Murray gets lessons from Brad Gilbert,
Odessa Tennis Club, Ukraine, 2006.
Andy Murray erhält Unterricht von Brad Gilbert,
Odessa Tennis Club, Ukraine, 2006.

→ 10 years later, Murray gets lessons from
Ivan Lendl with Jamie Delgado at the Aegon
Championships, Queen's Club, 2016.
Zehn Jahre später erhält Murray Unterricht von
Ivan Lendl mit Jamie Delgado bei den Aegon
Championships, Queen's Club, 2016.

In recent years, it has become fashionable for top players to team up with former top players to get advice from them and benefit from their experience. Stefan Edberg coached Roger Federer, Boris Becker was at Novak Djokovic's side for three years, and Ivan Lendl helped Andy Murray get over his many final disappointments and finally become a Grand Slam winner. The move is understandable: things are so tight at the top that all the world-class players are looking for a few percent advantage.

↑ Break, Roger Federer and coach Stefan Edberg at the French Open, 2015.
Pause, Roger Federer und Trainer Stefan Edberg bei den French Open, 2015.

seine Tennisakademie im italienischen San Remo ist wohl das berühmteste Leistungszentrum Europas.

In den letzten Jahren ist es Mode geworden, dass sich Spitzenspieler mit ehemaligen Spitzenspielern zusammentun, um von ihnen Rat zu bekommen und von ihrer Erfahrung zu profitieren. Stefan Edberg coachte Roger Federer, Boris Becker war drei Jahre lang an Novak Djokovics Seite, und Ivan Lendl half Andy Murray, über die vielen Finalenttäuschungen hinweg zu kommen und endlich ein Grand-Slam-Sieger zu werden. Der Schritt ist ja auch nachvollziehbar: An der Spitze geht es so eng zu, dass alle Weltklassespieler auf der Suche nach ein paar Prozenten Vorteil sind.

Team Sport Tennis

Teamsport Tennis

Tennis players are lone warriors – but only on the court. Beyond the actual matches, a whole swarm of specialists surrounds them, and every year there seem to be more of them. In addition to the classic coach, there is the mental trainer and the physiotherapist who takes care of physical fitness and regeneration. When they travel, they often have a cook with them, and their partner also flies along to the tournaments. Each player has a trusted doctor, a nutritionist designs special diet plans, and experts are often paid to observe upcoming opponents,

Tennisspieler sind Einzelkämpfer – aber nur auf dem Platz. Jenseits der eigentlichen Matches umgibt sie ein ganzer Schwarm von Spezialisten, und jedes Jahr scheinen es mehr zu werden. Neben dem klassischen Coach gibt es den Mentaltrainer und den Physiotherapeuten, der sich um die körperliche Fitness und die Regeneration kümmert. Auf Reisen ist oft noch ein Koch dabei und auch der Partner fliegt mit zu den Turnieren. Jeder Spieler hat einen Arzt seines Vertrauens, ein Ernährungsberater entwirft spezielle Diätpläne, und oft werden auch Experten be-

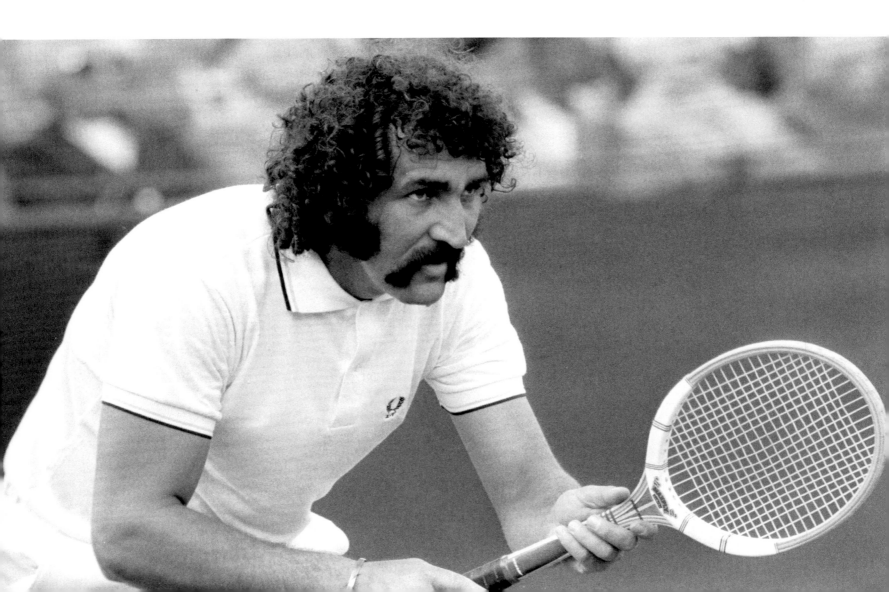

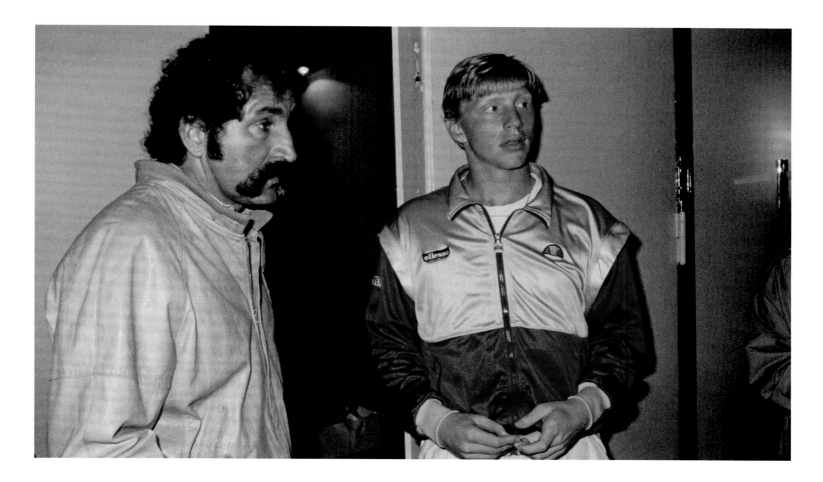

analyze their strengths and weaknesses, and
design optimal strategies. And, of course, there
is the manager, perhaps the most important
figure: he is the ringmaster.

The public became really aware of the manag-
er's role when, during the appearances of the
young Boris Becker in the 1980s, the camera
liked to pan to the stands, where a manager
who was as charismatic as he was shady-look-
ing watched the matches without any emotion.
The Romanian Ion Țiriac was himself a world-
class player who once won the French Open in
doubles. He also looked after Henri Leconte,
Mary Joe Fernández, Anke Huber and Goran
Ivanišević. In the process, enough apparently

zahlt, die kommende Gegner beobachten, ihre
Stärken und Schwächen analysieren und opti-
male Strategien entwerfen. Und natürlich gibt es
den Manager, die vielleicht wichtigste Figur: Er
ist der Zirkusdirektor.

Richtig bewusst wurde der Öffentlichkeit die
Rolle des Managers, als bei den Auftritten des
jungen Boris Becker in den 1980er-Jahren die
Kamera gern auf die Tribüne schwenkte, wo ein
ebenso charismatisch wie zwielichtig aussehender
Manager den Matches ohne jede Regung zusah.
Der Rumäne Ion Țiriac war selbst ein Weltklas-
sespieler, der einst die French Open im Doppel
gewann. Er kümmerte sich auch um Henri Le-
conte, Mary Joe Fernández, Anke Huber und
Goran Ivanišević. Dabei fiel offenbar genug für
ihn ab: Er investierte geschickt in Hotels und
Golfplätze, gründete eine Privatbank, eine Flug-
gesellschaft und eine Krankenversicherung. Mit
einem Vermögen von 700 Millionen Dollar soll
er aktuell der reichste Rumäne sein.

↑ Ion Țiriac, as a manager with his protégé Boris Becker, circa 1985.
Ion Țiriac, als Manager mit seinem Schützling Boris Becker, um 1985.

← Ion Țiriac as a player at the 1973 British Hard Court Championships in
Bournemouth, 1973.
Ion Țiriac als Spieler bei den britischen Hartplatzmeisterschaften 1973 in
Bournemouth.

fell off for him: he made shrewd investments in hotels and golf courses, founded a private bank, an airline and a health insurance company. With a fortune of 700 million dollars, he is currently said to be the richest Romanian.

However, he was unable to protect Boris Becker from his later financial escapades; his time as manager of the German prodigy ended in 1993.

Becker's compatriot Steffi Graf was to learn just how important a good manager is: her father Peter Graf, an insurance salesman and used car dealer, believed he could do everything himself. That might have worked in her junior years, but when Steffi Graf rose to the top of the world, her father was obviously overwhelmed and still thought he was clever enough to outsmart the system. He didn't succeed: he evaded at least 12.3 million deutschmarks (it was probably considerably more) and was sentenced to three years and nine months in prison in 1997.

Vor den späteren finanziellen Eskapaden konnte er Boris Becker jedoch nicht schützen; seine Zeit als Manager des deutschen Wunderkindes endete 1993.

Wie wichtig ein guter Manager ist, sollte auch Beckers Landsfrau Steffi Graf erfahren: Ihr Vater Peter Graf, Versicherungskaufmann und Gebrauchtwagenhändler, glaubte, alles selbst machen zu können. Das mochte in der Junioren-zeit noch funktionieren, doch als Steffi Graf zur Weltspitze aufstieg, war Papa offenbar überfordert und hielt sich dennoch für clever genug, das System austricksen zu können. Das gelang nicht: Er hinterzog mindestens 12,3 Millionen D-Mark (vermutlich war es noch deutlich mehr) und wurde 1997 zu drei Jahren und neun Monaten Haft verurteilt.

Auch Richard Williams kümmerte sich als Coach und Manager um seine Töchter Venus und Serena. Als seine Töchter gerade das Laufen lern-

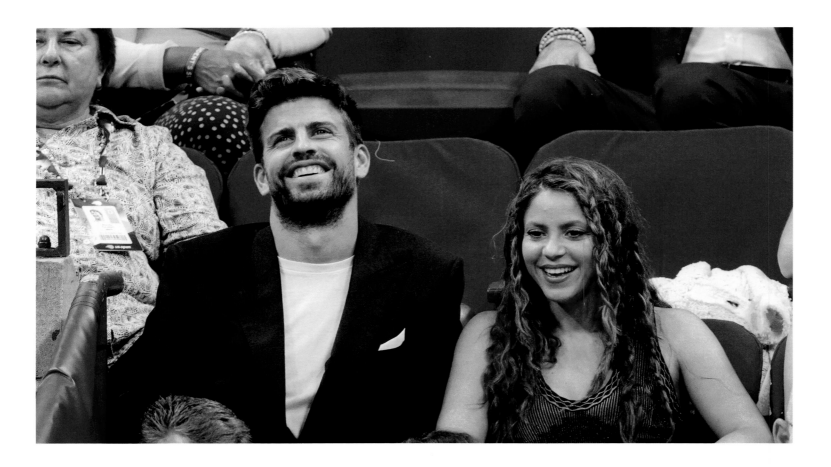

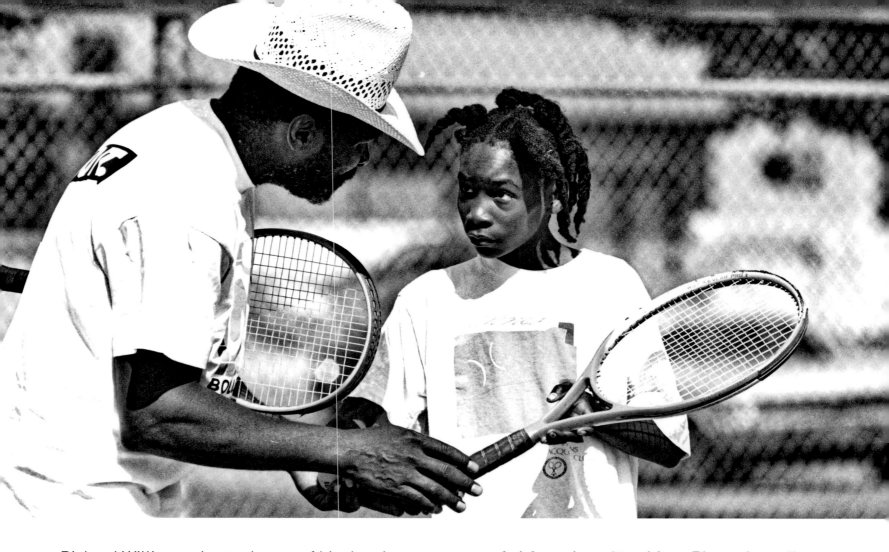

Richard Williams also took care of his daughters Venus and Serena as coach and manager. When his daughters were just learning to walk, he wrote an 85-page plan on how to get them to the top of the world.

But one-man businesses are becoming increasingly rare – modern times are too complex, too many things to juggle: advertising partnerships, bonuses, equipment supplier contracts, entry fees, tournament planning, press inquiries, social media. That's why almost all top players work with large management companies like IMG Models, where several experts share the work.

ten, schrieb er einen 85-seitigen Plan, wie er die beiden zur Weltspitze heranführen könne.

Doch Ein-Mann-Unternehmen werden immer seltener – zu komplex sind die modernen Zeiten, zu viele Dinge gilt es zu jonglieren: Werbepartnerschaften, Prämien, Ausrüsterverträge, Antrittsgelder, Turnierplanung, Presseanfragen, Social Media. Fast alle Spitzenspieler sind darum bei großen Management-Firmen wie IMG Models, wo sich gleich mehrere Experten die Arbeit teilen.

← Gerard Piqué and pop singer Shakira at the US Open, 2019. The FC Barcelona legend very controversially reformed the Davis Cup with his investment group Kosmos in 2018. In 2023, the World Tennis Federation and the Kosmos group parted ways. Piquet parted ways with Shakira in 2022.
Gerard Piqué und Pop-Sängerin Shakira bei den US Open, 2019. Die FC Barcelona-Legende reformierte 2018 sehr umstritten den Davis Cup mit seiner Investmentgruppe Kosmos. Im Jahr 2023 trennten sich der Tennis-Weltverband und die Kosmos-Gruppe. Von Shakira trennte sich Piquet medienwirksam bereits 2022.

↑ Venus Williams listens to her father and coach Richard Williams at the young age of 11. Venus and Serena were both coached by their father.
Venus Williams hört im jungen Alter von 11 Jahren ihrem Vater und Trainer Richard Williams zu. Venus und Serena wurden beide von ihrem Vater trainiert.

The Tragic Tennis Baron: Gottfried von Cramm

Der tragische Tennisbaron: Gottfried von Cramm

A horse almost prevented a great career: the animal bit off the tip of the index finger of little Gottfried's right hand on his parents' estate in Lower Saxony. When he held a tennis racket in his hand for the first time at the age of eleven, it was clear that he needed a particularly thin grip. But perhaps that provided the special feeling in the stroke that soon made the young nobleman a German champion. He was actually supposed to enter the diplomatic service, but he abandoned his law studies in Berlin in favor of a career in sports; his parents agreed.

In the 1930s he was one of the most popular German athletes and also popular. In 1934 and 1936 he won the French Open and three times, in 1935, 1936 and 1937, the "tennis baron" was in the Wimbledon final; three times he lost, although the crowd was on his side. He also failed to win the final of the US Open in 1937, but the winner Donald Budge praised his opponent: "He

Beinahe hätte ein Pferd eine große Karriere verhindert: Das Tier biss dem kleinen Gottfried auf dem elterlichen Gut in Niedersachsen die Zeigefingerkuppe der rechten Hand ab. Als er mit elf Jahren zum ersten Mal einen Tennisschläger in der Hand hielt, war klar: Er brauchte einen besonders dünnen Griff. Aber vielleicht sorgte das für das besondere Gefühl im Schlag, das den jungen Adligen bald zum deutschen Meister werden ließ. Eigentlich sollte er in den diplomatischen Dienst eintreten, doch sein Jurastudium in Berlin brach er zugunsten einer Sportlerkarriere ab; die Eltern waren einverstanden.

In den 1930er-Jahren war er einer der populärsten deutschen Sportler und auch in der ganzen Welt beliebt. 1934 und 1936 gewann er die French Open und drei Mal, 1935, 1936 und 1937, stand der »Tennisbaron« im Wimbledon-Finale; drei Mal verlor er, obwohl die Zuschauer auf seiner Seite standen. Auch das Finale der US Open 1937 konnte er nicht gewinnen, doch der Sieger Donald Budge lobte seinen Gegner: »Er spielt schönes, einfach beneidenswert schönes Tennis, das ist ihm wichtiger als der Sieg«.

Mit dem Deutschen Tennis Bund ging es per Schiff auf eine 200-tägige Welttournee. Bei seiner Rückkehr 1938 wurde Gottfried von Cramm verhaftet: Ein Strichjunge hatte ihm eine Affäre

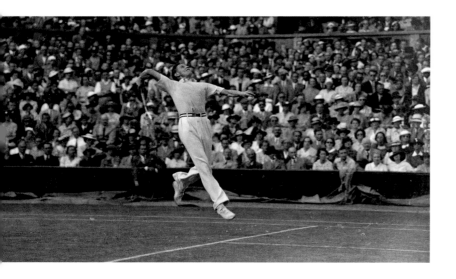

Baron Gottfried von Cramm playing on Centre Court in the men's singles at the Wimbledon Championships, 1937.
Baron Gottfried von Cramm im Spiel auf dem Center-Court im Herreneinzel der Wimbledon Championships, 1937.

plays beautiful, just enviably beautiful tennis, that's more important to him than winning".

He went on a world tour by ship with the German Tennis Federation. On his return in 1938, Gottfried von Cramm was arrested: a hustler had accused him of having an affair with the Jewish actor Manasse Herbst. He was sent to prison and was released on parole after seven months when Gottfried's mother intervened with Hermann Göring. Göring was also Gottfried's club mate at the Rot-Weiß Berlin tennis club.

In 1939, after three defeats in the finals, Gottfried von Cramm was finally to win Wimbledon. But the Wimbledon officials withdrew the great favorite's eligibility to play – persons with a criminal record were not allowed to compete. In the preparatory tournament in Queens, he had defeated the future Wimbledon winner Bobby Riggs 6:0 and 6:1.

A few weeks later, World War II broke out, and Gottfried von Cramm was sent to the Eastern Front in 1940, where he suffered severe frostbite as a common soldier. In 1942 he was discharged from the Wehrmacht as an "unreliable element" – quite possibly someone had done him a favor.

In 1946, he was the first German athlete ever to receive permission from the British occupying forces to leave the country, and he also rebuilt the German Tennis Federation and continued to compete in the Davis Cup until 1951.

The tennis baron, who was voted Germany's Sportsman of the Year in 1947 and 1948, founded an import company for Egyptian cotton and was killed in a car accident in Cairo in 1976.

mit dem jüdischen Schauspieler Manasse Herbst unterstellt. Er kam ins Gefängnis und wurde nach sieben Monaten auf Bewährung freigelassen, als Gottfrieds Mutter bei Hermann Göring intervenierte. Göring war zudem Gottfrieds Vereinskamerad im Tennisclub Rot-Weiß Berlin.

1939 sollte es nach drei Finalniederlagen endlich mit dem Wimbledon-Sieg klappen, Gottfried von Cramm war in der Form seines Lebens. Doch die Verantwortlichen von Wimbledon entzogen dem großen Favoriten zum Entsetzen aller Sportfans die Spielberechtigung – Vorbestrafte durften nicht antreten. Noch im Vorbereitungsturnier in Queens hatte er den späteren Wimbledon-Sieger Bobby Riggs mit 6:0 und 6:1 besiegt.

Wenige Wochen später brach der Zweite Weltkrieg aus, und Gottfried von Cramm wurde 1940 an die Ostfront geschickt, wo er sich als einfacher Soldat (die für einen Adligen übliche Offizierslaufbahn blieb ihm wegen seiner Vorstrafe verwehrt) schwere Erfrierungen zuzog. 1942 wurde er als »unzuverlässiges Element« aus der Wehrmacht entlassen – gut möglich, dass ihm da jemand einen Gefallen getan hatte.

1946 bekam er als erster deutscher Sportler überhaupt von den britischen Besatzern eine Ausreisegenehmigung, zudem baute er den Deutschen Tennis Bund wieder auf und trat noch bis 1951 beim Davis Cup an.

Der Tennisbaron, der 1947 und 1948 als Deutschlands Sportler des Jahres gewählt wurde, gründete eine Importfirma für ägyptische Baumwolle und kam 1976 bei einem Autounfall in Kairo ums Leben.

The Racehorse Principle: the Rise of Tommy Haas

Das Rennpferd-Prinzip: der Aufstieg von Tommy Haas

What to do when kids are exceptionally talented, but their parents don't have the money to pay for expensive training to become top players? Austrian tennis coach and ex-judoka Peter Haas and his German wife Brigitte had an idea: they set up a sponsorship pool for their children Tommy and Sabine. Investors were to finance Nick Bollettieri's tennis academy in return for 15% of all their earnings until 2004. Fifteen people, including the journalist Helmut Markwort, each invested 10,000 German marks per year over five years in the "TOSA Tennis Talent Promotion"; TOSA stands for Tommy and Sabine. The model attracted a lot of attention worldwide and also criticism, as it put the children under enormous pressure long before their actual careers. The siblings went to Florida in 1991. Tommy, then 13, became Andre Agassi's playing partner and soon had an excellent career, finishing second in the world rankings. He won the silver medal at the Sydney Olympics in 2000, reached the semifinals of the Australian Open and Wimbledon, and won 15 singles titles by the time his career ended in 2018, while his big sister, three years his senior, gave up her career – the stress had simply become too much. "I never loved tennis, but wanted to be loved and recognized," she says today.

Peter Haas, always a creative financial juggler, had already stopped paying out to the TOSA backers in 1999, it went to court, the investors got justice in the last instance in 2003 and 500,000 euros were transferred. Most recently, Peter Haas made headlines because he had un-

Was tun, wenn die Kinder zwar außergewöhnlich talentiert sind, die Eltern aber nicht das Geld für die teure Ausbildung zum Spitzenspieler haben? Der österreichische Tennislehrer und Ex-Judoka Peter Haas und seine deutsche Frau Brigitte hatten eine Idee: Sie gründeten für ihre Kinder Tommy und Sabine einen Förderpool. Investoren sollten die Tennisakademie von Nick Bollettieri finanzieren und dafür bis zum Jahr 2004 15 Prozent aller Einnahmen der beiden erhalten. 15 Personen, darunter der Journalist Helmut Markwort, investierten je 10.000 Deutsche Mark pro Jahr über fünf Jahre in die »TOSA Tennistalentförderung«; TOSA steht für Tommy und Sabine. Das Modell sorgte weltweit für viel Beachtung und auch für Kritik, setzte es die Kinder doch schon lange vor ihrer eigentlichen Karriere unter einen enormen Druck. Die Geschwister gingen 1991 nach Florida. Tommy, damals 13, wurde Spielpartner von Andre Agassi und legte bald eine exzellente Karriere hin, die auf Platz 2 der Weltrangliste endete. Er holte die Silbermedaille bei den Olympischen Spielen in Sydney im Jahr 2000, erreichte die Halbfinals von den Australian Open und Wimbledon und gewann bis zu seinem Karriereende im Jahr 2018 15 Einzeltitel, während seine große Schwester, drei Jahre älter, ihre Karriere aufgab – der Stress war einfach zu groß geworden. »Ich habe den Tennissport nie geliebt, sondern wollte geliebt und anerkannt werden«, sagt sie heute.

Peter Haas, seit jeher ein kreativer Finanzjongleur, hatte die Auszahlung an die TOSA-Geld-

justifiably received benefits – a court sentenced him to probation in 2014.

Tommy Haas now works as a tennis official and is tournament director of the tradition-steeped BNP Paribas Open in Indian Wells, California, while Sabine passes on her experience as a mental coach.

geber schon 1999 eingestellt, es ging vor Gericht, die Investoren bekamen 2003 in letzter Instanz Recht und 500.000 Euro überwiesen. Zuletzt machte Peter Haas Schlagzeilen, weil er unberechtigt Hartz IV bezogen hatte – ein Gericht verurteilte ihn 2014 zu einer Bewährungsstrafe.

Tommy Haas arbeitet inzwischen als Tennisfunktionär und ist Turnierdirektor der traditionsreichen BNP Paribas Open im kalifornischen Indian Wells, während Sabine als Mentalcoach ihre Erfahrungen weitergibt.

Tommy Haas against Daniel Evans at the Zagreb Indoors, 2014.
Tommy Haas gegen Daniel Evans bei den Zagreb Indoors, 2014.

THE FOUR GRAND SLAM TOURNA-MENTS

DIE VIER GRAND-SLAM-TURNIERE

Four tournaments decide whether the players become immortal. Because history is only made here: At the Australian Open in Melbourne, at the French Open in Paris, at Wimbledon and at the US Open in New York.

Vier Turniere entscheiden, ob die Spielerinnen und Spieler unsterblich werden. Denn Geschichte wird nur hier geschrieben: Bei den Australian Open in Melbourne, bei den French Open in Paris, in Wimbledon und bei den US Open in New York.

The surfaces of the four Grand Slams in the well-known colors.
Die Bodenbeläge der vier Grand Slams in den bekannten Farben.

The Start on the Other Side of the Globe: the Australian Open

Der Start auf der anderen Seite der Welt: die Australian Open

The season kicks off 22 hours by plane from London and Paris: the Australian Open in Melbourne is the continent's largest and most attended sporting event – attracting up to 800,000 spectators. The predecessor tournament, the Australasian Championships, was held in 1905 together with New Zealand, but the neighboring country withdrew in 1922. For a long time, the tournament rotated through Australia, but since 1972 Melbourne has been a permanent venue. Until 1988, the Australian Open was played on grass, then the tournament moved to today's Melbourne Park and 24 hard courts. The Rod Laver Arena, named after the eleven-time Grand Slam winner from Queensland, holds 16,000 spectators.

Two notable records: in 1976, local hero Mark Edmondson won. Not only was he the last Australian to do so, but he also caused the biggest sensation in modern tennis history, as he was only ranked 212 in the world rankings; no Grand Slam winner has ever been ranked lower. And Steffi Graf succeeded in beating Chris Evert in Melbourne in 1988, thus kicking off her unique "Golden Slam": victories in all other Grand Slam tournaments that year followed, as well as Olympic gold.

Record winner / Rekordsieger:
Novak Djokovic, 10 titles / Titel
Serena Williams, 7 titles / Titel

Der Auftakt der Saison findet 22 Flugstunden von London und Paris statt: Die Australian Open in Melbourne sind das größte und besucherstärkste Sportereignis des Kontinents – es kommen bis zu 800.000 Zuschauer. Bereits 1905 fand das Vorläuferturnier namens Australasian Championships statt, es wurde mit Neuseeland gemeinsam ausgetragen; 1922 zog sich das Nachbarland aber zurück. Lange rotierte das Turnier durch Australien, seit 1972 ist Melbourne fester Austragungsort. Bis 1988 wurden die Australian Open auf Rasen ausgetragen, dann folgte der Wechsel in den heutigen Melbourne Park und auf 24 Hartplätze. Die Rod Laver Arena, benannt nach dem elfmaligen Grand-Slam-Sieger aus Queensland, fasst 16.000 Zuschauer.

Zwei bemerkenswerte Rekorde: 1976 gewann Local Hero Mark Edmondson. Er war nicht nur der letzte Australier, dem das gelang, sondern er sorgte dabei auch für die größte Sensation in der modernen Tennisgeschichte, denn er stand nur auf Rang 212 der Weltrangliste; niedriger platziert war nie ein Grand-Slam-Sieger. Und Steffi Graf gelang in Melbourne 1988 der Sieg gegen Chris Evert und damit der Auftakt ihres einmaligen »Golden Slam«: Es folgten Siege bei allen weiteren Grand-Slam-Turnieren in jenem Jahr sowie Olympia-Gold.

↗ Unseeded Mark Edmondson after his victory at the Australian Open, Melbourne, 1976.
Der ungesetzte Mark Edmondson nach seinem Sieg bei den Australian Open, Melbourne, 1976.

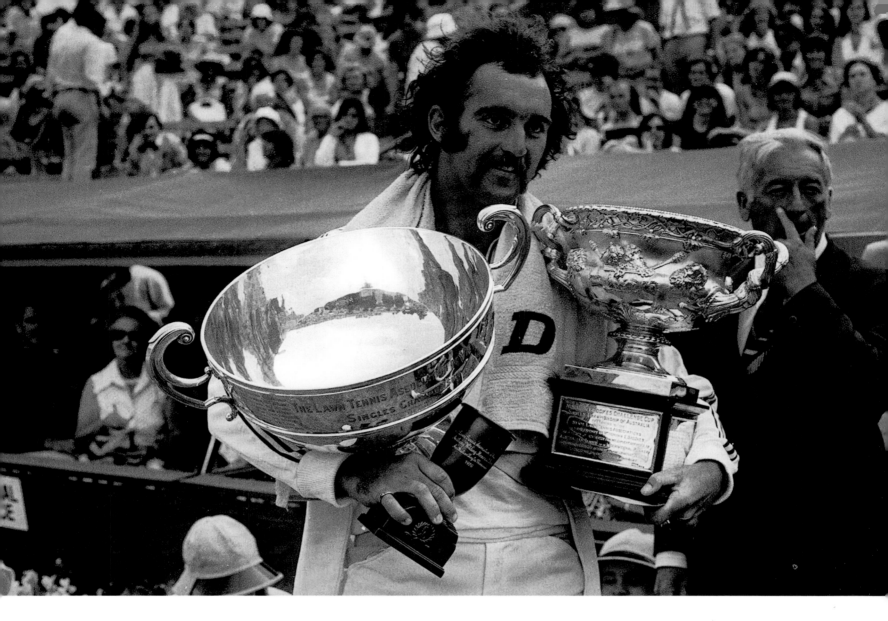

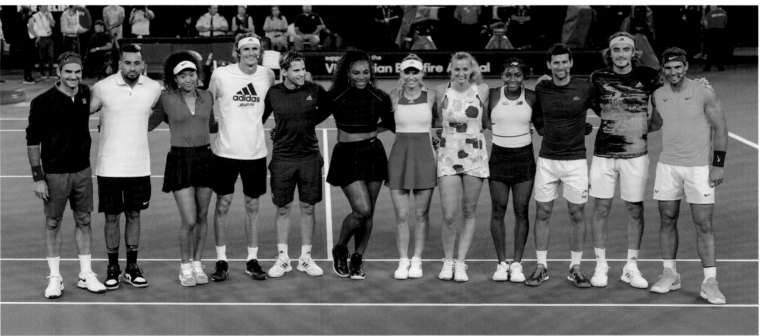

↑ The top players in Melbourne, 2020, from left to right: Roger Federer, Nick Kyrgios, Naomi Osaka, Alexander Zverev, Dominic Thiem, Serena Williams, Caroline Wozniacki, Petra Kvitova, Coco Gauff, Novak Djokovic, Stefanos Tsitsipas and Rafael Nadal.

Die Top-Spieler in Melbourne im Jahr 2020, von links nach rechts: Roger Federer, Nick Kyrgios, Naomi Osaka, Alexander Zverev, Dominic Thiem, Serena Williams, Caroline Wozniacki, Petra Kvitova, Coco Gauff, Novak Djokovic, Stefanos Tsitsipas und Rafael Nadal.

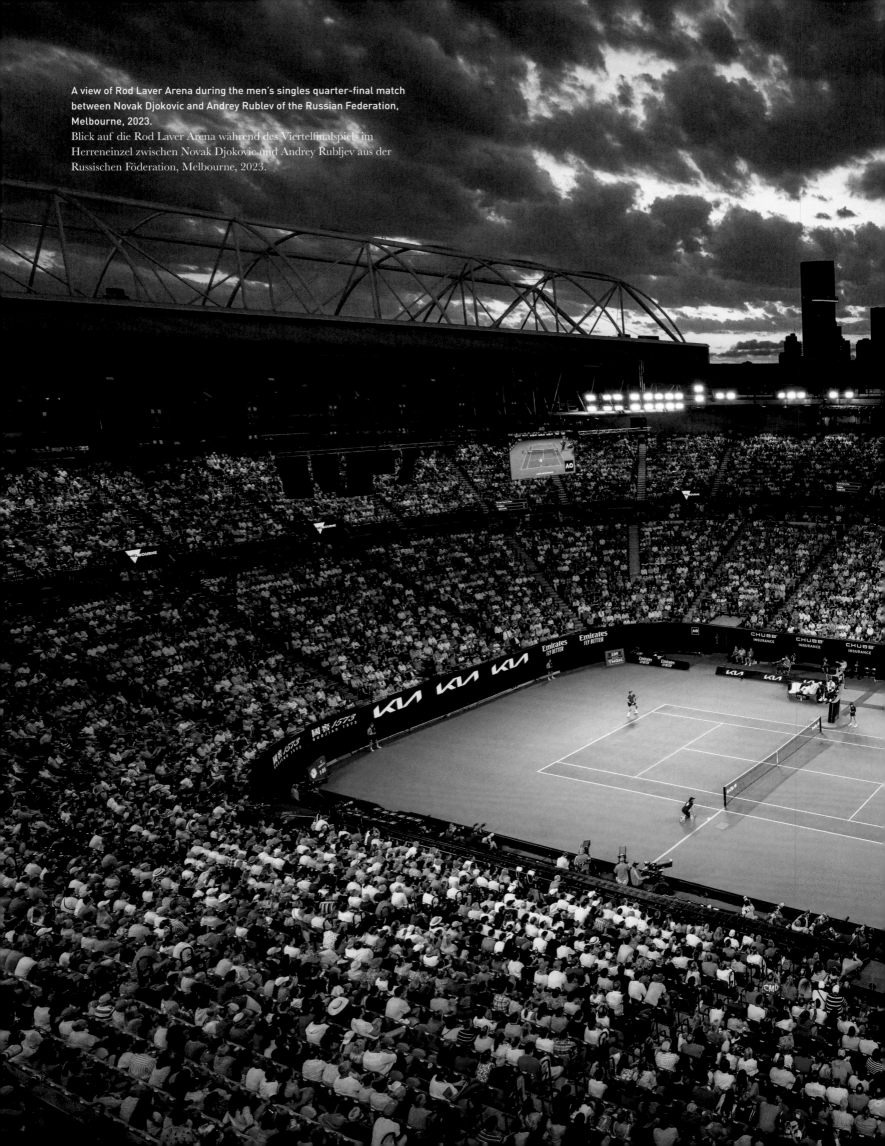

A view of Rod Laver Arena during the men's singles quarter-final match between Novak Djokovic and Andrey Rublev of the Russian Federation, Melbourne, 2023.
Blick auf die Rod Laver Arena während des Viertelfinalspiels im Herreneinzel zwischen Novak Djokovic und Andrey Rubljev aus der Russischen Föderation, Melbourne, 2023.

The Aesthetics of Slowness: the French Open

Die Ästhetik der Langsamkeit: die French Open

As a youth, Roland Garros was an avid cyclist and soccer player, and also won prizes for his piano playing. He never picked up a tennis racket, as his enthusiasm for airplanes soon ignited. In 1913 he was the first pilot to fly over the Mediterranean, and he also set a new altitude record of 13,944 feet. During World War I, he single-handedly converted his plane with a machine gun into the first known true fighter. He managed to make a few kills until he was taken prisoner of war by the Germans. After three years he escaped from the fortress of Magdeburg, he re-enlisted in the Aéronautique Militaire and was shot down over Vouziers in the Ardennes in October 1918, just days before the end of the war, at the age of 29.

In 1927, the French decided to name the Open de France, which had been held since 1891, after the nation's first aviation hero. And since then, the tournament has been officially called Roland Garros. It is the only one of the four Grand Slam tournaments to be played on clay. That makes the ball slower and the rallies longer. Rafael Nadal is considered the clay-court king with his 14 wins in Paris, but colleague Chris Evert has an equally impressive record: She won 125 matches in a row on clay for more than six years – a record for the ages.

Record winner / Rekordsieger
Rafael Nadal, 14 titles / Titel
Chris Evert, 7 titles / Titel

Als Jugendlicher war Roland Garros begeisterter Radfahrer und Fußballer und gewann auch Preise für sein Klavierspiel. Einen Tennisschläger hat er nie in die Hand genommen, denn bald entflammte seine Begeisterung für Flugzeuge. 1913 überflog er als erster Pilot das Mittelmeer, zudem stellte er mit 4250 Metern einen neuen Höhenrekord auf. Im Ersten Weltkrieg baute er sein Flugzeug im Alleingang mit einem Maschinengewehr zu dem ersten bekannten echten Jagdflugzeug um. Ihm gelangen einige Abschüsse, bis er in deutsche Kriegsgefangenschaft geriet. Nach drei Jahren konnte er aus der Festung Magdeburg fliehen, er meldete sich erneut zur Aéronautique Militaire und wurde im Oktober 1918, nur wenige Tage vor Ende des Krieges, über Vouziers in den Ardennen abgeschossen im Alter von 29 Jahren.

1927 beschlossen die Franzosen, die Open de France, die seit 1891 ausgetragen wurde, nach dem ersten Fliegerhelden der Nation zu benennen. Und seitdem heißt das Turnier ganz offiziell Roland Garros. Es ist das einzige der vier Grand-Slam-Turniere, das auf Sand gespielt wird. Das macht den Ball langsamer und die Ballwechsel länger. Als Sandplatzkönig gilt Rafael Nadal mit seinen 14 Siegen in Paris, doch Kollegin Chris Evert kann eine genauso beeindruckende Bilanz vorweisen: Sie gewann auf Sand über sechs Jahre lang 125 Partien in Folge – ein Rekord für die Ewigkeit.

Rafael Nadal is seen celebrating eight of his 14 French Open wins. Nadal is the only male player to win a Grand Slam tournament 14 times.
Rafael Nadal ist zu sehen, wie er acht seiner 14 French-Open-Siege feiert. Nadal ist der einzige männliche Spieler, der ein Grand-Slam-Turnier 14-mal gewonnen hat.

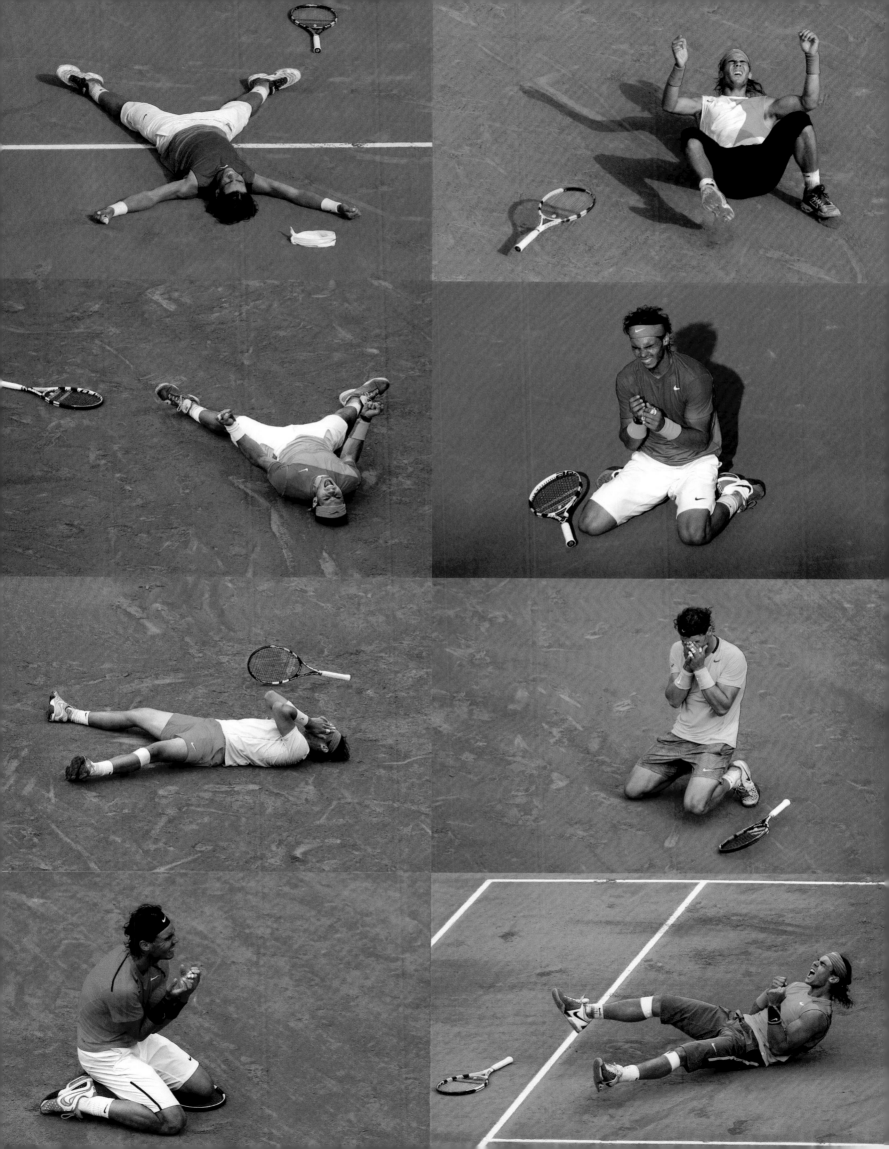

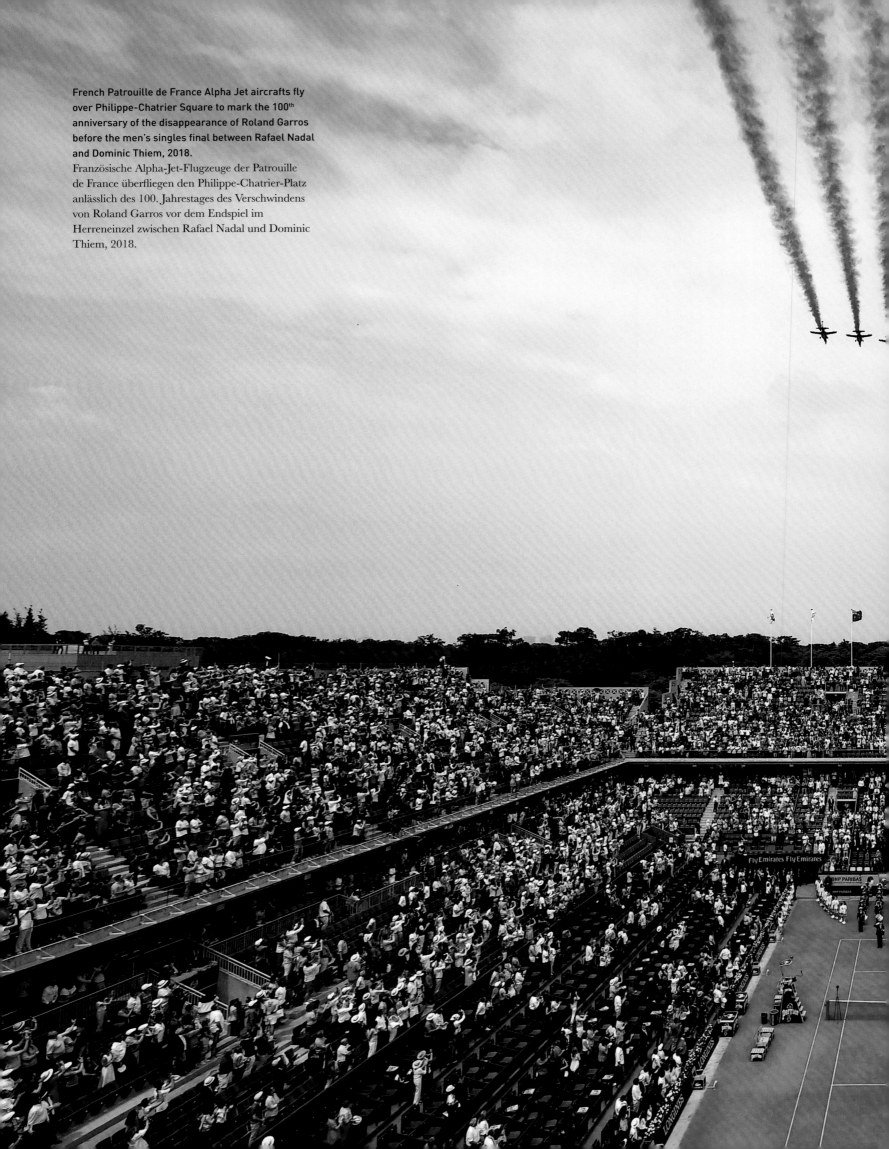

French Patrouille de France Alpha Jet aircrafts fly over Philippe-Chatrier Square to mark the 100th anniversary of the disappearance of Roland Garros before the men's singles final between Rafael Nadal and Dominic Thiem, 2018.

Französische Alpha-Jet-Flugzeuge der Patrouille de France überfliegen den Philippe-Chatrier-Platz anlässlich des 100. Jahrestages des Verschwindens von Roland Garros vor dem Endspiel im Herreneinzel zwischen Rafael Nadal und Dominic Thiem, 2018.

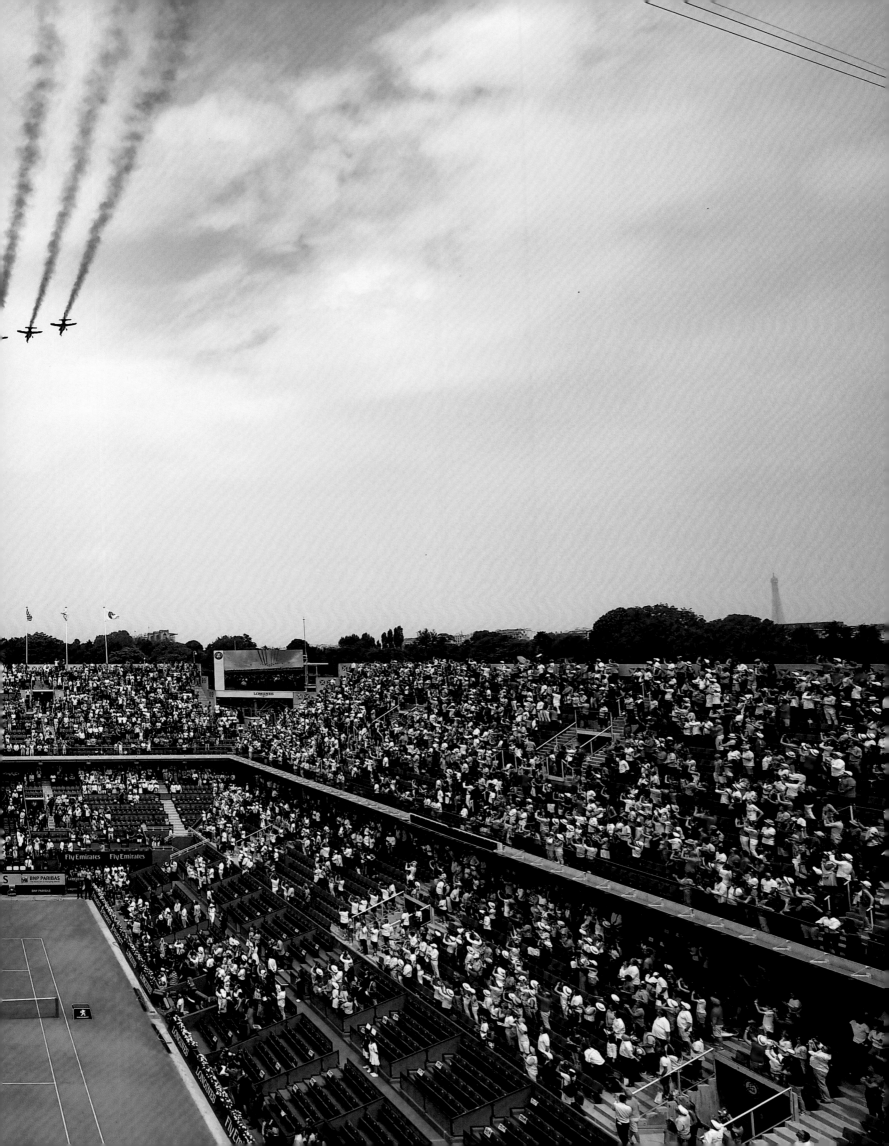

Strawberries and Grass, Volleys and Royals: Wimbledon

Erdbeeren und Gras, Volleys und Royals: Wimbledon

It's the oldest, most famous and most prestigious tennis tournament in the world, and it has plenty more superlatives to offer - and it all started with a broken lawn roller that cost £10 to replace. The All England Lawn Tennis and Croquet Club had an idea: hold a tournament and charge spectators to pay for the new equipment. The year was 1877, and the first winner was Spencer Gore, brother of the Bishop of Birmingham. He confounded his opponent in front of 200 spectators with his serve-and-volley game, which was also to become the start of a long tradition at Wimbledon. As early as 1884, women's singles and men's doubles were introduced, and television broadcast the tournament as early as 1937.

Winning Wimbledon makes you immortal. Not only because it is the oldest tournament in the world. Not only because it is the only one of the four Grand Slam tournaments to be played on grass. And not just because it pays out a generous 40 million pounds in prize money. But above all because there is a very special atmosphere here. The professionals play in front of members of the British royal family (since 1922, the royals

Es ist das älteste, berühmteste und prestigereichste Tennisturnier der Welt und hat noch jede Menge mehr Superlative zu bieten – und alles begann mit einer kaputten Rasenwalze, deren Ersatz 10 Pfund verschlang. Der All England Lawn Tennis and Croquet Club hatte eine Idee: Man veranstaltete ein Turnier und knöpfte den Zuschauern Eintritt ab, um das neue Gerät zu bezahlen. Es war das Jahr 1877, und der erste Sieger hieß Spencer Gore, der Bruder des Bischofs von Birmingham. Er verwirrte vor 200 Zuschauern seinen Gegner mit seinem Serve-and-Volley-Spiel, was ebenfalls der Beginn einer langen Tradition in Wimbledon werden sollte. Schon 1884 wurde das Dameneinzel sowie das Herrendoppel eingeführt, und bereits 1937 übertrug das Fernsehen das Turnier.

Wer in Wimbledon gewinnt, macht sich unsterblich. Nicht nur, weil es das älteste Turnier der Welt ist. Nicht nur, weil es das einzige der vier Grand-Slam-Turniere ist, das auf Rasen ausgetragen wird. Nicht nur, weil es mit 40 Millionen Pfund auch reichlich Preisgeld ausschüttet. Sondern vor allem, weil hier eine ganz besondere

↗ German players Steffi Graf and Boris Becker pose with their trophies after their victories in the women's and men's singles at Wimbledon, 1989. Their success marked the beginning of a tennis boom in Germany.
Die deutschen Spieler Steffi Graf und Boris Becker posieren mit ihren Trophäen nach ihren Siegen im Damen- und Herreneinzel in Wimbledon, 1989. Ihr Erfolg ist der Beginn eines Tennisbooms in Deutschland.

→ Andre Agassi in white ironically defies Wimbledon dress code regulations by competing in all white, including shoelaces and sweatbands.
Andre Agassi trotzt ironisch den Wimbledon-Dresscode-Verordnungen, indem er komplett in Weiß antritt, inklusive Schnürsenkeln und Schweißbändern.

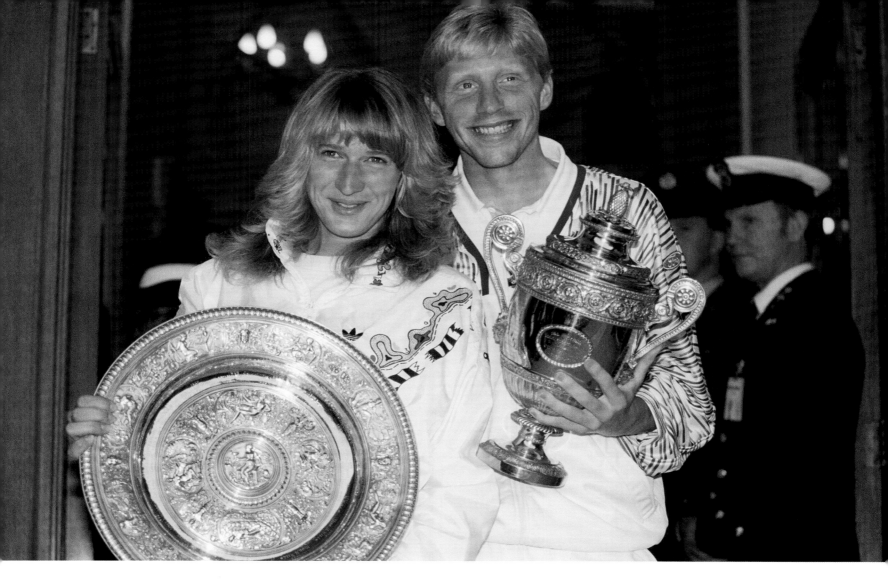

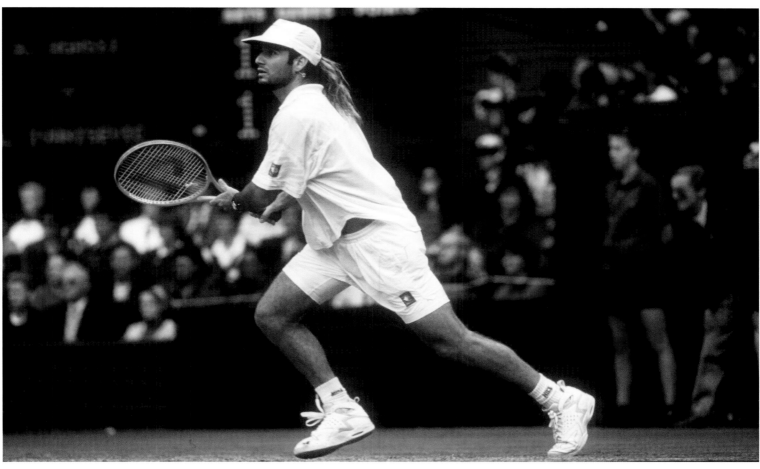

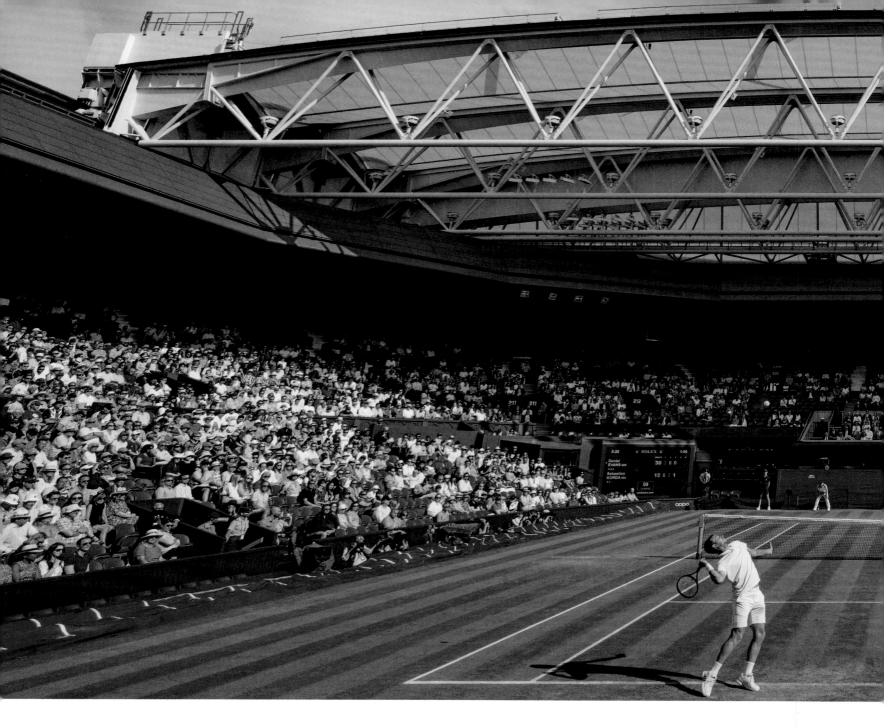

have had their own box with 74 seats), and on a few occasions, even the late Queen Elizabeth II herself has performed the award ceremonies.

The dress code is stricter than anywhere else in the world, as 90 percent of the players' clothing must be white. The bird of paradise Andre Agassi, who in the 1990s had worn garishly colored clothing all over the world, ironically submitted to the regulations by competing completely in white, including shoelaces and sweatbands. The rain breaks are bridged by the spectators stoically or even with little singing interludes, and as a snack there are strawberries with cream.

Atmosphäre herrscht. Die Profis spielen vor Mitgliedern der britischen Königsfamilie (seit 1922 haben die Royals ihre eigene Loge mit immerhin 74 Sitzplätzen), und ein paar Mal hat sogar die selige Queen Elizabeth II. höchstselbst die Siegerehrungen vorgenommen. Der Dresscode ist strenger als überall sonst auf der Welt, denn 90 Prozent der Spielerbekleidung muss Weiß sein. Paradiesvogel Andre Agassi, in den 1990ern weltweit mit schrillbunter Bekleidung unterwegs, unterwarf sich ironisch den Verordnungen, indem er komplett in Weiß antrat, inklusive Schnürsenkeln und Schweißbändern. Die Regenpausen werden von den Zuschauern stoisch oder gar

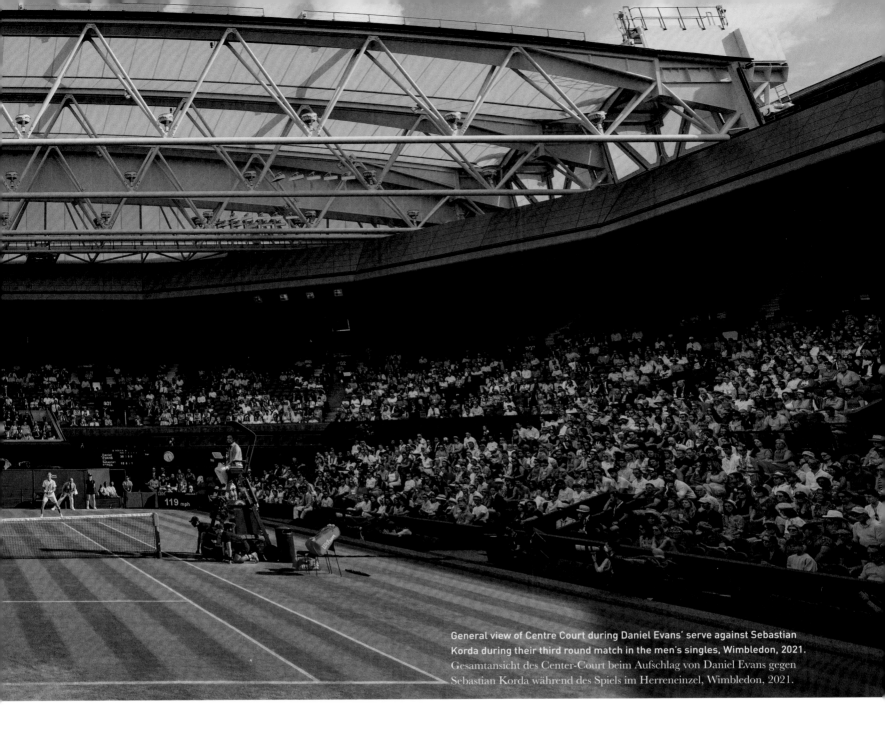

General view of Centre Court during Daniel Evans' serve against Sebastian Korda during their third round match in the men's singles, Wimbledon, 2021. Gesamtansicht des Center-Court beim Aufschlag von Daniel Evans gegen Sebastian Korda während des Spiels im Herreneinzel, Wimbledon, 2021.

Today, Wimbledon is a major event that skillfully combines tradition and modernity – virtually a specialty of Great Britain, which for decades has combined royal stiffness with dynamic entrepreneurship. And so, since 2019, Centre Court has had a sliding roof that can be closed when it rains. The stars play in the dry, and the 15,000 spectators and royals don't get wet either.

Record winner / **Rekordsieger**
Roger Federer, 8 titles / Titel
Martina Navratilova, 9 titles / Titel

mit kleinen Gesangseinlagen überbrückt, und als Snack gibt es Erdbeeren mit Sahne.

Heute ist Wimbledon ein Großereignis, das Tradition und Moderne gekonnt verbindet – geradezu eine Spezialität Großbritanniens, das seit Jahrzehnten royale Steifheit mit dynamischem Unternehmertum verknüpft. Und so hat der Center-Court seit 2019 ein Schiebedach, das bei Regen geschlossen werden kann. Die Stars spielen im Trockenen, und auch die 15.000 Zuschauer sowie die Royals werden nicht nass.

Loud & Lively: the US Open

Laut & lebhaft: die US Open

Almost as old as Wimbledon: the tournament has been around since 1881, when it was still called the U.S. National Championship, and has been held without interruption until today – amazingly, it was the only major tennis tournament to do so, even during the two world wars and the COVID pandemic. It did not become an open championship until 1968, and Flushing Meadows has been the venue since 1978. In the early decades, the Challenger principle applied to both the men's and women's tournaments: the previous year's winner was automatically seeded as a finalist, and the competition had to play for the other place in the final. The US Open in 1970 was the first Grand Slam tournament to introduce the tie-break to prevent marathon matches.

The tournament is also called Flushing Meadows, after the park in the New York borough of Queens where the tennis arenas are located. It is considered the loudest and liveliest of the four major tournaments, largely because of the passionate New York crowds. When the Centre Court, named for Arthur Ashe, and its 20,000 seats are covered because of rain, the noise swells especially. "I couldn't even hear myself hitting my own ball," Rafael Nadal complained in 2017. "With the roof closed, it's definitely the loudest tennis court in the world," U.S. player Madison Keys also declared. "I don't think it's that bad," says Roger Federer, on the other hand. "It's actually quite cool. A great atmosphere!"

Fast so alt wie Wimbledon: Seit 1881 gibt es das Turnier, das damals noch U.S. National Championship hieß und bis heute ununterbrochen stattfand – als einziges großes Tennisturnier erstaunlicherweise auch während der beiden Weltkriege und der COVID-Pandemie. Zur offenen Meisterschaft wurde es erst im Jahr 1968, und seit 1978 ist Flushing Meadows der Spielort. In den ersten Jahrzehnten galt bei den Damen und Herren das Challenger-Prinzip: Der Vorjahressieger war automatisch als Finalist gesetzt, und die Konkurrenz musste um den weiteren Finalplatz spielen. Als erstes Grand-Slam-Turnier wurde bei der US Open 1970 der Tie-Break eingeführt, um Marathon-Matches zu verhindern.

Das Turnier wird auch Flushing Meadows genannt, nach dem Park im New Yorker Stadtteil Queens, in dem die Tennisarenen liegen. Es gilt als lautestes und lebhaftestes der vier großen Turniere, was vor allem an den leidenschaftlichen New Yorker Zuschauern liegt. Wenn der Center-Court, benannt nach Arthur Ashe, mit seinen 20.000 Sitzplätzen wegen Regen überdacht wird, schwillt der Lärm besonders stark an. »Ich konnte nicht einmal hören, wie ich meinen eigenen Ball traf«, beklagte sich Rafael Nadal 2017. »Bei geschlossenem Dach ist es definitiv der lauteste Tennisplatz der Welt«, erklärt auch die US-Amerikanerin Madison Keys. »Ich finde es gar nicht so schlimm«, sagt dagegen Roger Federer. »Es ist sogar ganz cool. Eine tolle Atmosphäre!«

Record winners / Rekordsieger:
Jimmy Connors, Pete Sampras,
Roger Federer, 5 titles / Titel
Chris Evert, Serena Williams, 6 titles / Titel

→ Actors Brad Pitt and
Bradley Cooper watch the
men's singles final between
Russia's Daniil Medvedev
and Novak Djokovic, 2021,
Billie Jean King National
Tennis Center.
Die Schauspieler Brad
Pitt und Bradley Cooper
verfolgen das Endspiel im
Herreneinzel zwischen dem
Russen Daniil Medwedew
und Novak Djokovic, 2021,
Billie Jean King National
Tennis Center.

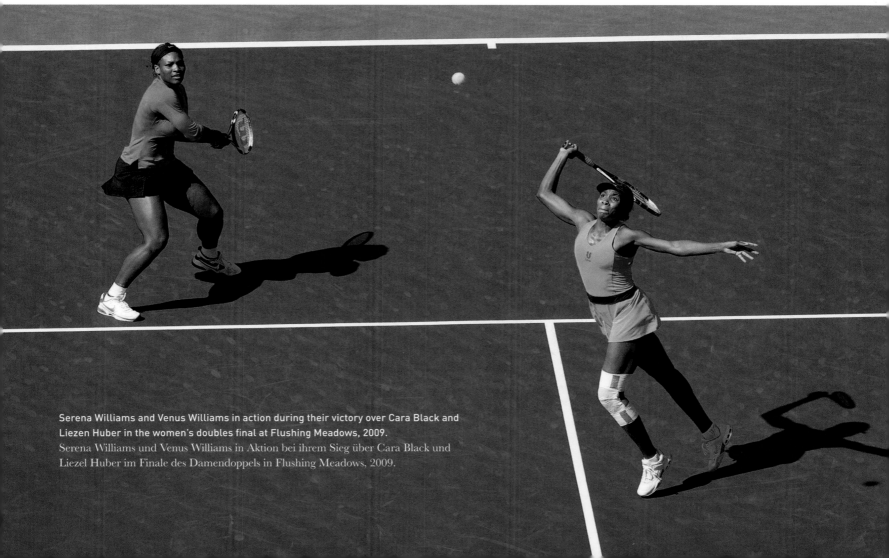

Serena Williams and Venus Williams in action during their victory over Cara Black and
Liezen Huber in the women's doubles final at Flushing Meadows, 2009.
Serena Williams und Venus Williams in Aktion bei ihrem Sieg über Cara Black und
Liezel Huber im Finale des Damendoppels in Flushing Meadows, 2009.

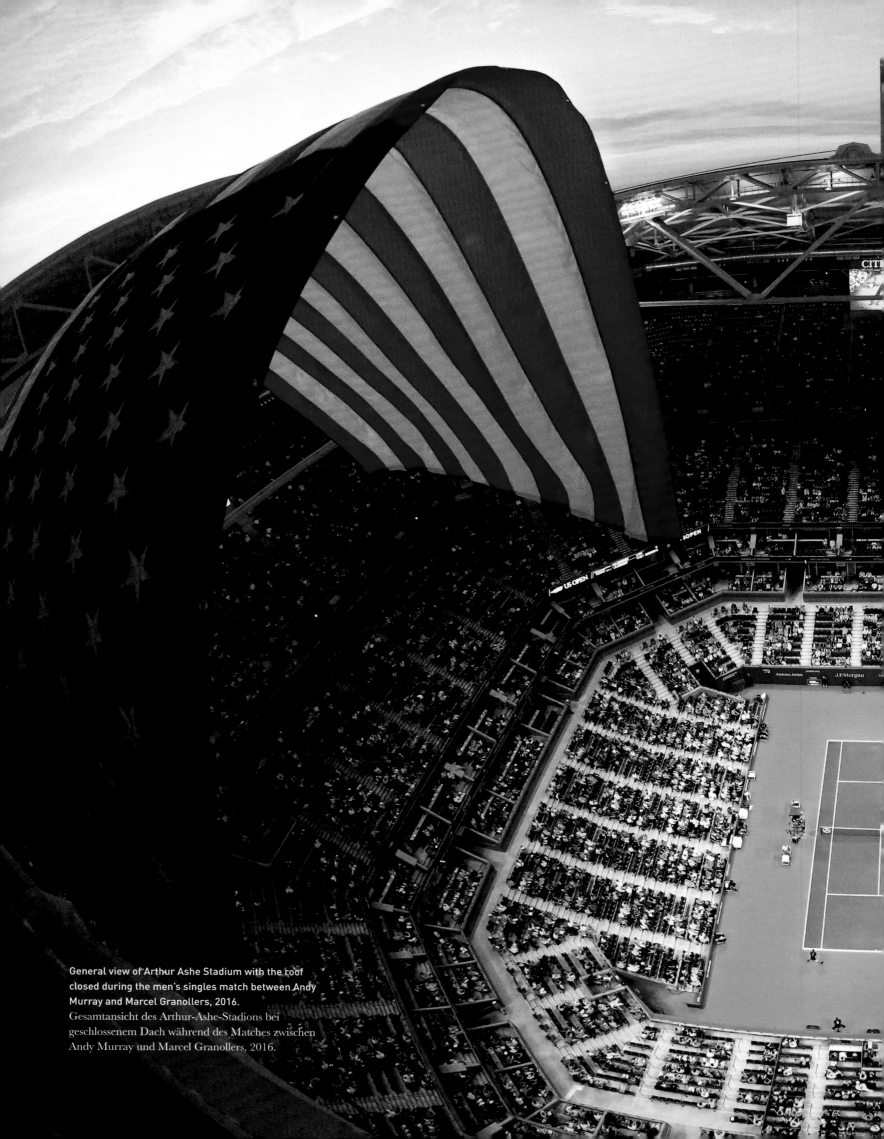

General view of Arthur Ashe Stadium with the roof
closed during the men's singles match between Andy
Murray and Marcel Granollers, 2016.
Gesamtansicht des Arthur-Ashe-Stadions bei
geschlossenem Dach während des Matches zwischen
Andy Murray und Marcel Granollers, 2016.

The Golden Era of the 1920s:
When Tennis Came of Age

. .

Die Goldene Ära der 1920er:
Als Tennis erwachsen wurde

The terrible war with its millions of casualties was finally over, the economy was picking up almost everywhere, and people wanted to read heroic stories other than those from the horrific trench warfare at Verdun. And unlike so many team sports and even some individual sports, in tennis it was the constant head-to-head duels that wrote great stories of their own accord – of those brave ones who never gave up, of those rebellious players who refused to bend to the usual rules, of those tragic figures who were always denied the great triumph and yet kept on trying.

With Suzanne Lenglen and Helen Wills on the ladies' side and Bill Tilden, Henri Cochet and René Lacoste on the men's side, a royal family emerged – real superstars about whom extensive articles were written. And people flocked to their matches: the organizers of English championships had to build a new arena in 1922, whose Centre Court could seat 14,000 spectators, and in 1925 a stadium for 14,000 spectators was also opened for the American championships. Tennis was also booming in France, especially after the "Four Musketeers" Jean Borotra, Jacques Brugnon, Henri Cochet and René Lacoste won the Davis Cup in 1928, and the French Open moved to the Stade Roland Garros, named after a World War II aviation hero. More than 10,000 fans could watch their idols there.

Der furchtbare Krieg mit seinen Millionen Opfern war endlich vorbei, die Wirtschaft zog nahezu überall an, und die Menschen wollten andere Heldengeschichten lesen als jene aus den entsetzlichen Grabenkämpfen von Verdun. Und im Gegensatz zu so vielen Mannschafts- und auch manchen Einzelsportarten waren es beim Tennis die ständigen direkten Duelle, die wie von selbst große Geschichten schrieben – von jenen Tapferen, die nie aufgaben, von jenen rebellischen Spielerinnen, die sich nicht den üblichen Regeln beugen wollten, von jenen tragischen Gestalten, denen der große Triumph stets verwehrt blieb und die es dennoch immer weiter versuchten.

Mit Suzanne Lenglen und Helen Wills bei den Damen und mit Bill Tilden, Henri Cochet und René Lacoste bei den Herren bildete sich eine royale Familie heraus – echte Superstars, über die ausführliche Artikel geschrieben wurden. Und die Menschen strömten zu ihren Matches herbei: Die Veranstalter englischer Meisterschaften mussten 1922 ein neues Areal errichten, dessen Center-Court 14.000 Zuschauern Platz bot, und 1925 wurde für die amerikanischen Meisterschaften ebenfalls ein Stadion für 14.000 Zuschauer

Suzanne Lenglen training for her first American professional appearance, New York, 1926.
Suzanne Lenglen beim Training für ihren ersten amerikanischen Profi-Auftritt, New York, 1926. Ihr Erfolg ist der Beginn eines Tennisbooms in Deutschland.

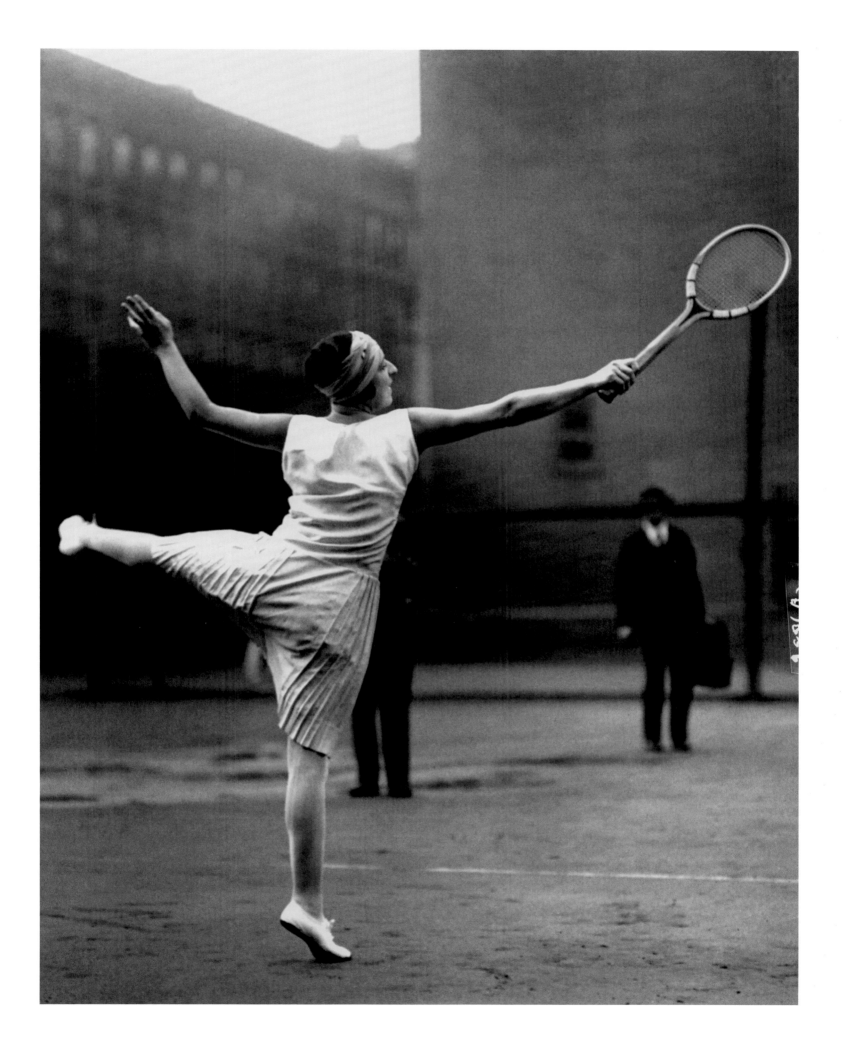

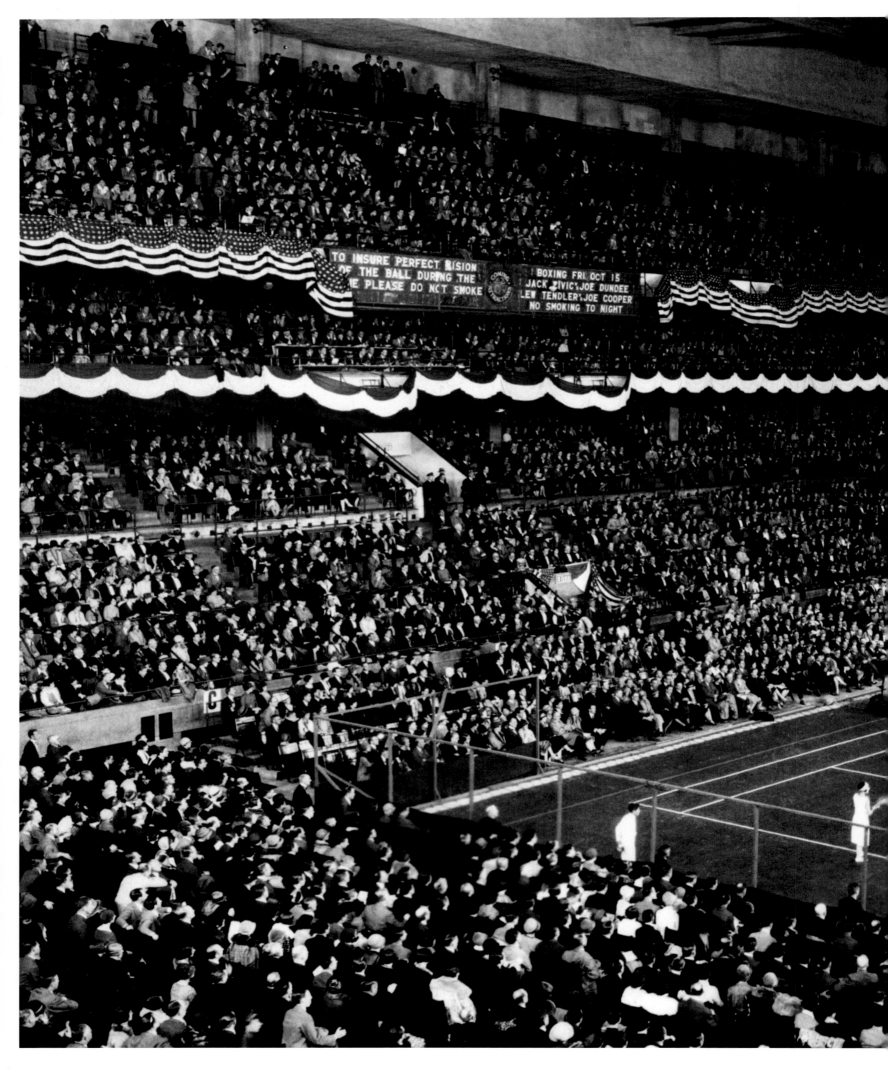

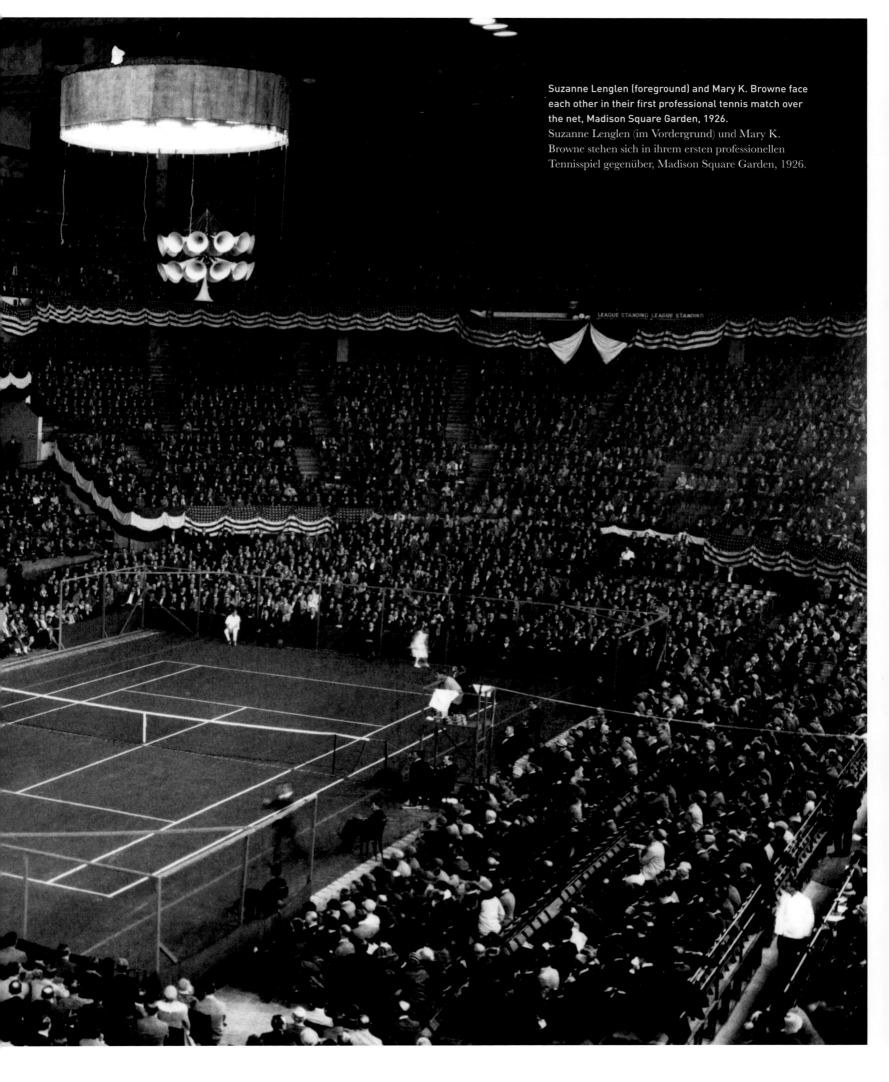

Suzanne Lenglen (foreground) and Mary K. Browne face each other in their first professional tennis match over the net, Madison Square Garden, 1926.
Suzanne Lenglen (im Vordergrund) und Mary K. Browne stehen sich in ihrem ersten professionellen Tennisspiel gegenüber, Madison Square Garden, 1926.

Sports manager Charles Pyle had a very special idea to make tennis even more famous: he hired Suzanne Lenglen, Mary Kendall Browne, Vinnie Richards and several other top players in 1926 for a promotional tournament series across the United States. The success was enormous, with 13,000 spectators cheering at Madison Square Garden. Lenglen alone reportedly earned $75,000 from the tour, which was problematic since amateur statutes still applied to major championships.

The Golden Era of the 1920s thus ensured professionalization, but also the rise of a former noble pastime to one of the most popular sports in the world.

eröffnet. Auch in Frankreich boomte Tennis, besonders nach dem Davis-Cup-Gewinn der »Vier Musketiere« Jean Borotra, Jacques Brugnon, Henri Cochet und René Lacoste im Jahr 1928. Die French Open zog ins Stade Roland Garros um, benannt nach einem Fliegerhelden aus dem Weltkrieg. Mehr als 10.000 Fans konnten hier ihre Idole sehen.

Der Sportmanager Charles Pyle hatte eine ganz besondere Idee, Tennis noch berühmter zu machen: Er engagierte Suzanne Lenglen, Mary Kendall Browne, Vinnie Richards und einige andere Spitzenspieler im Jahr 1926 für eine Promo-Turnierserie quer durch die Vereinigten Staaten. Der Erfolg war enorm, im Madison Square Garden jubelten 13.000 Zuschauer. Allein Lenglen soll an der Tournee 75.000 Dollar verdient haben, was problematisch war, galten doch bei den großen Meisterschaften immer noch die Amateur-Statuten.

Die Goldene Ära der 1920er-Jahre sorgte damit für eine Professionalisierung, aber auch für den Aufstieg eines einstigen noblen Zeitvertreibs zu einer der beliebtesten Sportarten weltweit.

The photo from the 1930s shows the French tennis players Jacques Brugnon, Henri Cochet, René Lacoste and Jean Borotra (from left to right). The four Musketeers won the Davis Cup six times between 1927 and 1932.
Das Foto aus den 1930er Jahren zeigt die französischen Tennisspieler Jacques Brugnon, Henri Cochet, René Lacoste und Jean Borotra (von links nach rechts). Die vier Musketiere gewannen zwischen 1927 und 1932 sechs Mal den Davis Cup.

Prize Money and Ranking Points

..

Von Preisgeldern und Ranglistenpunkten

Tennis has a problem: How can the sport be kept exciting beyond the four Grand Slam tournaments? Superstars could make it easy for themselves and play only those major tournaments that guarantee them particularly high prize money and a place in the history books.

But those responsible persons counter this – among other things with high victory bonuses even beyond the four big tournaments. In men's tennis, there is the enormously lucrative ATP Finals (formerly: Masters), a year-end world championship that has been held in Turin,

Tennis hat ein Problem: Wie kann der Sport auch jenseits der vier Grand-Slam-Turniere spannend gehalten werden? Superstars könnten es sich ja leicht machen und nur jene großen Turniere spielen, die ihnen besonders viel Preisgeld und einen Platz in den Geschichtsbüchern garantieren.

Doch die Verantwortlichen halten dagegen – unter anderem mit hohen Siegprämien auch jenseits der vier großen Turniere. Im Herrentennis gibt es die enorm lukrativen ATP Finals (früher: Masters), eine Jahresend-Weltmeisterschaft, die seit 2017 im

Taylor Fritz, Felix Auger-Aliassime, Casper Ruud,
Rafael Nadal, Stefanos Tsitsipas, Daniil Medvedev,
Andrey Rublev and Novak Djokovic (left to right)
pose for the official photo before the Nitto ATP
Finals, Turin, 2022.
Taylor Fritz, Felix Auger-Aliassime, Casper Ruud,
Rafael Nadal, Stefanos Tsitsipas, Daniil Medvedev,
Andrey Rublev und Novak Djokovic (von links nach
rechts) posieren für das offizielle Foto anlässlich der
Nitto ATP Finals, Turin, 2022.

Italy, since 2017. There, the top eight players in the world rankings compete, usually initially in two groups of four against each other. The semi-finalists are determined from the top two in each group. Below that are the ATP Tour Masters 1000 tournaments (named after the 1000 points awarded to the winner in the world rankings); this elite group includes the traditional clay-court tournaments in Monte Carlo, Madrid and Rome. These are followed by the ATP Tour 500 and the ATP Tour 250 with correspondingly lower prize money. The more dates the world's top players play, the greater are their chances of really cashing in at the end of the year.

Similarly, the women's tournaments at the end of the year are the WTA Finals, the WTA 1000, the WTA 500 and the WTA 250, with the prize money and ranking points graded accordingly.

italienischen Turin ausgetragen wird. Dort treten die besten acht Spieler der Weltrangliste an, üblicherweise zunächst in zwei Vierergruppen gegeneinander. Aus den beiden Gruppenbesten werden die Halbfinalisten ermittelt. Darunter rangieren die Turniere der ATP Tour Masters 1000 (benannt nach den 1000 Punkten, die es für den Sieger in der Weltrangliste gibt); zu diesem elitären Kreis gehören etwa die traditionsreichen Sandplatzturniere von Monte Carlo, Madrid und Rom. Es folgen die ATP Tour 500 sowie die ATP Tour 250 mit entsprechend geringerem Preisgeld. Je mehr Termine die Weltklassespieler wahrnehmen, desto größer ist ihre Chance, am Ende des Jahres noch einmal richtig abzukassieren.

Analog gibt es bei den Damen zum Jahresende die WTA Finals, die WTA 1000-, die WTA 500- und die WTA 250-Turniere mit entsprechenden Abstufungen in Preisgeldern und Ranglistenpunkten.

133

ABOVE THE CLOUDS, IN THE WIND, UNDER WATER

ÜBER DEN WOLKEN, IM WIND, UNTER WASSER

The Most Unusual Places in the World.

Die ungewöhnlichsten Plätze der Welt.

THE ULTIMATE BOOK

At Singita Safari Lodge on the edge of the Serengeti National Park, guests don't have to go on a safari tour to see exotic animals. The lodge is situated on top of Sasakwa Hill and offers a great view of the Serengeti.

In der Singita Safari Lodge am Rande des Serengeti-Nationalparks müssen die Gäste nicht unbedingt auf Safari-Tour gehen, um exotische Tiere zu sehen. Die Lodge liegt auf der Anhöhe des Sasakwa Hill und bietet einen wunderbaren Blick auf die Serengeti.

Of course, it was a provocation, especially in Catholic Italy – but the church had already been desecrated, after all, so it was no longer used for religious services. And so the U.S. artist Asad Raza was able to open a tennis court in the church of San Paolo Converso, built in the 16th century in the center of Milan; only as part of an art exhibition, but still. Raza finds the back-and-forth of the ball to be a meditative, almost religious experience all of its own; besides, he himself is an avid tennis player.

Natürlich war es eine Provokation, gerade im katholischen Italien – aber die Kirche war immerhin schon entweiht, wurde also nicht mehr für Gottesdienste genutzt. Und so konnte der US-amerikanische Künstler Asad Raza in der Kirche San Paolo Converso, im 16. Jahrhundert im Zentrum von Mailanderbaut, einen Tennis-platz eröffnen; zwar nur im Rahmen einer Kunstausstellung, aber immerhin. Raza findet, das Hin und Her des Balles sei eine ganz eigene, meditative, fast religiöse Erfahrung; außerdem ist er selbst begeisterter Tennisspieler.

People play tennis on the US artist Asad Raza's new piece of art, a tennis court, called "Untitled (Plot for Dialogue)", inside the San Paolo Converso church, in Milan.
Ein Tennis-Match auf dem Kunstwerk des US-Künstlers Asad Raza, einem Tennisplatz mit dem Titel »Untitled (Plot for Dialogue)«, im Inneren der Kirche San Paolo Converso, Mailand.

Tennis courts are standardized in size and should be protected from wind and weather as much as possible – quite the opposite of golf courses which like to be located on spectacular, windswept cliffs or other dramatic-looking locations.

Tennis courts, meanwhile, want as little exposure to nature as possible. Almost all the courts in the world, therefore, if they are not enclosed by a hall anyway, are located in rather boring, unromantic areas. But there are notable exceptions. If you want to play tennis in Positano on Italy's Amalfi Coast, you have to climb hundreds of steps down the steep coast to the artificial turf court. In Scotland, the court at Bunabhainneadar on the island of Harris, part of the Outer

Tennisplätze sind in ihrer Größe genormt und sollen möglichst nicht Wind und Wetter ausgesetzt sein – ganz im Gegensatz zu Golfplätzen, die sich gern auf spektakulären, windgepeitschten Klippen oder an sonstigen dramatisch wirkenden Orten befinden.

Tennisplätze wollen derweil so wenig Natureinfluss wie möglich. Fast alle Plätze dieser Welt liegen daher, wenn sie nicht ohnehin von einer Halle umschlossen sind, in eher langweiligen, unromantischen Gegenden. Aber es gibt bemerkenswerte Ausnahmen. Wer in Positano an der italienischen Amalfiküste Tennis spielen will, muss über hunderte Stufen die Steilküste hinabsteigen bis zum Kunstrasenplatz. In Schottland zählt der Court von Bunabhainneadar auf der

← The tennis court overlooking the Mediterranean Sea, south of Naples, is located in a rocky gorge and belongs to the five-star hotel "Il San Pietro di Positano".
Der Tennisplatz mit Blick auf das Mittelmeer, südlich von Neapel, befindet sich in einer Felsschlucht und gehört zum Fünf-Sterne-Hotel »Il San Pietro di Positano«.

↑ Bunabhainneadar Tennis Court is the most remote tennis court in the British Isles. It is located on the road to Husinish, on the island of Harris. Der Bunabhainneadar Tennisplatz ist der abgelegenste Tennisplatz auf den britischen Inseln. Er befindet sich an der Straße nach Husinish, auf der Insel Harris.

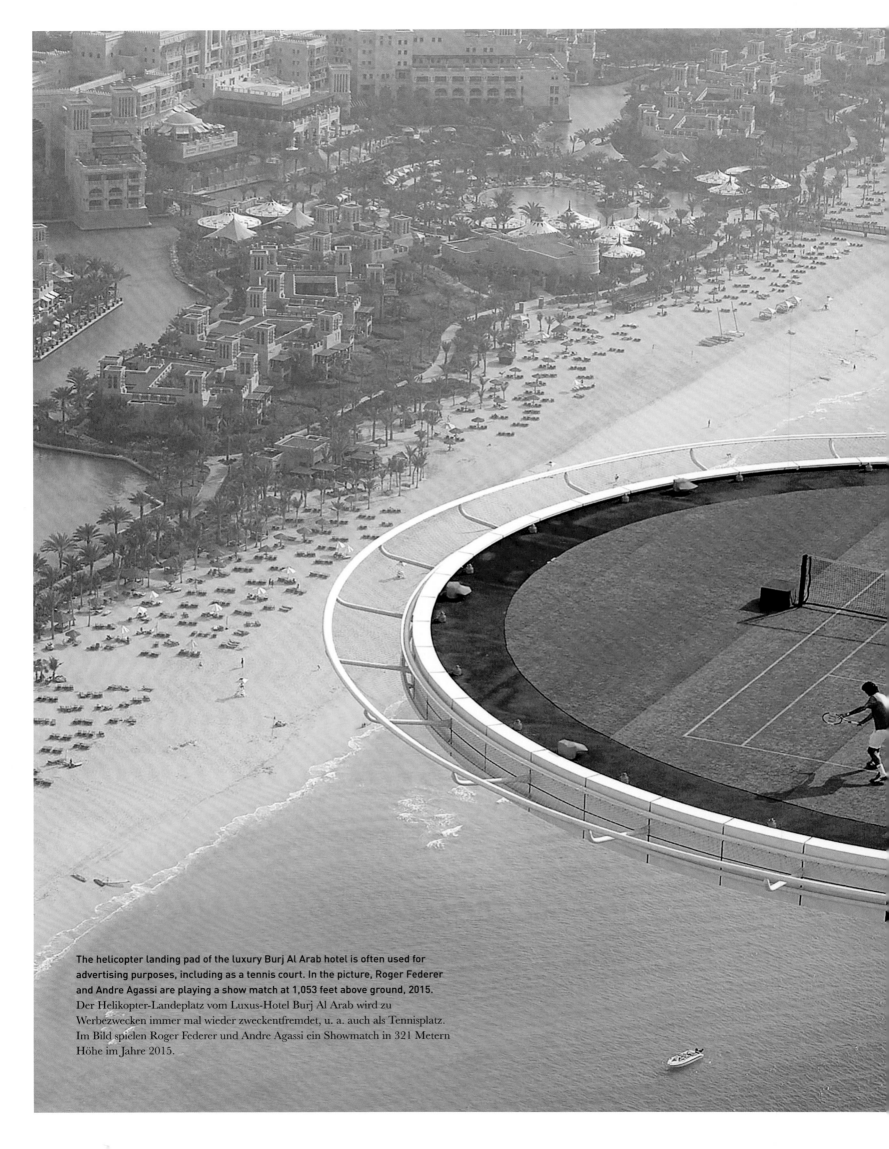

The helicopter landing pad of the luxury Burj Al Arab hotel is often used for advertising purposes, including as a tennis court. In the picture, Roger Federer and Andre Agassi are playing a show match at 1,053 feet above ground, 2015.
Der Helikopter-Landeplatz vom Luxus-Hotel Burj Al Arab wird zu Werbezwecken immer mal wieder zweckentfremdet, u. a. auch als Tennisplatz. Im Bild spielen Roger Federer und Andre Agassi ein Showmatch in 321 Metern Höhe im Jahre 2015.

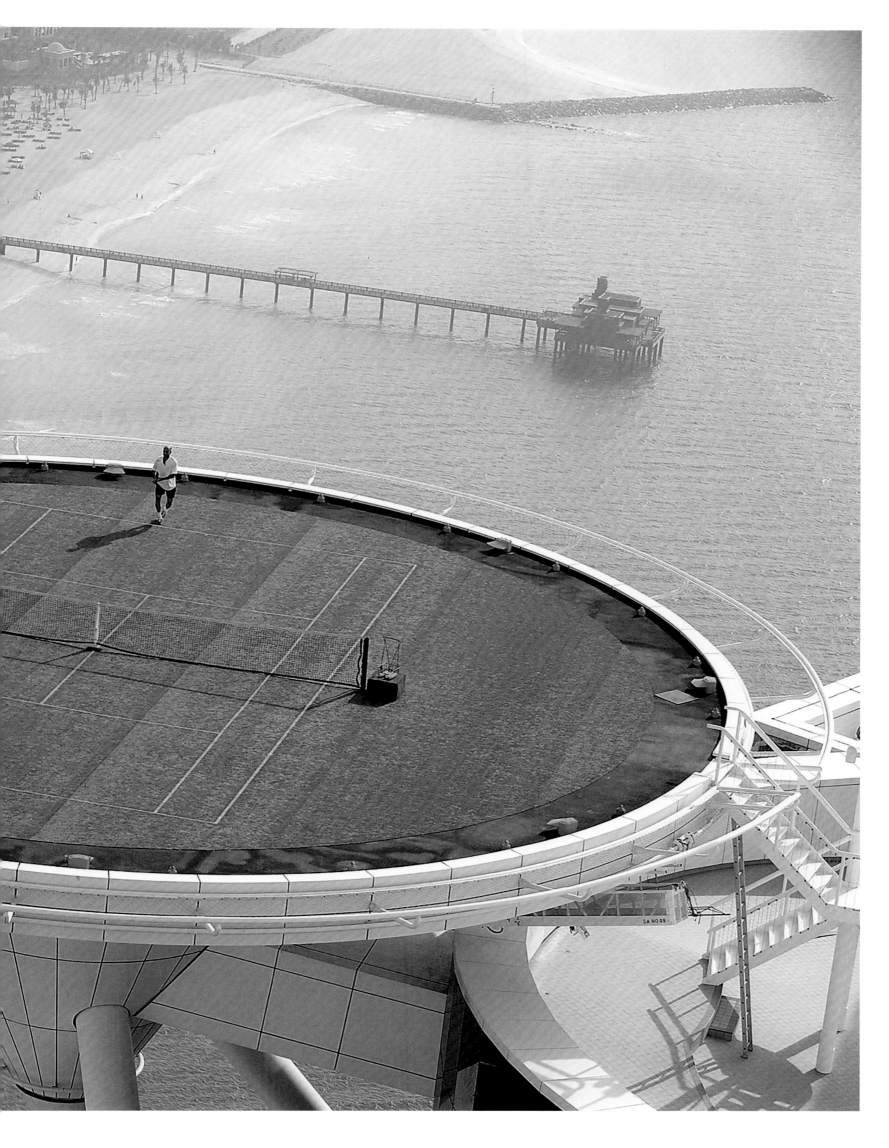

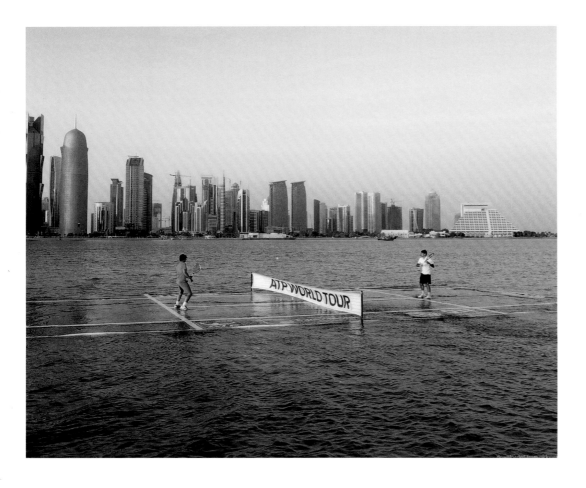

← Roger Federer plays against Rafael Nadal but not on clay, grass or hard court – instead the tennis court is a raft on the water, Doha Bay in Qatar, 2011.
Roger Federer spielt gegen Rafael Nadal, aber nicht auf Sand, Rasen oder Hartplatz – der Tennisplatz ist ein Floß auf dem Wasser, Bucht von Doha in Katar, 2011.

↓ Aerial view of a mariachi band during an exhibition tennis match between Dominic Thiem and Alexander Zverev in the forum of the Hotel "Sinfonia del Mar" before they play the Mexico ATP 500 Tennis Open, Acapulco, 2018.
Luftaufnahme einer Mariachi-Band während eines Showmatches zwischen Dominic Thiem und Alexander Zverev vor dem Hotel »Sinfonia del Mar«, bevor beide bei den Mexico ATP 500 Tennis Open spielen, Acapulco, 2018.

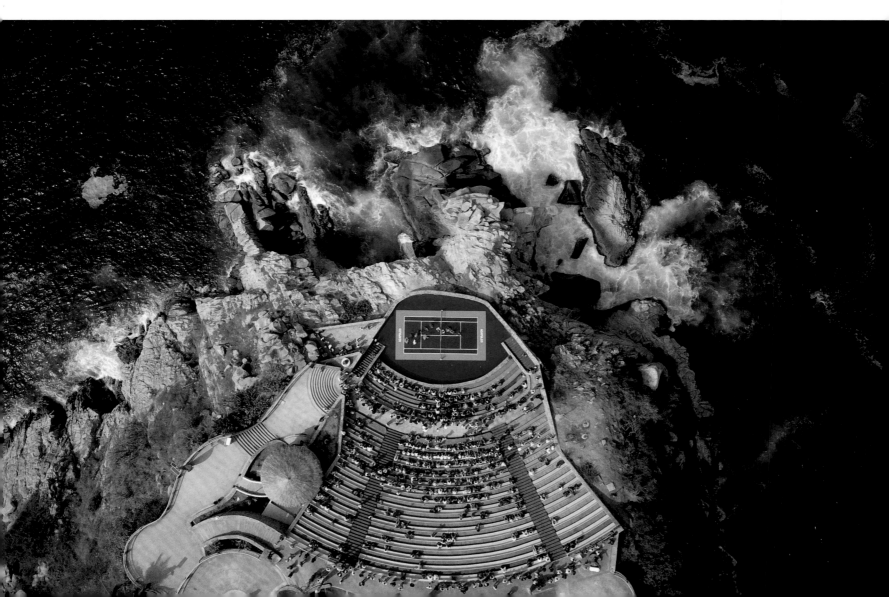

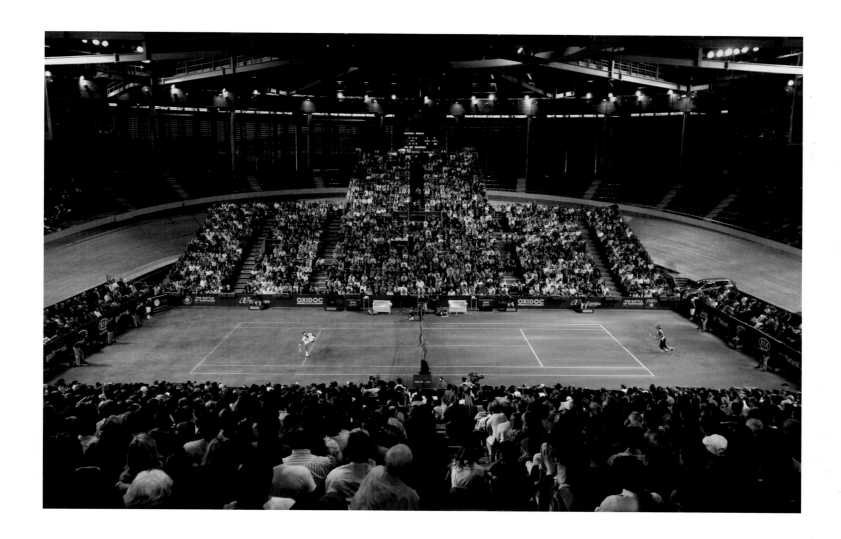

Hebrides, is one of the most remote in Europe. Nevertheless, it is exceptionally popular; interested parties should book early. There are also tennis courts in New York's Grand Central Station, on the roof of the Holiday Inn in Singapore, or in the middle of Tanzania's savannah.

And then there are courts that are only built for shows, such as the floating tennis court below the Perito Moreno glacier in Argentina, on which – financed by the country's tourism association – Rafael Nadal and Novak Djokovic once hit a few balls.

Insel Harris, die zu den Äußeren Hebriden gehört, zu den abgelegensten Plätzen Europas. Dennoch ist er außergewöhnlich beliebt; Interessenten sollten frühzeitig buchen. Es gibt außerdem Tennisplätze in der New Yorker Grand Central Station, auf dem Dach des Holiday Inn in Singapur oder mitten in der Savanne Tansanias.

Und dann existieren Plätze, die nur für Shows errichtet werden, etwa der schwimmende Tennisplatz unterhalb des Perito-Moreno-Gletschers in Argentinien, auf dem – finanziert vom Tourismusverband des Landes – Rafael Nadal und Novak Djokovic einmal ein paar Bälle schlugen.

↑ In what is probably the craziest match in tennis history, the "Battle of Surfaces", not only did the two top stars of tennis face each other, it was also a match of grass against clay, Palma de Mallorca, 2007.
Beim wohl verrücktesten Match im Tennis, dem »Battle of Surfaces« (»Schlacht der Beläge«) standen sich nicht nur die zwei Top-Stars des Tennis gegenüber, es war auch das Match Rasen gegen Sand, Palma de Mallorca, 2007.

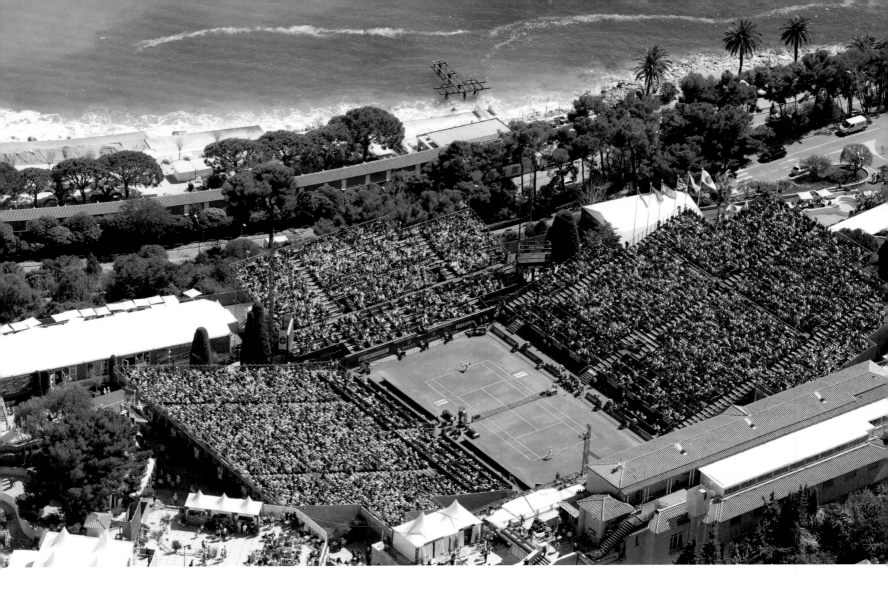

Or the two-surface court at the Palma Arena in Palma de Mallorca, where Rafael Nadal, a son of Palma, and Roger Federer played a curious match in 2007: Federer's half consisted of his favorite surface, grass, while Nadal was allowed to compete on his preferred terrain, clay. The work to prepare the court took three weeks. Nadal won the match very narrowly in three sets.

As always, Dubai takes it to the extreme: the emirate has the world's most breathtaking tennis court at 1,148 feet above the Burj al Arab hotel, which is used for all kinds of promotions and advertising shots. An underwater tennis stadium is also planned in Dubai, at an estimated cost of $3.5 billion. So far, however, it has remained a matter of planning.

Oder den Zwei-Belag-Court in der Palma Arena in Palma de Mallorca, auf dem Rafael Nadal, ein Sohn Palmas, und Roger Federer 2007 ein kurioses Match austrugen: Federers Hälfte bestand aus seinem Lieblingsbelag, Gras, Nadal durfte auf seinem bevorzugten Terrain, Sand, antreten. Drei Wochen dauerten die Arbeiten, um den Platz herzurichten. Nadal gewann das Match ganz knapp in drei Sätzen.

Wie immer treibt es Dubai auf die Spitze: Das Emirat besitzt den atemberaubendsten Tennisplatz der Welt auf 350 Metern oberhalb des Hotels Burj al Arab, der für allerlei Promotionen und Werbeaufnahmen genutzt wird. Auch ein Unterwasser-Tennisstadion ist in Dubai geplant, dessen Kosten auf 3,5 Milliarden Dollar geschätzt werden. Bislang blieb es aber beim Planen.

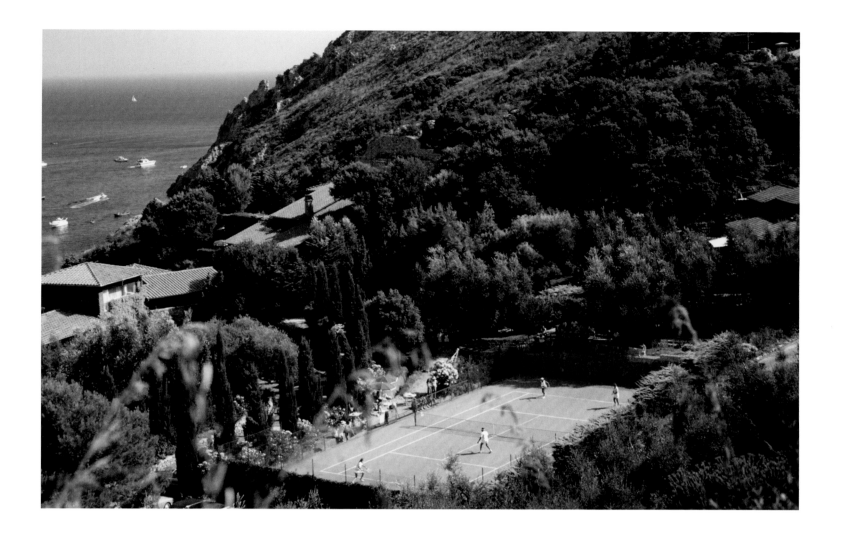

↖ Beautiful views await fans and players on the Centre Court near Monte Carlo, named after Prince Rainier III in 2015 – the proximity to the Côte d'Azur is heavenly.
Schöne Aussichten erwarten Fans und Spieler auf dem 2015 nach Fürst Rainier III. benannten Center-Court bei Monte Carlo – die Nähe zur Côte d'Azur ist himmlisch.

↑ The tennis courts of the Hotel Il Pellicano in Porto Ercole, Tuscany, 1980.
Die Tennisplätze des Hotels Il Pellicano in Porto Ercole, Toskana, 1980.

→↑ In the exclusive Rolling Hills district of Los Angeles, the fifth basement of the villa "Hacienda de la Paz" is home to an indoor court of the highest order.
Im exklusiven Stadtteil Rolling Hills in Los Angeles befindet sich im fünften Kellergeschoss der Villa »Hacienda de la Paz« ein Indoor-Platz der Extraklasse.

→↓ In contrast to the "Hacienda de la Paz", the Jesmond Dene Real Tennis Club is simple and traditional, one of only 27 Real Tennis Courts in the UK and 46 in the world (Australia 5, France 3, USA 11). Built in 1894, the court is 2 to 3 miles north of the centre of Newcastle.
Im Gegensatz zur »Hacienda de la Paz« ist der Jesmond Dene Real Tennis Club einfach und traditionell, einer von nur 27 Real Tennis Courts im Vereinigten Königreich und 46 in der Welt (Australien 5, Frankreich 3, USA 11). Der 1894 erbaute Platz liegt 2 bis 3 Meilen nördlich des Zentrums von Newcastle.

→→↑ An "upper-class amusement arcade", so titled by the *New York Times*, was laid out by John Jacob Astor in 1902, 90 miles north of Manhattan.
Eine »Amüsierhalle der Upper-Class«, so betitelt von der *New York Times*, ließ John Jacob Astor 1902 anlegen, 150 Kilometer nördlich von Manhattan.

→→↓ Tennis de la Cavallerie has been located on the fifth floor of an Art déco building, not far from the Eiffel Tower, since 1924. The special feature of the court is its honeycomb-shaped arched roof, constructed from 1,400 pieces of wood.
»Tennis de la Cavallerie«, liegt seit 1924 im fünften Stock eines Art-déco-Hauses, nicht weit vom Eiffelturm. Das Besondere an dem Court ist sein wabenförmiges Bogendach, das aus 1.400 Holzteilen konstruiert wurde.

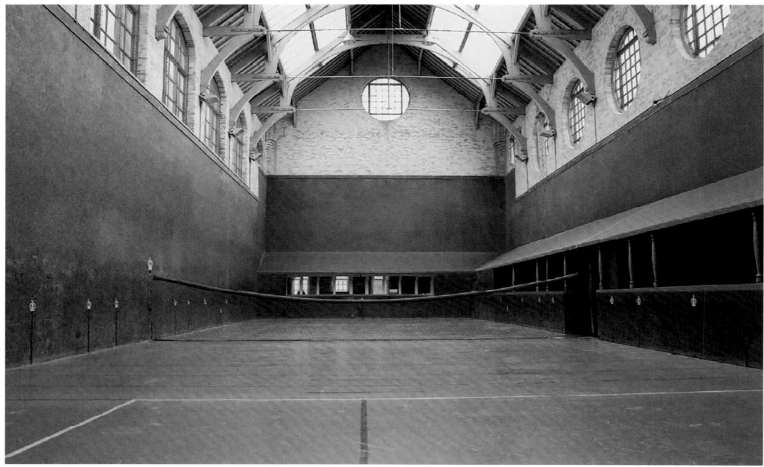

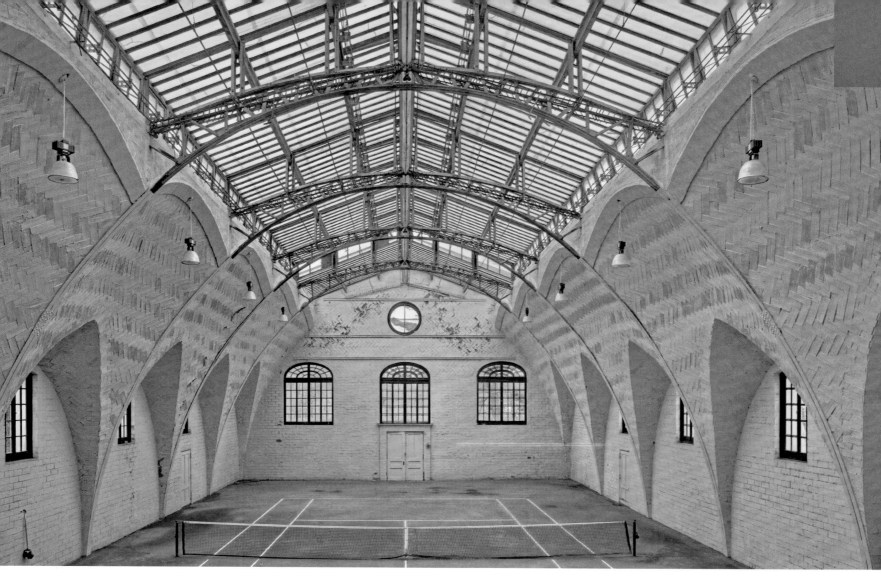

Many visitors are so captivated by the view from the noble hotel "Gstaad Palace" that they come back here every year – Roy Emerson, for example: "This is tennis in paradise", he said about the court.

Viele Besucher zieht der Blick vom Edelhotel »Gstaad Palace« dermaßen in seinen Bann, dass sie jedes Jahr wieder hierher kommen – Roy Emerson zum Beispiel: »Das ist Tennis im Paradies«, sagte er über den Platz.

↖ Amidst flowers, lemon trees and cypresses lies one of the best tennis resorts in the world, the La Quinta Resort & Club in the desert region of Palm Springs. Maria Sharapova and Novak Djokovic have also trained here.
Inmitten von Blumen, Zitronenbäumen und Zypressen liegt eines der besten Tennis-Resorts der Welt, das La Quinta Resort & Club in der Wüstenregion von Palm Springs. Maria Sharapova und Novak Djokovic trainierten auch schon hier.

← Enchantment is the name of the five-star resort in the middle of Arizona. The five tennis courts offer enchanting views of the Red Rock Hills.
Enchantment = Verzauberung, so heißt das Fünf-Sterne-Resorts mitten in Arizona. Die fünf Tenniscourts bieten zauberhafte Ausblicke auf die Red Rock Hills.

↑ The Everglades Tennis Club in the early days, Palm Beach, 1968.
Der Everglades Tennis Club in frühen Jahren, Palm Beach, 1968.

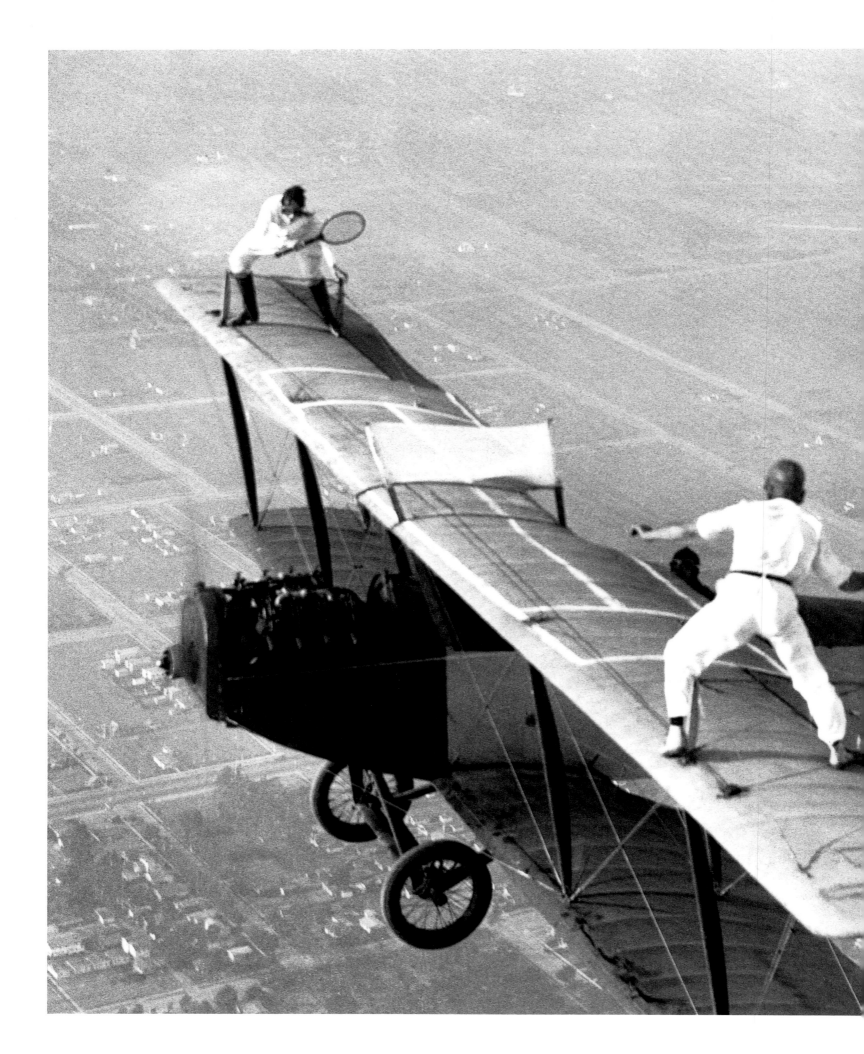

Gladys Roy likes to do unusual things with planes. Ivan Unger (a member of the "Flying Black Hats") is her opponent. The only problem with this game is trying to get a ball back after it has bounced off the wing of the plane and fallen 3,000 thousand feet.

Gladys Roy macht gerne ungewöhnliche Dinge mit Flugzeugen. Ivan Unger (Mitglied der »Flying Black Hats«) ist ihr Gegner. Das einzige Problem bei diesem Spiel ist der Versuch, einen Ball zurückzubekommen, nachdem er von der Tragfläche des Flugzeugs abgeprallt und knapp einen Kilometer tief gefallen ist.

Young, Dynamic, Successful: Tennis Advertising

Jung, dynamisch, erfolgreich: Tenniswerbung

↑ Apart from her sporting achievements, Kurnikova owes her great fame and advertising contracts to her looks and relationship with singer Enrique Iglesias.
Neben ihren sportlichen Leistungen verdankt Kurnikowa ihre große Bekanntheit und die Werbeverträge ihrem Aussehen und der Beziehung mit dem Sänger Enrique Iglesias.

↗ Roger Federer as advertising partner of Mercedes-Benz.
Roger Federer als Werbepartner von Mercedes-Benz.

Tennis is not only considered a dynamic, elegant sport, but was long the preserve of the upper classes. Those who played tennis had money and style – at least in the public perception. All these attributes ensured that tennis was captured by advertising at an early stage. To this day, Roger Federer (including Mercedes-Benz, Nike, Rolex, Credit Suisse, Moët & Chandon) and Rafael Nadal (including Babolat, Kia, Richard Mille, Santander, Amstel Ultra) are among the best-known advertising figures in the sports world. But more exciting is a look at the past, when tennis was much more exclusive and was exploited unrestrainedly for advertising. Alcohol advertising was particularly popular: smart, athletic people in white clothes playing on lush green grass, and on the edge of the court, the well-deserved

Tennis gilt nicht nur als dynamischer, eleganter Sport, sondern war lange der Oberschicht vorbehalten. Wer Tennis spielte, hatte Geld und Stil – jedenfalls in der öffentlichen Wahrnehmung. All diese Attribute sorgten dafür, dass Tennis schon früh von der Werbung vereinnahmt wurde. Bis heute gehören Roger Federer (u. a. Mercedes-Benz, Nike, Rolex, Credit Suisse, Moët & Chandon) und Rafael Nadal (u. a. Babolat, Kia, Richard Mille, Santander, Amstel Ultra) zu den bekanntesten Werbefiguren der Sportwelt. Doch spannender ist ein Blick in die Vergangenheit, als Tennis noch deutlich exklusiver war und hemmungslos für die Reklame ausgenutzt wurde. Besonders beliebt war Alkoholwerbung: Smarte, sportliche Menschen in weißer Kleidung spielen auf sattgrünem Gras, und am Rand des Courts

beer gleams auspiciously golden. Whiskey and gin producers also prefer to help themselves to tennis – sometimes the bottle is draped discreetly in front of a tennis racket, sometimes the good-humored drinking couple stands in front of the house bar still in their tennis outfits.

glänzt verheißungsvoll golden das wohlverdiente Bier. Auch Whisky- und Gin-Produzenten bedienten sich bevorzugt beim Tennis – mal wird die Flasche dezent vor einem Tennisschläger drapiert, mal steht das gutgelaunte Trinker-Pärchen noch im Tennisoutfit vor der Hausbar.

↑ Novak Djokovic advertises for Seiko watches.
Novak Djokovic wirbt für Seiko Uhren.

← The tennis stars are popular advertising partners, gladly also for luxury articles. Earlier advertising for alcoholic beverages or other stimulants was not necessarily compatible with sport.
Die Tennis-Stars sind beliebte Werbe-Partner, gern auch für Luxus-Artikel. Die frühe Werbung für alkoholische Getränke oder andere Genußmittel war nicht unbedingt mit Sport in Einklang zu bringen.

Game, Set & Cut! Tennis on the Big Screen

Game, Set & Cut! Tennis auf der großen Leinwand

Plenty of feature films focus exclusively on tennis, including the well-received 2017 biopic *Borg/McEnroe*, about the years-long rivalry between the two supposedly disparate characters, or *King Richard*, with Will Smith as the father of Venus and Serena Williams, who uses controversial methods to mold two superstars.

But it's much more interesting when tennis is used more subtly, as in Woody Allen's *Annie Hall*, when Diane Keaton helplessly flirts with Woody Allen in the clubhouse after the match and eventually brings him home in her Beetle convertible

Jede Menge Kinofilme beschäftigen sich ausschließlich mit Tennis, darunter die vielbeachtete Biografie *Borg/McEnroe* aus dem Jahr 2017 über die jahrelange Rivalität der beiden vermeintlich so unterschiedlichen Charaktere, oder *King Richard* mit Will Smith als Vater von Venus und Serena Williams, der mit umstrittenen Methoden zwei Superstars formt.

Doch viel interessanter ist es, wenn Tennis subtiler eingesetzt wird, etwa in Woody Allens *Der Stadtneurotiker*, als Diane Keaton Woody Allen nach dem Match im Clubhaus hilflos anflirtet und

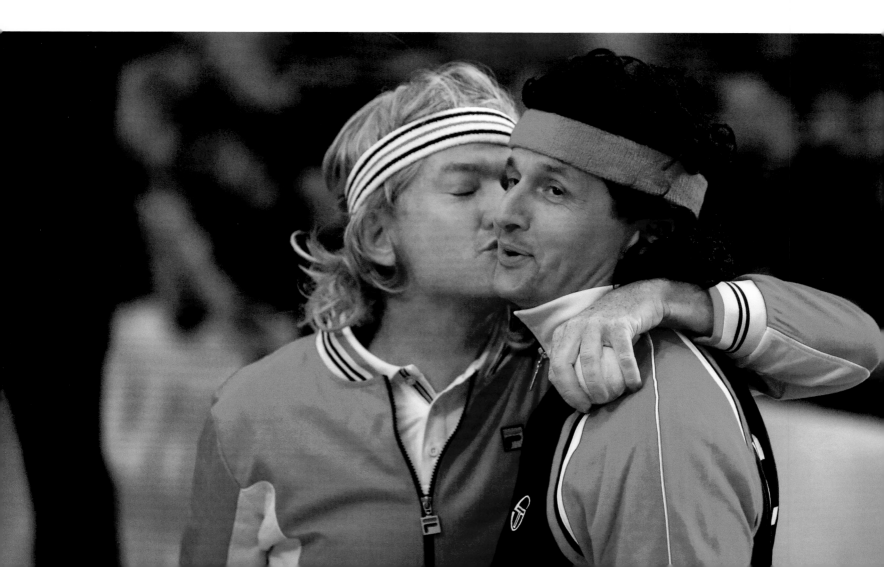

→ Screenshots of the pantomine scene
from the film *Blow Up*.
Screenshots der Pantomine-Szene aus
dem Film *Blow Up*.

↙ Producers Jon Nohrstedt and Fredrik Wikström in
costume for the *Borg/McEnroe* film premiering at the
2017 Toronto International Film Festival.
Die Produzenten Jon Nohrstedt und Fredrik
Wikström im Kostüm für den *Borg/McEnroe*-Film, der
auf dem Toronto International Film Festival 2017
Premiere hatte.

after countless near-misses. Almost three decades later, Allen, who is a self-confessed basketball and baseball fan, filmed *Match Point*: A tennis instructor, played by Jonathan Rhys Meyers, wants to make it in London at any price – also with the help of the unscrupulous American Nola Rice (Scarlett Johansson). Luke Wilson as prodigy Richie in Wes Anderson's *The Royal Tenenbaums* simply breaks off the tennis match in the middle of the US Nationals because "The Baumer" is in love with his adopted sister Margot, played by Gwyneth Paltrow – and she got married the day before.

But arguably no one wove tennis into the plot as elegantly as grand master Michelangelo Antonioni in 1966's *Blow Up*, in which two mimes play an imaginary match in the final sequence: it's four minutes of disturbing, mesmerizing silence.

schließlich in ihrem Käfer Cabrio nach zahllosen Beinahe-Unfällen heimbringt. Fast drei Jahrzehnte später drehte Allen, der bekennender Basketball- und Baseballfan ist, *Match Point*: Ein Tennislehrer, gespielt von Jonathan Rhys Meyers, will in London um jeden Preis den Aufstieg schaffen – auch mit Hilfe der skrupellosen Amerikanerin Nola Rice (Scarlett Johansson). Luke Wilson als Wunderkind Richie in Wes Andersons *Die Royal Tenenbaum* bricht bei den US Nationals das Tennismatch mittendrin einfach ab, weil »The Baumer« in seine Adoptivschwester Margot, gespielt von Gwyneth Paltrow, verliebt ist – und die hat am Tag zuvor geheiratet.

Aber wohl niemand verwob Tennis so elegant mit der Handlung wie Großmeister Michelangelo Antonioni in *Blow Up* von 1966, in der zwei Pantomimen in der Schlusssequenz ein imaginäres Match spielen: Es sind vier Minuten verstörende, faszinierende Stille.

The World Is Round: a Little Ball History

Die Welt ist rund: eine kleine Ballgeschichte

Today, the tennis ball is a mass product: worldwide annual production is estimated at 325 million pieces or 20,000 tons. But once upon a time, production was laborious manual work that only a few specialists could perform. Royal edicts also ensured rigid quality standards: In 1480, Louis XI stipulated that French tennis balls had to be sewn only from good leather and filled with wool – and not with sawdust, earth or sand. The Scots used sheep's or goat's stomach; balls made of putty and human hair have survived from the time of Henry VIII. And in Shakespeare, a gift of tennis balls to Henry V., which the latter takes as an insult, triggers the Hundred Years' War between England and France.

Heute ist der Tennisball eine Massenware: Die weltweite jährliche Produktion wird auf 325 Millionen Stück oder 20.000 Tonnen geschätzt. Doch einst war die Fertigung aufwendige Handarbeit, die nur wenige Spezialisten ausführen konnten. Königliche Edikte sorgten überdies für rigide Qualitätsstandards: Ludwig der Elfte legte im Jahr 1480 fest, dass französische Tennisbälle nur aus gutem Leder genäht und mit Wolle gefüllt sein müssen – und nicht mit Sägespänen, Erde oder Sand. Die Schotten benutzten Schafs- oder Ziegenmagen; aus der Zeit Heinrichs des Achten sind Bälle aus Kitt und menschlichem Haar überliefert. Und bei Shakespeare löst ein Geschenk von Tennisbällen an Heinrich den Fünften, das dieser als Beleidigung auffasst, den Hundertjährigen Krieg zwischen England und Frankreich aus.

Heutzutage ist die Fertigung ein komplizierter, aber automatisierter Prozess: Die Filzschicht besteht aus Schafswolle und Nylon, der hohle Ballkern aus Naturgummi und verschiedenen Chemikalien. Die typische gelblich-grüne Farbe haben die Bälle übrigens seit 1972 (auch wenn theoretisch bei offiziellen Turnieren noch Weiß erlaubt wäre), denn optische Tests hatten damals ergeben, dass die Farbe bei TV-Übertragungen am besten zu sehen ist und auch von den Spielern selbst am besten wahrgenommen wird. Weitere Spezifikationen: Der Durchmesser muss

Today, manufacturing is a complicated but automated process: the felt layer is made of sheep's wool and nylon, and the hollow ball core is made of natural rubber and various chemicals. By the way, the balls have had the typical yellowish-green color since 1972 (even if white would theoretically still be allowed in official tournaments), because optical tests at that time had shown that the color is best seen on TV broadcasts and is also best perceived by the players themselves. Other specifications: the diameter must be between 2.57 and 2.7 inches, and the weight between 1.98 and 2.10 ounces. Dropped from a height of 100 inches, they must bounce between 53 and 58 inches high, provided that the test is carried out at sea level and at a temperature of 68 °F. The specialists of yore could only dream of such precision data.

6,54 und 6,86 Zentimeter betragen, das Gewicht liegt zwischen 56 und 59,4 Gramm. Aus 254 Zentimeter Höhe fallen gelassen, müssen sie zwischen 135 und 147 Zentimeter hoch abspringen, sofern der Test auf Meereshöhe und bei 20 °C Temperatur ausgeführt wird. Von solchen Präzisionsdaten konnten die Spezialisten von einst nur träumen.

↑ Eyes like tennis balls, Dominic Thiem returns the ball to Alexander Zverev during their men's singles quarterfinal match, French Open, 2018.
Augen wie Tennisbälle, Dominic Thiem returniert den Ball zu Alexander Zverev während ihres Herreneinzel-Viertelfinalspiels, French Open, 2018.

← The official ball for the US Open has been provided slightly modified by the Wilson company for 40 years.
Der offizielle Ball für die US Open wird seit 40 Jahren von der Firma Wilson leicht modifiziert zur Verfügung gestellt.

From Wood to Titanium: the History of Rackets

Von Holz zu Titan: die Geschichte der Rackets

The first tennis rackets were simple wooden boards, possibly even without handles. Later, it was easier to play with handles, and the invention of a stringing system is dated to the 14th century – unfortunately, because the materials are so perishable, no really old tennis rackets have survived. The strings of the stringing were made of animal gut, and cow gut stringing is still available today. The rackets themselves changed little until the 20th century, although there were some exotic attempts, such as rackets with trapezoidal instead of teardrop-shaped or round hitting surfaces.

After World War II, manufacturers experimented with laminated rackets using different types of wood, which led to a massive reduction in weight. The first racket made of metal came on the market in 1957. Around the 1980s, glass-fiber-reinforced and carbon-fiber-reinforced plastic began to be used. The new high-tech materials made the racket both light and stiff. This allowed the hitting surface to grow without becoming unwieldy.

Many players still swear by the properties of natural stringing, but gut strings cost 30 euros and more – unaffordable for hobby players in the long run. The commercially available artificial strings are made of nylon and polyester. Modern stringing is a science in itself, and each player prefers his own specifications. Often, for example, the main strings are strung a bit harder than the

Die ersten Tennisschläger waren einfache Holzbretter, möglicherweise sogar ohne Griff. Mit Griffen spielte es sich später dann leichter, und die Erfindung einer Bespannung wird auf das 14. Jahrhundert datiert – weil die Materialien so vergänglich sind, sind leider keine richtig alten Tennisschläger erhalten. Die Saiten der Bespannung bestanden aus Tierdarm, und bis heute sind Bespannungen aus Kuhdarm erhältlich. Die Schläger selbst veränderten sich bis ins 20. Jahrhundert kaum, auch wenn es einige exotische Versuche gab, etwa Schläger mit trapez- statt tropfenförmiger oder runder Schlagfläche.

Nach dem Zweiten Weltkrieg experimentierten die Hersteller mit laminierten Schlägern, bei denen sie verschiedene Holzarten verwendeten, was zu einer massiven Gewichtsreduktion führte. Der erste Schläger aus Metall kam im Jahr 1957 auf den Markt. Etwa ab den 1980er-Jahren wurde glasfaserverstärkter und kohlenstofffaserverstärkter Kunststoff verwendet. Die neuen High-Tech-Materialien machten den Schläger sowohl leicht als auch steif. Damit konnte die Schlagfläche wachsen, ohne unhandlich zu werden.

Viele Spieler schwören auch heute noch auf die Eigenschaften einer Naturbespannung, allerdings kosten Darmsaiten 30 Euro und mehr – für Hobbyspieler auf Dauer unerschwinglich. Die handelsüblichen Kunstsaiten bestehen aus Nylon und Polyester. Die moderne Bespannung ist eine Wissenschaft für sich, und jeder Spieler präferiert

cross strings. In general, the harder the racket is strung, the more ball control the player has, but he pays for it with a less powerful stroke.

The clubs were subjectively selected, compiled and commented by Michael Graf, a passionate collector from Berlin.
Die Schläger wurden subjektiv ausgesucht, zusammengestellt und kommentiert von Michael Graf, einem leidenschaftlichen Sammler aus Berlin.

seine eigenen Spezifikationen. Oft werden beispielsweise die Längssaiten etwas härter bespannt als die Quersaiten. Allgemein gilt: Je härter der Schläger bespannt ist, desto mehr Ballkontrolle hat der Spieler, aber er bezahlt dafür mit einem weniger kräftigen Schlag.

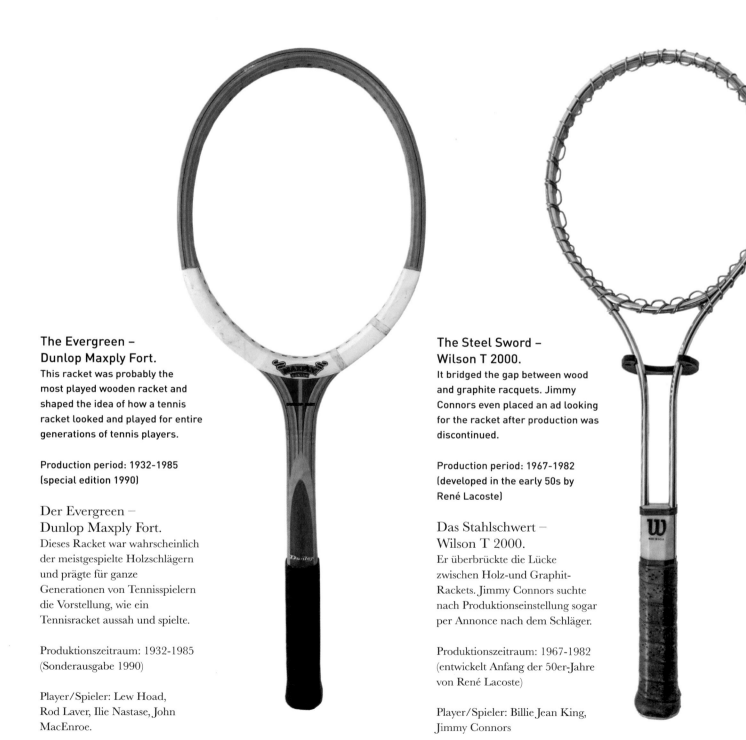

The Evergreen – Dunlop Maxply Fort.
This racket was probably the most played wooden racket and shaped the idea of how a tennis racket looked and played for entire generations of tennis players.

Production period: 1932-1985 (special edition 1990)

Der Evergreen –
Dunlop Maxply Fort.
Dieses Racket war wahrscheinlich der meistgespielte Holzschlägern und prägte für ganze Generationen von Tennisspielern die Vorstellung, wie ein Tennisracket aussah und spielte.

Produktionszeitraum: 1932-1985 (Sonderausgabe 1990)

Player/Spieler: Lew Hoad, Rod Laver, Ilie Nastase, John MacEnroe.

The Steel Sword – Wilson T 2000.
It bridged the gap between wood and graphite racquets. Jimmy Connors even placed an ad looking for the racket after production was discontinued.

Production period: 1967-1982 (developed in the early 50s by René Lacoste)

Das Stahlschwert –
Wilson T 2000.
Er überbrückte die Lücke zwischen Holz-und Graphit-Rackets. Jimmy Connors suchte nach Produktionseinstellung sogar per Annonce nach dem Schläger.

Produktionszeitraum: 1967-1982 (entwickelt Anfang der 50er-Jahre von René Lacoste)

Player/Spieler: Billie Jean King, Jimmy Connors

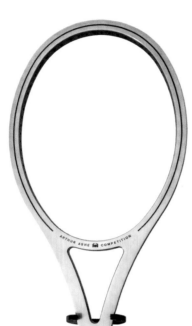

The Elegant – Head Arthur Ashe Competition.
It came on the market in 1969. Developed by Arthur Ashe, it was the first synthetic racket and one of the most elegant in design.

Der Elegante – Head Arthur Ashe Competition.
1969 von Arthur Ashe entwickelt war er der erste Kunststoffschläger und vom Design einer der elegantesten überhaupt.

The Golden Touch – Dunlop Max 200 g.
This racket made of a graphite-nylon mixture replaced the era of wooden rackets.

Production period: 1982-1992

The Golden Touch – Dunlop Max 200 g.
Mit diesem Racket aus einer Graphit-Nylonmischung wurde die Ära der Holzschläger abgelöst.

Produktionszeitraum: 1982-1992

Player/Spieler: Steffie Graf, John McEnroe

The Largest – Prince Original Graphite Oversize (POGOS).
Racquets with larger hitting surface became possible with the advent of plastics in racquet construction.

Production period: since 1980

Der Größte – Prince Original Graphite Oversize (POGOS).
Schläger mit größerer Schlagfläche wurden möglich mit dem Aufkommen von Kunststoffen im Racketbau.

Produktionszeitraum: seit 1980

Player/Spieler: Andre Agassi; Michael Chang, Gene Mayer, Gabriela Sabatini, Monica Seles

The Versatile – Wilson Pro Staff Mid.
This racket was developed especially for Jimmy Connors. The Pro Staff Mid is perhaps the most versatile racket ever made.

Production period: 1984-2000, (2011 Reissue)

Der Vielseitige – Wilson Pro Staff Mid.
Der Schläger wurde insbesondere für Jimmy Connors entwickelt. Er blieb aber bei seinem gewohnten Stahlracket T 2000. Der Pro Staff Mid ist vielleicht der vielseitigste Schläger, der jemals hergestellt wurde

Produktionszeitraum: 1984-2000, (2011 Reissue)

Player/Spieler: Pete Sampras, Stefan Edberg, Jim Courier, Roger Federer, Chris Evert, Mary Pierce, Steffi Graf.

Everybody's Darling – Wilson Pro Staff Classic.
On the market since 1991, the racket is still today, with slight modifications, the frame most used by professional tennis players, especially in men's doubles.

Production period: 1991-today (slightly modified from 1995 in different versions)

Everybody's Darling – Wilson Pro Staff Classic.
Seit 1991 auf dem Markt ist der Racket bis heute, mit leichten Modifizierungen, der von professionellen Tennisspielern am meisten verwendete Rahmen, insbesondere im Herren-Doppel.

Produktionszeitraum: 1991-heute (leicht modifiziert ab 1995 in verschiedenen Versionen)

Player/Spieler: Juan Martin Del Potro, Tim Henman, Daniil Medvedev, Andrej Rublev, Denis Shapovalov, Nicolas Kiefer, Philipp Kohlschreiber.

The Instrument Of The Maestro – Wilson 6.1 tour.
This racket was designed for Roger Federer, who started his professional career with the pro staff 85, in Swiss red and white instead of the traditional matte black.

Das Instrument des Maestro – Wilson 6.1 tour.
Dieser Schläger wurde für Roger Federer entwickelt, der seine Profikarriere mit dem pro staff 85 begonnen hatte, im schweizerischen Rot-Weiß statt des traditionellen Mattschwarzes.

The Controlled One – Head Prestige Classic.
With its stiff frame, it offered the best ball acceleration with very good control. An evolutionary, not a revolutionary racket with eye-catching paint.

Production period: 1989-94 (for professionals until today)

Der Kontrollierte – Head Prestige Classic.
Mit seinem steifen Rahmen bot er beste Ballbeschleunigung bei sehr guter Kontrolle. Ein evolutionärer, kein revolutionärer Schläger mit auffallender Lackierung.

Produktionszeitaum 1989-94 (für Profis bis heute)

Player/Spieler: Marat Safin, Mark Philippoussis, Goran Ivanisevic

The Balanced – Head Pro Tour.
Developed in the early 90s by and for Thomas Muster.

Production period: 1994-present (1994-97 as Pro Tour, from 2001 slightly modified as Prestige Midplus, Reissue 2020 without Twaron)

Der Ausgewogene – Head Pro Tour.
Anfang der 90er-Jahre von und für Thomas Muster entwickelt.

Produktionszeitraum: 1994-heute (1994-97 als Pro Tour, ab 2001 leicht verändert als Prestige Midplus, Reissue 2020 ohne Twaron)

Player/Spieler: Gustavo „Guga" Kuerten, Andy Murray, Tommy Haas, Thomas Enqvist, Robin Söderling, Amelie Mauresmo, Patty Schnyder.

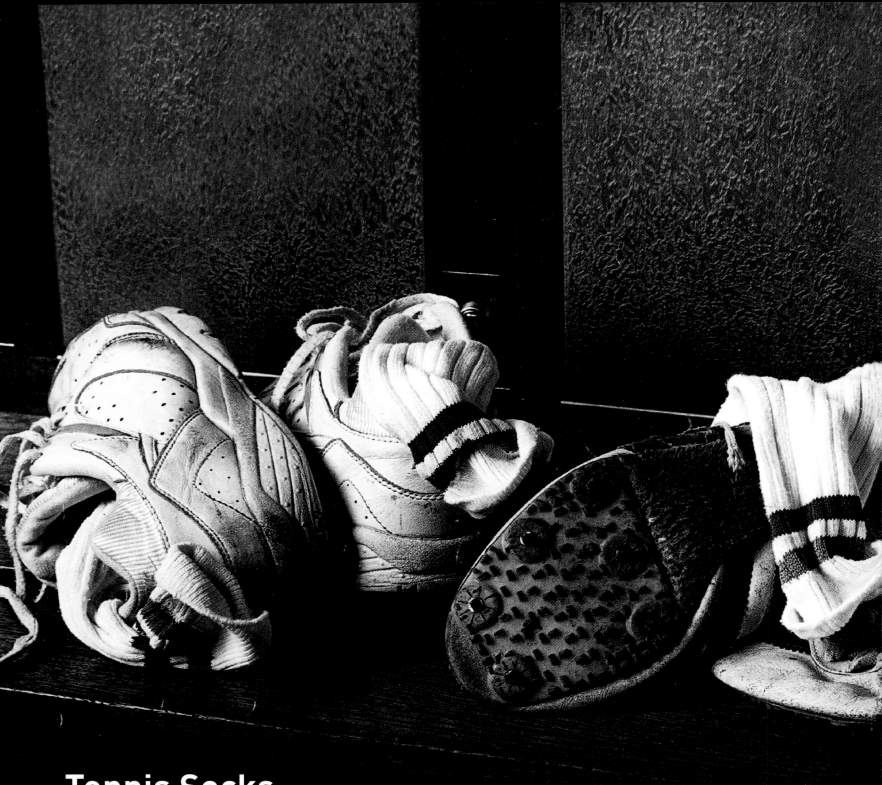

Tennis Socks

· ·

Tennissocken

Once considered cool and sporty, then a major fashion sin for decades, they're now making a comeback: white socks are suddenly making an appearance on runways around the world – even with the infamous sandal.

Sie galten einst als cool und sportlich, dann über Jahrzehnte als große Modesünde, nun kommen sie zurück: Die weißen Socken sind plötzlich auf den Laufstegen dieser Welt zu sehen – sogar mit der berüchtigten Sandale.

Famous in a Different Way

Anders berühmt

Stan Smith won a hard-fought Wimbledon final against Ilie Nastase in 1972, but that's not why the U.S. player's name is world-famous – his equipment supplier at the time, Adidas, named a tennis shoe after him that remains an icon to this day and has been produced in countless versions and limited editions. However, the most coveted are the originals from 1965, which were still named after the Frenchman Robert Haillet, or the first "real" Stan Smiths, which from 1973 to 1978 already bore Smith's portrait on the flap, but still Haillet's signature.

↑ Two different versions of the cult shoe Stan Smith by Adidas.
Zwei verschiedene Ausführungen des Kultschuhs Stan Smith von Adidas.

↗ Billie Jean King, Pancho Segura and Stan Smith in Los Angeles, 1966.
Billie Jean King, Pancho Segura und Stan Smith in Los Angeles, 1966.

← Detail of an advertisement for tennis socks by stocking manufacturer Falke.
Ausschnitt aus einer Werbung für Tennis-Socken des Strümpfe-Herstellers Falke.

Stan Smith gewann 1972 ein hart umkämpftes Wimbledon-Finale gegen Ilie Nastase, doch der Name des US-Amerikaners ist nicht deswegen weltberühmt – sein damaliger Ausrüster Adidas benannte einen Tennisschuh nach ihm, der bis heute als Ikone gilt und in unzähligen Versionen und limitierten Auflagen produziert wurde. Am begehrtesten sind jedoch die Originale aus dem Jahr 1965, die noch nach dem Franzosen Robert Haillet benannt waren, oder die ersten »echten« Stan Smiths, die von 1973 bis 1978 auf der Lasche zwar bereits Smiths Portrait, aber noch die Signatur Haillets trugen.

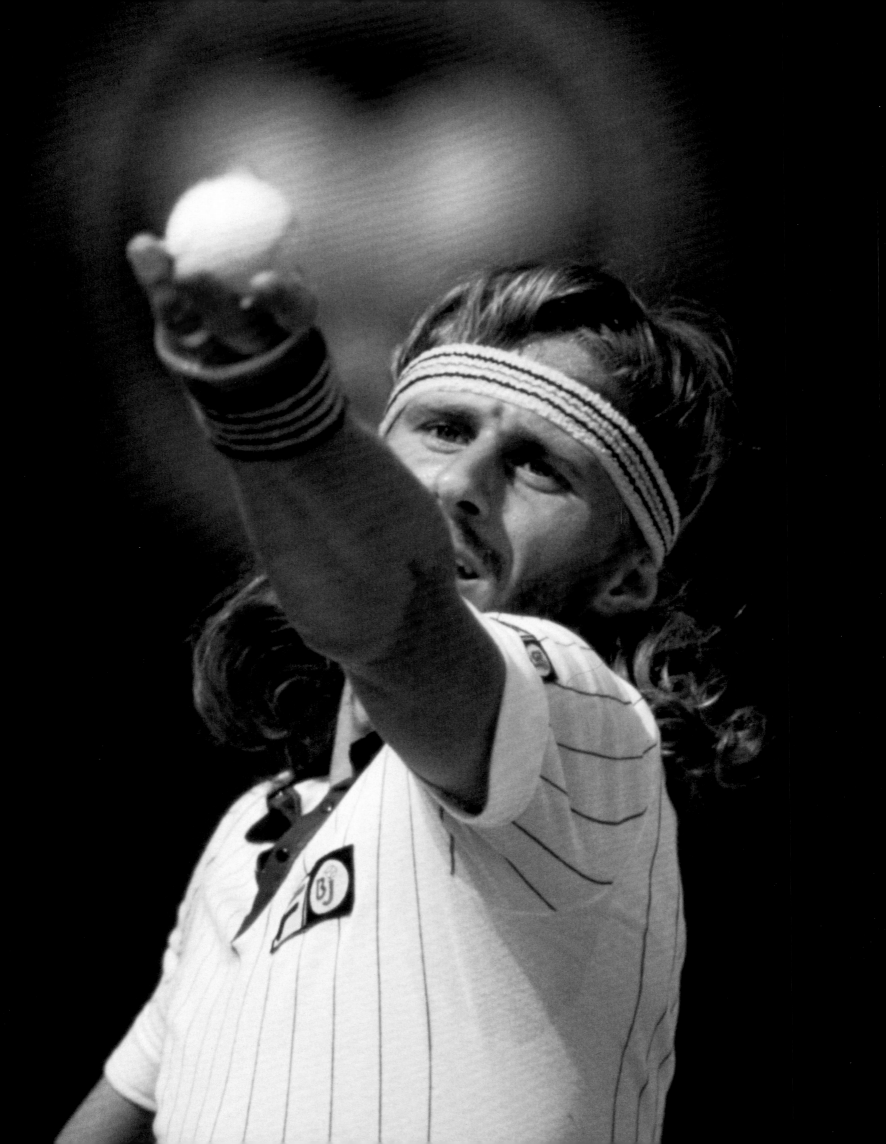

THE FIVE BEST MATCHES OF ALL TIME

DIE FÜNF BESTEN MATCHES ALLER ZEITEN

THE ULTIMATE BOOK

Sweden's Björn Borg prepares to serve in his final match against John McEnroe, Wimbledon, 1980.

Der Schwede Björn Borg bereitet sich auf seinen Aufschlag vor, im Endspiel gegen John McEnroe, Wimbledon, 1980.

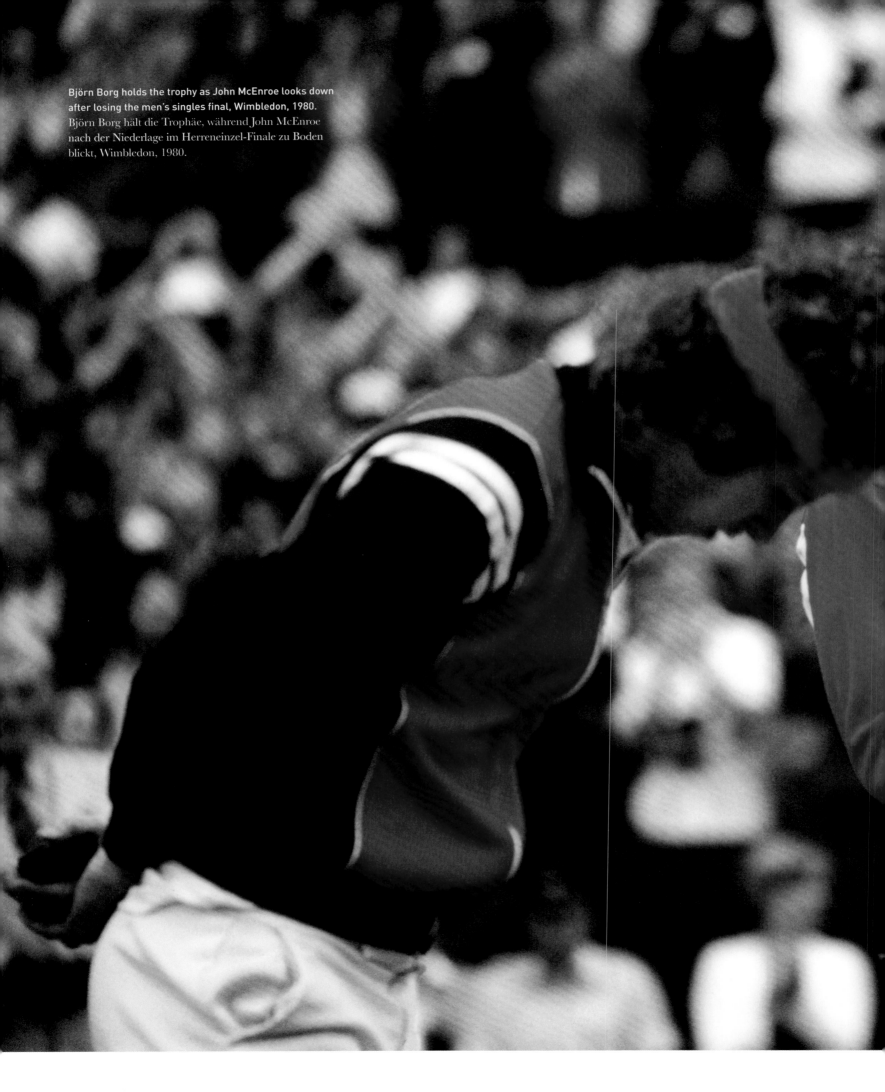

Björn Borg holds the trophy as John McEnroe looks down
after losing the men's singles final, Wimbledon, 1980.
Björn Borg hält die Trophäe, während John McEnroe
nach der Niederlage im Herreneinzel-Finale zu Boden
blickt, Wimbledon, 1980.

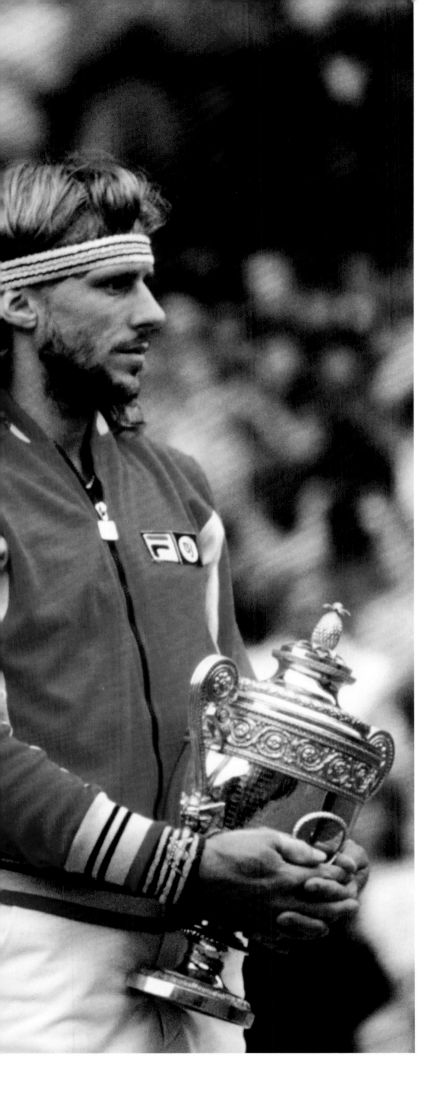

1980: Björn Borg vs. John McEnroe, Wimbledon final / **Wimbledon-Finale**
1:6, 7:5, 6:3, 6:7, 8:6

The very different character of the two person-
alities made almost every match between them
special, an event watched by the whole world.
But no duel was more fascinating than the one
on July 6, 1980. High-class? Of course! Dramat-
ic? Hitchcock couldn't have written the second,
fourth and fifth sets any better! The fourth set in
particular was a thriller: it went into a tie-break
in which McEnroe had to fend off two match
points before winning it 18:16. Nevertheless, in
the end the quiet Swede Björn Borg won for the
fifth time in a row at Wimbledon. The match was
immortalized in the 2017 feature film with the
somewhat unimaginative title *Borg/McEnroe*. If
you want unfiltered action, you should watch the
final on YouTube.

Der so unterschiedliche Charakter der beiden
Persönlichkeiten machte beinahe jedes Match
zwischen ihnen zu einer Besonderheit, zu einem
Event, dem die ganze Welt zuschaute. Doch kein
Duell war faszinierender als jenes vom 6. Juli
1980. Hochklassig? Natürlich! Dramatisch? Die
Sätze zwei, vier und fünf hätte Hitchcock nicht
besser schreiben können! Besonders der vierte
Satz war ein Thriller: Er ging in den Tie-Break,
in dem McEnroe zwei Matchbälle abwehren
musste, bevor er ihn mit 18:16 für sich entschied.
Dennoch gewann am Ende der stille Schwede
Björn Borg zum fünften Mal in Folge in Wimb-
ledon. Das Match wurde 2017 in dem Spielfilm
mit dem etwas einfallslosen Titel *Borg/McEnroe*
verewigt. Wer ungefilterte Action will, sollte sich
das Finale auf YouTube anschauen.

1985: Chris Evert vs. Martina Navratilova, French Open final / Finale der French Open 6:3, 6:7, 7:5

She wobbled but held firm against her fearsome opponent: Chris Evert had previously lost 15 of 16 matches against Navratilova, but in the third set of the high-class final she took a 5:3 lead. Would it be enough this time? Navratilova cut the gap to 5:5 and even had three break points at 0:40 on Evert's subsequent service game. But Chris Evert kept her nerve, brought her game through to 6:5 and finally broke Navratilova to 7:5. Evert not only won against her arch-rival, but above all against herself.

Sie wackelte, aber blieb gegen ihre Angstgegnerin standhaft: Zuvor hatte Chris Evert 15 der 16 Matches gegen Navratilova verloren, doch im dritten Satz des hochklassigen Finals ging sie mit 5:3 in Führung. Würde es dieses Mal reichen? Navratilova verkürzte auf 5:5 und hatte bei Everts anschließendem Aufschlagspiel bei 0:40 sogar drei Breakbälle. Doch Chris Evert behielt die Nerven, brachte ihr Spiel zum 6:5 durch und breakte schließlich Navratilova zum 7:5. Evert gewann nicht nur gegen ihre Erzrivalin, sondern vor allem gegen sich selbst.

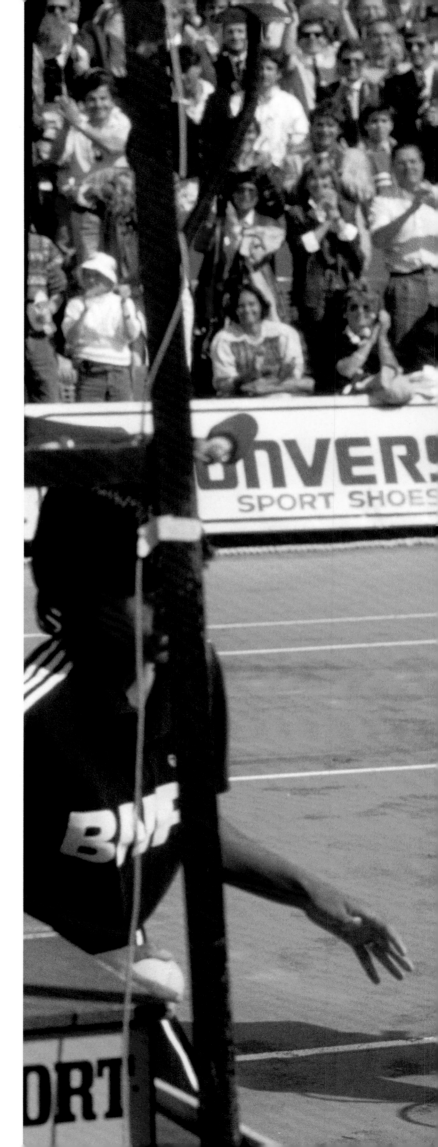

Martina Navratilova and Chris Evert embrace after the women's final at the Stade Roland Garros, French Open, 1985.
Martina Navratilova und Chris Evert umarmen sich nach dem Frauenfinale im Stade Roland Garros, French Open, 1985.

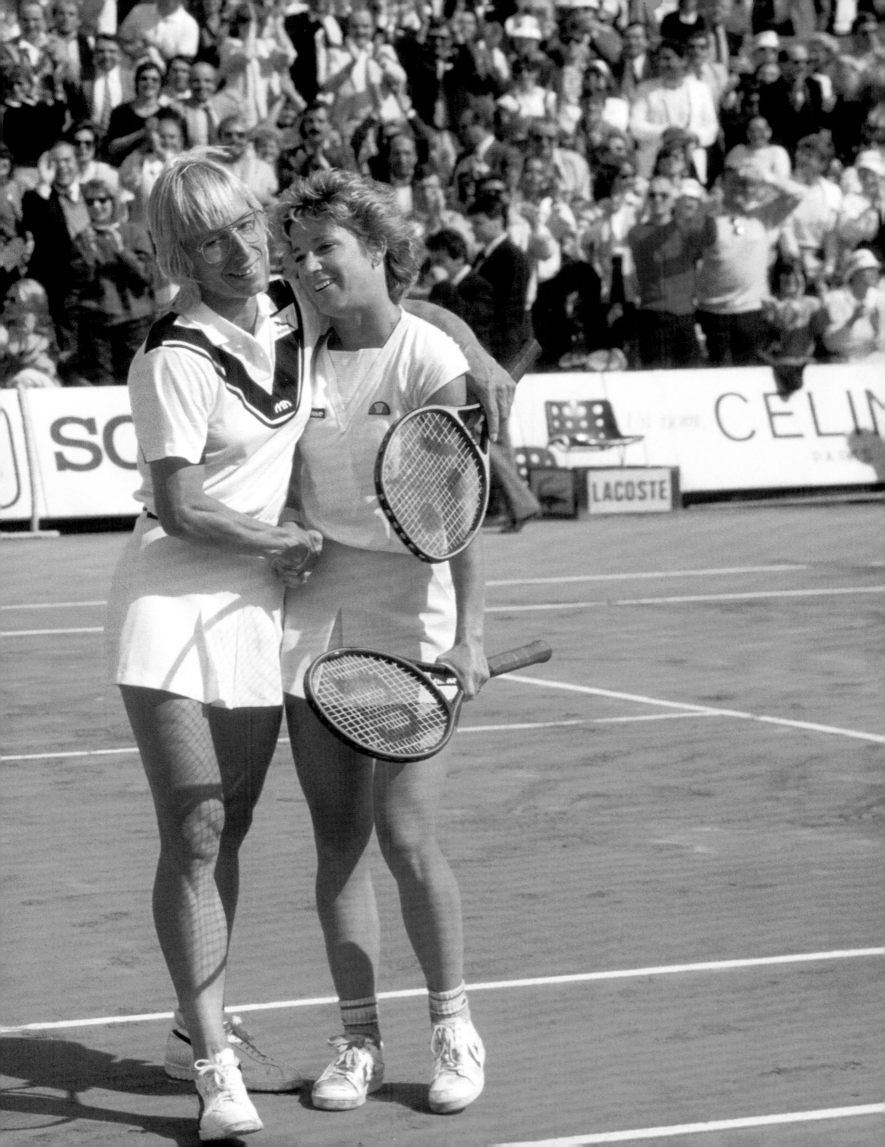

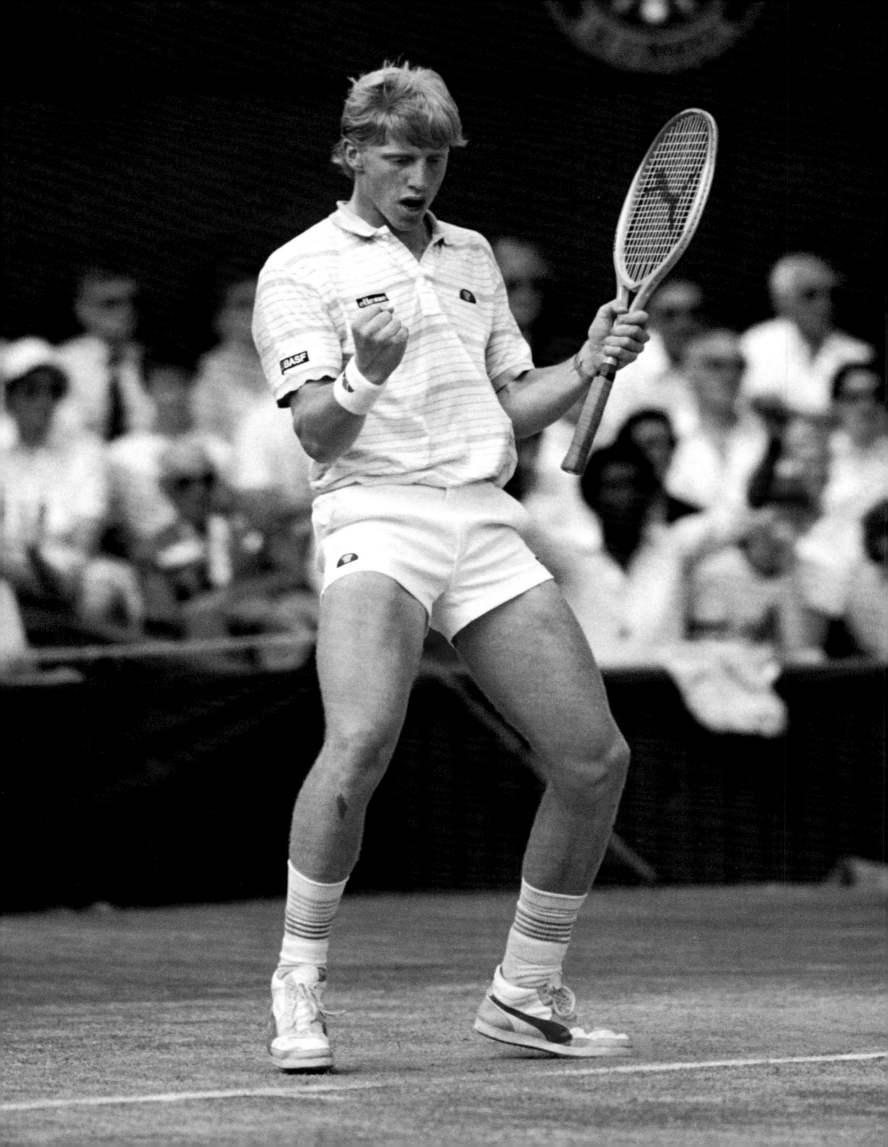

1985: Boris Becker vs. Kevin Curren, Wimbledon final / Wimbledon-Finale
6:3, 6:7, 7:6, 6:4

He was the first German, the first unseeded and the youngest player ever to win Wimbledon: Boris Becker sparked a tennis boom in his home country at just 17 years of age, but also won the hearts of the English and of tennis fans from all over the world with his thrilling game. Unforgettable is the acclaimed Becker dive, with which he jumped after the returns during net attacks. After each match, his tennis polos looked as if he had played a soccer match in them.

Er war der erste Deutsche, der erste ungesetzte und der jüngste Spieler, der Wimbledon je gewinnen konnte: Boris Becker löste mit gerade mal 17 Jahren in seiner Heimat einen Tennisboom aus, gewann mit seinem mitreißenden Spiel aber auch die Herzen der Engländer und von Tennisfans aus aller Welt. Unvergessen ist der umjubelte Becker-Hecht, mit der er bei Netzattacken den Returns hinterhersprang. Seine Tennis-Polos sahen nach jedem Spiel aus, als hätte er ein Fußballmatch in ihnen bestritten.

→ 2008: Rafael Nadal vs. Roger Federer, Wimbledon final / Wimbledon-Finale
6:4, 6:4, 6:7, 6:7, 9:7

One of the most high-class duels in tennis history enraptured fans for a full five hours and had to be interrupted twice because of rain; the final points on Centre Court were played at dusk. Roger Federer wanted to win Wimbledon for the fifth time in a row, but Rafael Nadel showed tennis like from another star, especially in the tie-breaks of the third and fourth sets. It was not a match, it was an epic.

Eines der hochklassigsten Duelle der Tennisgeschichte verzückte die Fans volle fünf Stunden lang und musste dabei zwei Mal wegen Regen unterbrochen werden; die letzten Punkte auf dem Center-Court wurden in der Abenddämmerung gespielt. Roger Federer wollte das fünfte Mal hintereinander Wimbledon gewinnen, doch Rafael Nadel zeigte vor allem in den Tie-Breaks des dritten und vierten Satzes Tennis wie von einem anderen Stern. Es war kein Match, es war ein Epos.

← Boris Becker shows the famous Becker fist to his opponent Kevin Curren, during the final of the Wimbledon Lawn Tennis Championship, 1985.
Boris Becker zeigt seinem Gegner Kevin Curren die berühmte Becker-Faust, während des Endspiels der Wimbledon Lawn Tennis Championship, 1985.

→ Roger Federer (next page) in action against Rafael Nadal as rain clouds gather, Wimbledon, 2008.
Roger Federer (nächste Seite) in Action gegen Rafael Nadal als Regenwolken aufziehen, Wimbledon, 2008.

2012: Novak Djokovic vs. Rafael Nadal, Australian Open final / Finale der Australian Open 5:7, 6:4, 6:2, 6:7, 7:5

At five hours and 53 minutes, the battle between the number one ranked Serb and the running machine from Mallorca was the longest Grand Slam final in history. Even the former superstars were almost speechless. Andre Agassi thought, "That was the best tennis match ever." Pete Sampras judged the almost endless exchange of blows, "The best I've ever seen." And John McEnroe's brother Patrick said, "You think you've seen it all, and then you see this match."

Mit fünf Stunden und 53 Minuten war der Kampf zwischen dem auf Nummer eins stehenden Serben und der Laufmaschine aus Mallorca das längste Grand-Slam-Finale der Geschichte. Selbst die ehemaligen Superstars waren nahezu sprachlos. Andre Agassi fand: »Das war das beste Tennismatch aller Zeiten.« Pete Sampras urteilte über den fast endlosen Schlagabtausch: »Das Beste, was ich je gesehen habe.« Und John McEnroes Bruder Patrick sagte: »Du denkst, du hast alles gesehen, und dann siehst du dieses Match.«

Novak Djokovic nearly rips his shirt off as he has set point against Rafael Nadal in the men's final, Melbourne, 2012.
Novak Djokovic reißt sich fast das Hemd vom Leib, als er im Herrenfinale gegen Rafael Nadal einen Satzball hat, Melbourne, 2012.

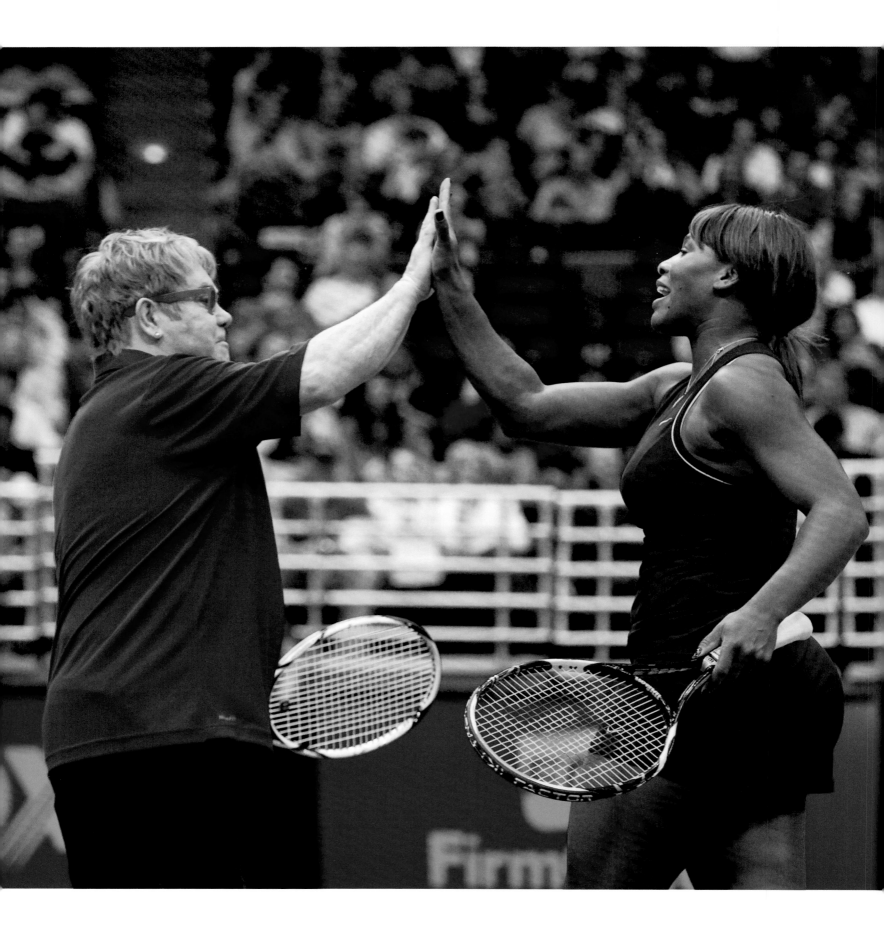

Both personalities are known for their flashy outfits. Sir Elton John high-fives teammate Serena Williams during the 17ᵗʰ annual World Team Tennis Smash Hit to benefit the Elton John AIDS Foundation and AIDS charities, Baton Rouge, 2009.

Beide Persönlichkeiten sind bekannt für ihre schrillen Outfits. Sir Elton John gibt seiner Teamkollegin Serena Williams ein High-Five, während des 17. jährlichen World Team Tennis Smash Hits zu Gunsten der Elton John AIDS Foundation und AIDS-Wohltätigkeitsorganisationen, Baton Rouge, 2009.

TENNIS FASHION

From Free Calves and
Rebellious Collars.

TENNIS MODE

Von freien Waden und
rebellischen Kragen.

THE ULTIMATE BOOK

Typical tennis fashion may seem a bit stiff to us today, but it was – and still is – always at the forefront and continues to set trends.

Tennis was already practiced in the 19th century as one of the very few leisure activities shared by men and women. When hunting or even golfing, the gentlemen decidedly kept to themselves, but in tennis it was common for the sexes to mix. This meant that there was a lot of flirting – and here and there more skin was shown than was considered proper. The first scandal soon broke at Wimbledon, too, when

Die typische Tennismode mag uns heute etwas steif vorkommen, doch sie war – und ist – immer vorne dabei und setzt nach wie vor Trends.

Tennis wurde schon im 19. Jahrhundert als eine der ganz wenigen Freizeitbeschäftigungen von Männern und Frauen gemeinsam ausgeübt. Bei der Jagd oder auch beim Golfen blieben die Herren dezidiert unter sich, doch beim Tennis war es üblich, dass sich die Geschlechter mischten. Das bedeutete, dass heftig geflirtet wurde – und hier und da mehr Haut gezeigt wurde, als es als schick-

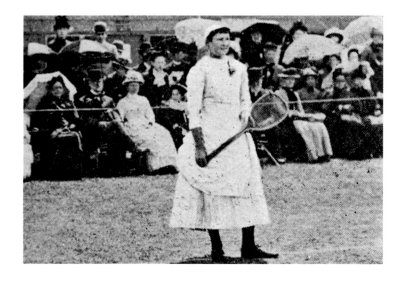

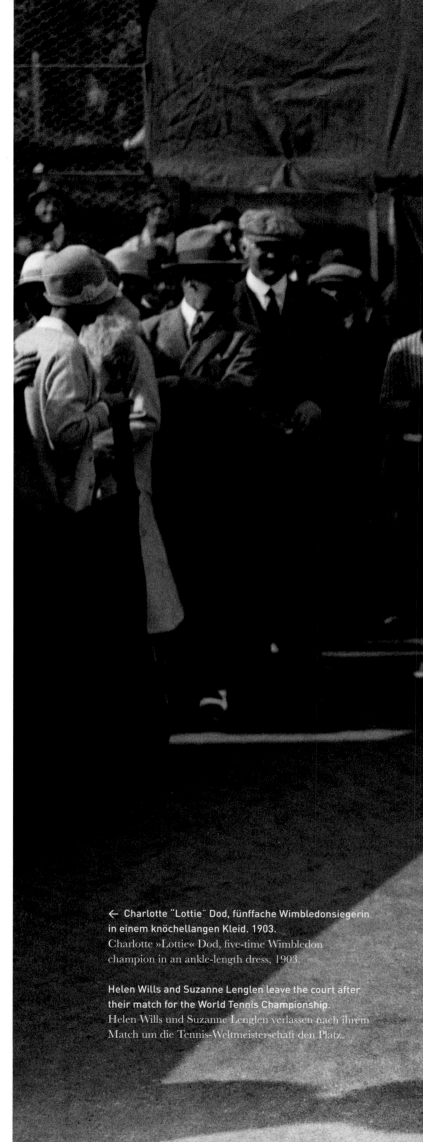

← Charlotte "Lottie" Dod, fünffache Wimbledonsiegerin in einem knöchellangen Kleid. 1903.
Charlotte »Lottie« Dod, five-time Wimbledon champion in an ankle-length dress, 1903.

Helen Wills and Suzanne Lenglen leave the court after their match for the World Tennis Championship.
Helen Wills und Suzanne Lenglen verlassen nach ihrem Match um die Tennis-Weltmeisterschaft den Platz.

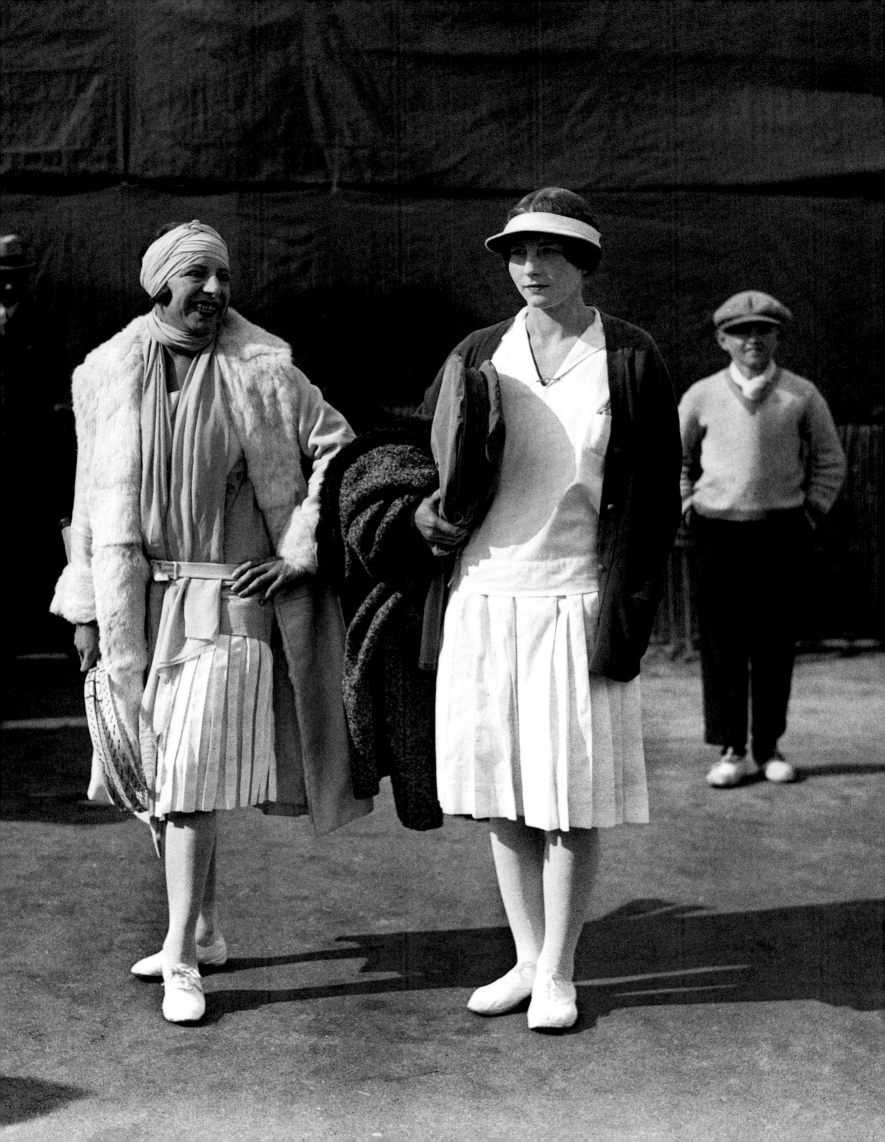

Charlotte Dod competed in 1887: because she was only 15 years old, the strict dress codes did not apply to her. Instead of having to wear a constricting corset, she was able to compete in an ankle-length dress, which outraged her older opponents. Fashion doping, so to speak.

Suzanne Lenglen's style also caused outrage, because in 1919 at Wimbledon the Frenchwoman wore a skirt that only reached her calves, not her ankles, and also a short-sleeved blouse. She won in a dramatic final against seven-time winner Dorothea Douglass Chambers. Later, she would often wear a silk headband: the "Lenglen bandeau" became style-defining in the golden 1920s. And last but not least, Suzanne Lenglen liked to enter the court in an open fur coat.

The trendy tennis fashion continued after the war: for the polo shirts, introduced by top player René Lacoste just before World War II, were

lich galt. Auch in Wimbledon gab es bald den ersten Skandal, als 1887 Charlotte Dod antrat: Weil sie erst 15 Jahre alt war, galten für sie die strengen Kleiderregeln nicht. Statt ein einengendes Korsett tragen zu müssen, konnte sie in einem knöchellangen Kleid antreten, was die älteren Gegnerinnen empörte. Mode-Doping, gewissermaßen.

Auch Suzanne Lenglens Stil sorgte für Entrüstung, denn 1919 trug die Französin in Wimbledon einen Rock, der nur bis zu den Waden reichte, nicht bis zu den Knöcheln, außerdem eine kurzärmlige Bluse. Sie siegte in einem dramatischen Endspiel gegen die siebenmalige Gewinnerin Dorothea Douglass Chambers. Später sollte sie oft ein seidenes Stirnband tragen: Das »Lenglen-Bandeau« wurde in den goldenen 1920er-Jahren stilbildend. Und zu guter Letzt betrat Suzanne Lenglen den Platz gern im offenen Pelzmantel.

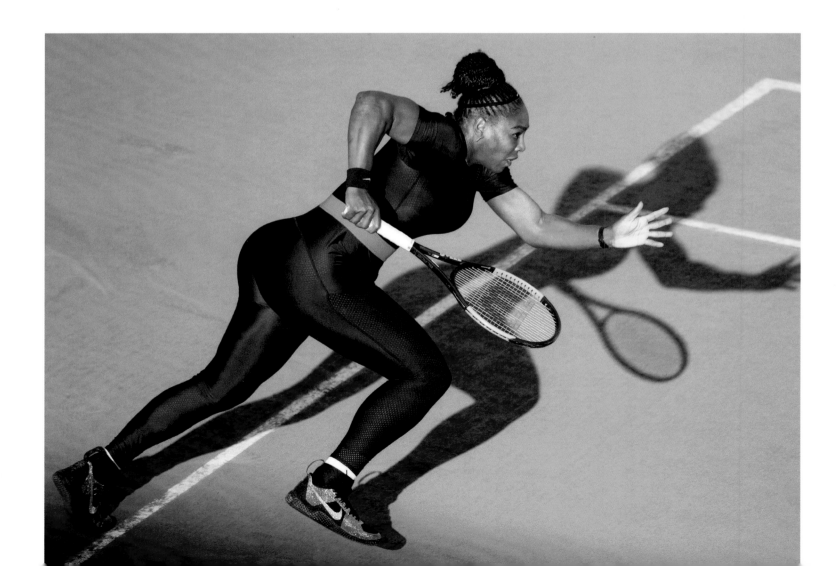

enthusiastically embraced by the mods in the early 1960s – an act of rebellion against the constricting shirts, but also the appropriation of an upper-class symbol by mod youth, most of whom came from working-class backgrounds.

And even today, tennis fashion still manages to cause scandals: in 2013, Roger Federer was asked at Wimbledon to forgo his Nike shoes with the overly garish orange sole, and French Open officials banned Serena Williams from wearing her skin-tight black catsuit in 2018.

↑ Hyeon Chung wearing a Lacoste polo shirt at the Australian Open, 2018.
Hyeon Chung trägt ein Lacoste-Poloshirt bei den Australian Open, 2018.

↗ Al Barr of the band Dropkick Murphys performing in a Fred Perry shirt with the famous laurel wreath logo, 2014.
Al Barr von der Band Dropkick Murphys bei einem Auftritt im Fred-Perry-Hemd mit dem bekannten Lorbeerkranz-Logo, 2014.

← Serena Williams in a too risqué outfit in action against Julia Goerges of Germany, French Open, 2018.
Serena Williams in einem zu gewagten Outfit in Aktion gegen Julia Goerges aus Deutschland, French Open, 2018.

Die trendige Tennismode setzte sich nach dem Krieg fort: Denn die Polo-Shirts, von Spitzenspieler René Lacoste kurz vor dem Zweiten Weltkrieg eingeführt, wurden in den frühen 1960er-Jahren von den Mods begeistert angenommen – ein Akt der Rebellion gegen die einengenden Hemden, aber auch die Aneignung eines Oberschicht-Symbols durch die Mod-Jugendlichen, die meistens aus der Arbeiterklasse stammten.

Und noch heute schafft es die Tennismode, für Skandale zu sorgen: Roger Federer wurde 2013 in Wimbledon gebeten, auf seine Nike-Schuhe mit der allzu schrillen orangen Sohle zu verzichten, und die Verantwortlichen der French Open untersagten Serena Williams 2018 das Tragen ihres hautengen schwarzen Catsuits.

CELEBRITIES AT THE RACKET

BERÜHMT-HEITEN AM SCHLÄGER

A sporty image never hurt anyone. That's why film stars and politicians alike have always liked to be photographed playing tennis. And: sporting activity in skimpy clothing is a good way to show oneself a little more sensual than usual, which is only right for many a celebrity.

Ein sportliches Image hat noch niemandem geschadet. Deswegen sich Filmstars wie Politiker seit jeher gern beim Tennis ablichten. Und: Die sportliche Betätigung in knapper Kleidung ist ein guter Weg, sich ein bisschen sinnlicher zu zeigen als üblich, was so mancher Berühmtheit nur recht ist.

Actor Robert Redford on the tennis court in a scene from the film "The Way We Were", Los Angeles, 1972.
Der Schauspieler Robert Redford auf dem Tennisplatz in einer Szene aus dem Film »The Way We Were«, Los Angeles, 1972.

↑ American actress Ava Gardner smiles as she leaps over the net with her racket in hand on a tennis court, 1940s.
Die amerikanische Schauspielerin Ava Gardner lächelt, als sie mit ihrem Schläger in der Hand auf einem Tennisplatz über das Netz springt, 1940er-Jahre.

→ Beverly Hills, California: Fred Astaire is an accomplished tennis player. The tap-dancing star is known for his quick and nimble feet, a tough opponent to beat, Beverly Hills.
Beverly Hills, Kalifornien: Fred Astaire ist ein ausgezeichneter Tennisspieler. Der Stepptanzstar ist bekannt für seine schnellen und flinken Füße, ein schwer zu schlagender Gegner, Beverly Hills.

FA-312X

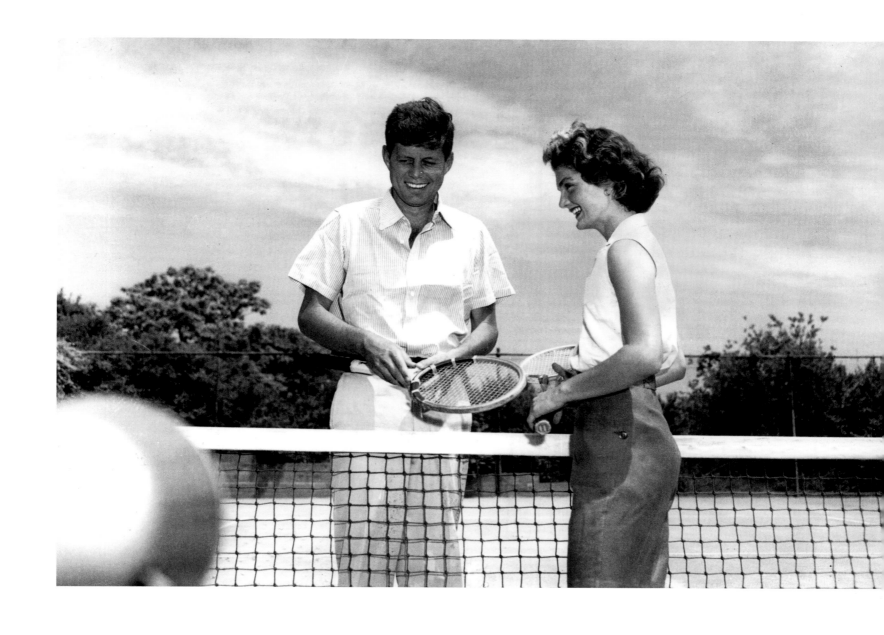

↑ Senator John F. Kennedy and his wife Jacqueline pose for photographers
at a tennis match, Massachusetts.
Senator John F. Kennedy und seine Frau Jacqueline posieren für die
Fotografen bei einem gemeinsamen Tennisspiel, Massachusetts.

← American actress Katharine Hepburn playing tennis, ca. 1935.
Die amerikanische Schauspielerin Katharine Hepburn beim Tennisspielen,
um 1935.

↑ American actor Paul Newman jokingly throws his racket in the air while playing tennis, 1960s.
Der amerikanische Schauspieler Paul Newman wirft seinen Schläger beim Tennisspielen scherzhaft in die Luft, 1960er-Jahre.

← Douglas Fairbanks (l.bottom), Manuel Alonso (m.) and Bill Tilden (r.bottom) on a tennis court forming a human pyramid with Charles Chaplin at the top, 1923.
Douglas Fairbanks (l. unten), Manuel Alonso (m.) und Bill Tilden (r. unten) bilden auf einem Tennisplatz eine menschliche Pyramide mit Charles Chaplin an der Spitze, 1923.

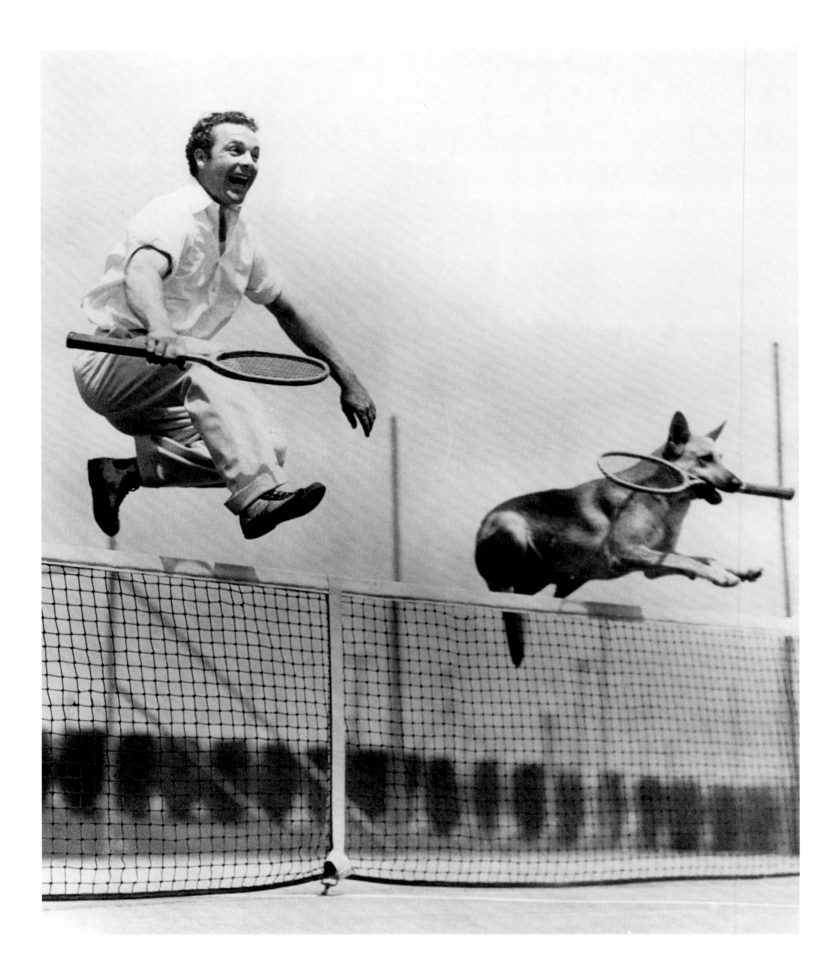

↑ James Murray and his "doubles partner" Flash don't find enough exercise in tennis, so they take jumps over the net.
James Murray und sein »Doppelpartner« Flash finden im Tennis nicht genug Bewegung und machen deshalb Sprungeinlagen über das Netz.

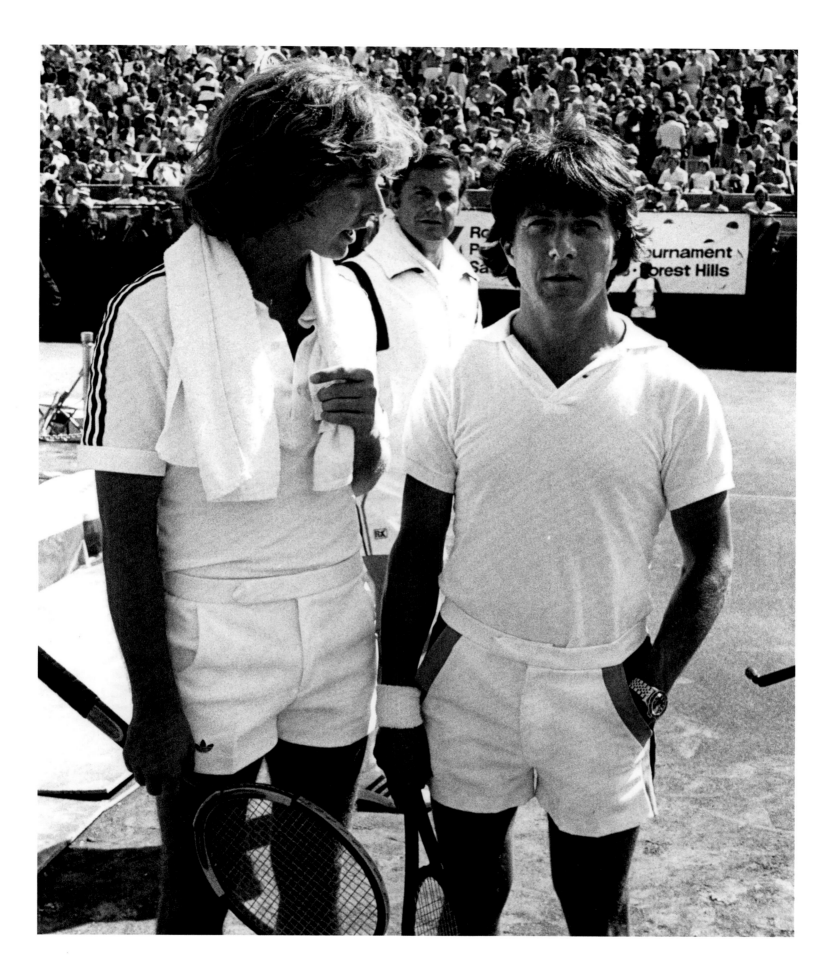

↑ Parker Stevenson and Dustin Hoffman in the 70s at a Pro-Celebrity Tennis Tournament, Forest Hills.
Parker Stevenson und Dustin Hoffman in den 70er-Jahren beim Pro-Celebrity Tennis Tournament, Forest Hills.

↑↑ Mick Jagger relaxes in the south of France playing tennis before the start of the Rolling Stones' European tour, 1976.

Mick Jagger entspannt sich in Südfrankreich beim Tennisspielen vor dem Start der Europatournee der Rolling Stones, 1976.

↑ Not just soccer, Pelé and Ethel Kennedy, widow of Robert Kennedy, meet on the tennis court, circa 1978 in Forest Hills.

Nicht nur Fußball, Pelé und Ethel Kennedy, die Witwe von Robert Kennedy, treffen auf dem Tennisplatz aufeinander, um 1978 in Forest Hills.

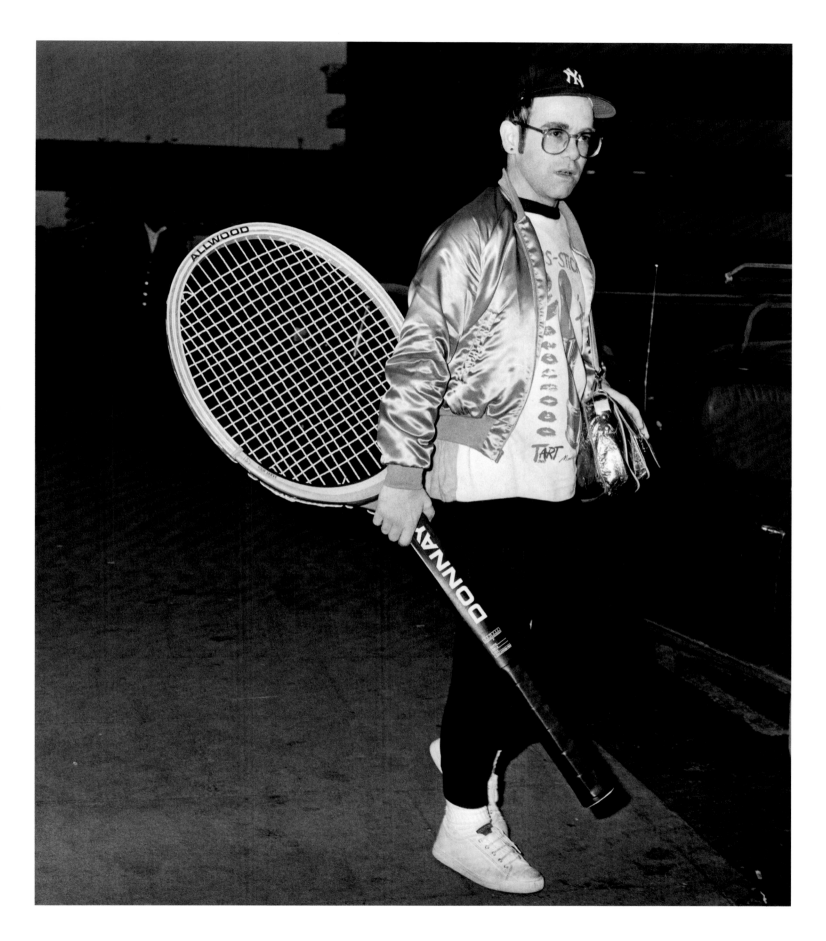

↑ Elton John at Heathrow Airport holding a giant tennis racket, 1978.
Elton John auf dem Flughafen Heathrow mit einem riesigen Tennisschläger
in der Hand, 1978.

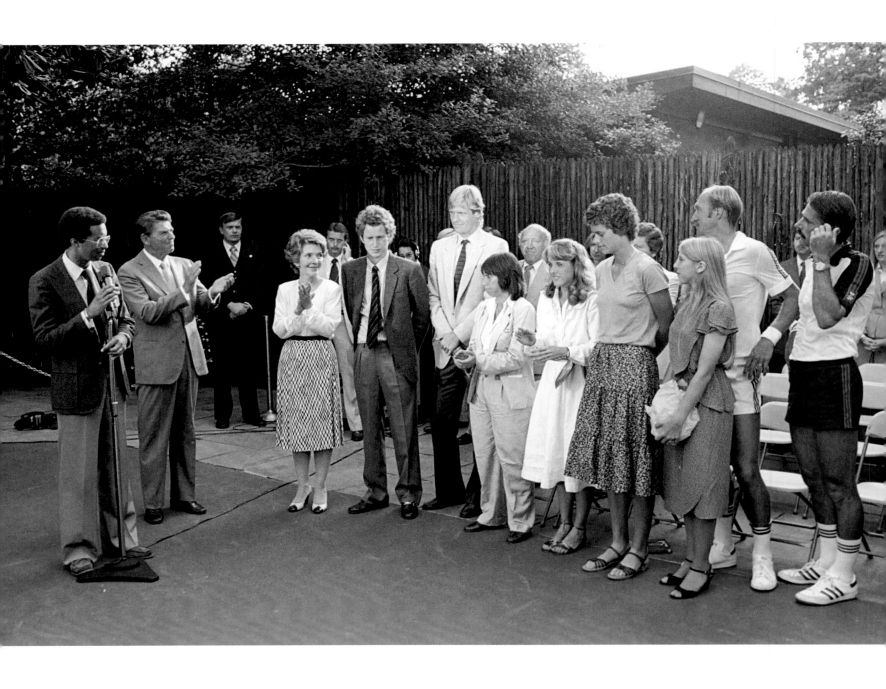

↑ President Ronald Reagan and Nancy Reagan welcome the American Davis
Cup and Wightman Cup teams on the White House tennis court with Arthur
Ashe, Tracy Austin, Rosie Casals, Bud Collins, Peter Fleming, Andrea Jaeger,
John McEnroe, Marty Riessen and Stan Smith, Washinton, 1981.
Präsident Ronald Reagan und Nancy Reagan empfangen die
amerikanischen Davis-Cup- und Wightman-Cup-Teams auf dem
Tennisplatz des Weißen Hauses mit Arthur Ashe, Tracy Austin, Rosie
Casals, Bud Collins, Peter Fleming, Andrea Jaeger, John McEnroe, Marty
Riessen und Stan Smith, Washington, 1981.

↗ Bill Gates shakes Roger Federer's hand after their Match for Africa at
KeyArena, Seattle, 2017.
Bill Gates schüttelt Roger Federer die Hand nach ihrem Match For Africa in
der KeyArena, Seattle, 2017.

→ Andre Agassi shows with his girlfriend Brooke Shields wearing Western
look in California in 1997. A year later he falls in love with Steffi Graf.
Andre Agassi zeigt sich mit seiner Freundin Brooke Shields 1997 im
Westernlook in Kalifornien. Ein Jahr später verliebt er sich in Steffi Graf.

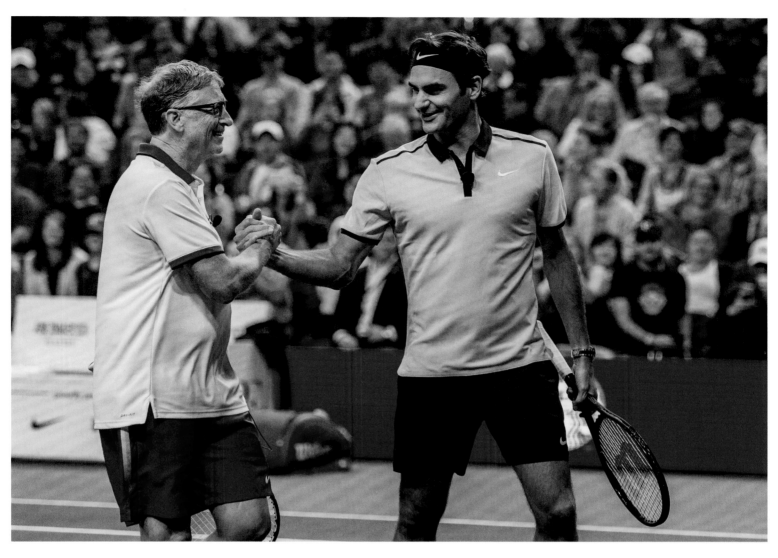

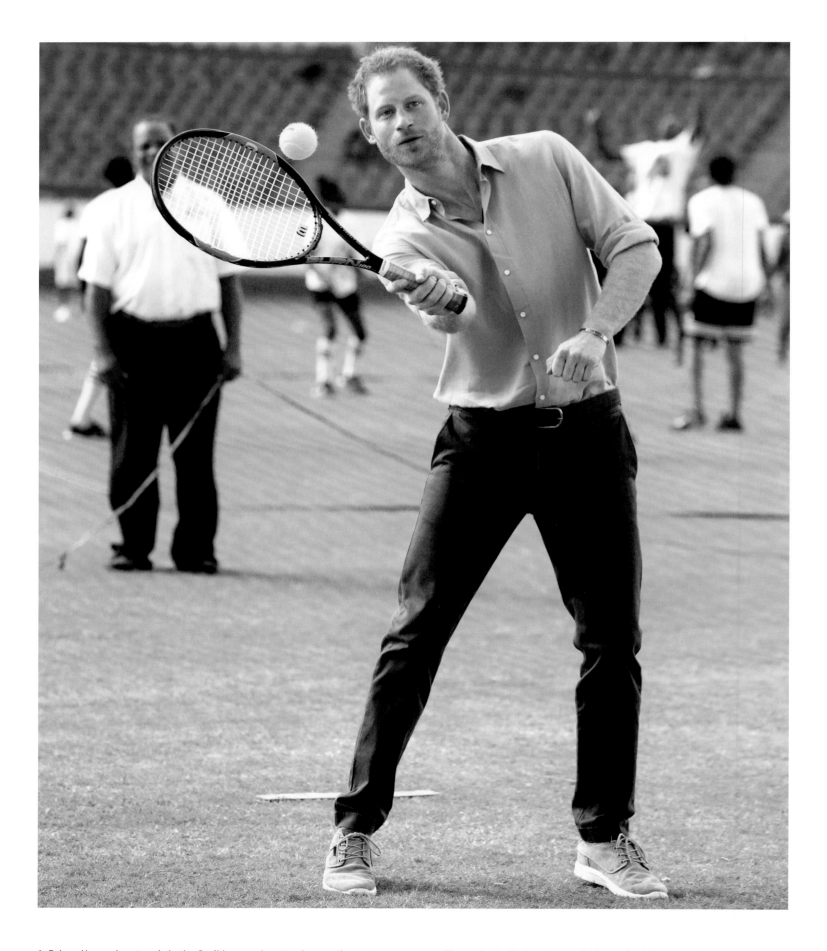

↑ Prince Harry plays tennis in the Caribbean as he attends a youth sports festival at the Sir Vivian Richards Stadium in North Sound. Antigua, 2016.
Prinz Harry spielt Tennis in der Karibik, als er an einem Jugendsportfest im Sir Vivian Richards Stadium in North Sound teilnimmt, Antigua, 2016.

→ Singer Justin Bieber shows off his tennis skills at the 11th Annual Desert Smash, La Quinta, 2015.
Sänger Justin Bieber zeigt seine Qualitäten im Tennisspiel beim 11th Annual Desert Smash, La Quinta, 2015.

"You Have to Stay on Your Feet!"
The Longest Match in History

»Du musst auf den Beinen bleiben!«
Das längste Match der Geschichte

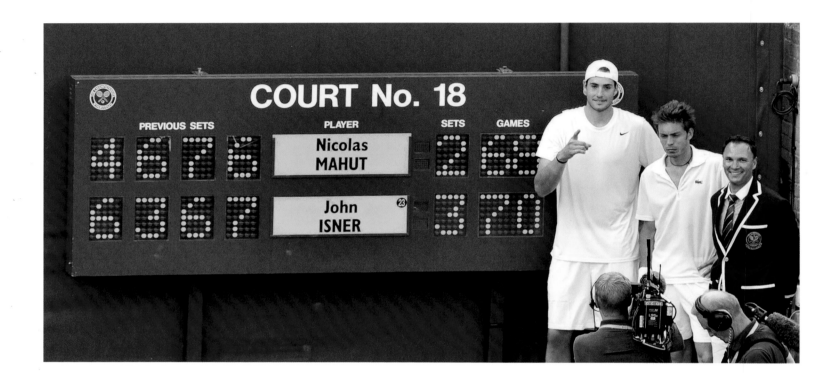

↑ At over eight hours, the last set was longer than all record matches so far. In the game between John Isner and Nicolas Mahut, the US American won 70 to 68, Wimbledon, 2010.

Der letzte Satz war mit über acht Stunden länger als alle Rekordspiele bislang. Im Spiel John Isner gegen Nicolas Mahut gewann der US-Amerikaner 70 zu 68, Wimbledon, 2010.

This was no longer tennis, this was pure fight for survival. In 2010, the first-round match at Wimbledon between John Isner of the United States and Nicolas Mahut of France lasted eleven hours and five minutes. The final set alone, at over eight hours, was longer than any record match to date.

"I just kept telling myself, 'You have to stay on your feet.' Your opponent is not doing any better,"

Das war kein Tennis mehr, das war der reine Überlebenskampf. Elf Stunden und fünf Minuten dauerte im Jahr 2010 das Erstrunden-Match in Wimbledon zwischen dem US-Amerikaner John Isner und dem Franzosen Nicolas Mahut. Allein der letzte Satz war mit über acht Stunden länger als alle Rekord-Matches bislang.

»Ich habe mir nur noch gesagt: Du musst auf den Beinen bleiben. Deinem Gegner geht's auch nicht besser«, sagte Isner. Und Mahut erklärte, er war nur noch »aus dem Unterbewusstsein gesteuert«. Das Ergebnis: 6:4, 3:6, 6:7, 7:6, 70:68 für den Amerikaner. »Sein Matchball traf mich ins Herz«,

Isner said. And Mahut explained that he was only "controlled from the subconscious." The result: 6:4, 3:6, 6:7, 7:6, 70:68 for the American. "His match point hit me in the heart," Mahut sighed. Both are service specialists; Isner managed 112 aces, Mahut 105. And: Mahut scored more points than his opponent (502:478) and still lost. "What these two players showed is among the greatest ever in this sport," raved John McEnroe. "It was pure heroism."

seufzte Mahut. Beide sind Aufschlagspezialisten; Isner gelangen 112 Asse, Mahut 105. Und: Mahut erzielte mehr Punkte als sein Gegner (502:478) und verlor dennoch. »Was diese beiden Spieler gezeigt haben, zählt zum Größten, was es in diesem Sport je gegeben hat«, schwärmte John McEnroe. »Das war pures Heldentum.«

Kurios: Die beiden standen sich ein Jahr später erneut in Wimbledon gegenüber, wieder in der ersten Runde. Dieses Mal machte Isner, der mit

↑ Sam Groth on serve. He holds the record for the hardest serve in tennis at 163 mph, 2014.
Sam Groth beim Aufschlag. Er hält mit 263 km/h den Rekord für den härtesten Aufschlag im Tennis, 2014.

↑ From 2011 to 2018, Sabine Lisicki (131 mph) holds the record for the fastest serve. In 2018, she is replaced by Aryna Sabalenka (133 mph) and this record is in turn replaced in 2021 by Georgina Garcia Pérez (137 mph).
Von 2011 bis 2018 hält Sabine Lisicki (211 km/h) den Rekord für den schnellsten Aufschlag. Im Jahr 2018 wird sie von Aryna Sabalenka (214 km/h) geknackt und dieser Rekord wiederum wird abgelöst im Jahr 2021 von Georgina Garcia Pérez (220 km/h).

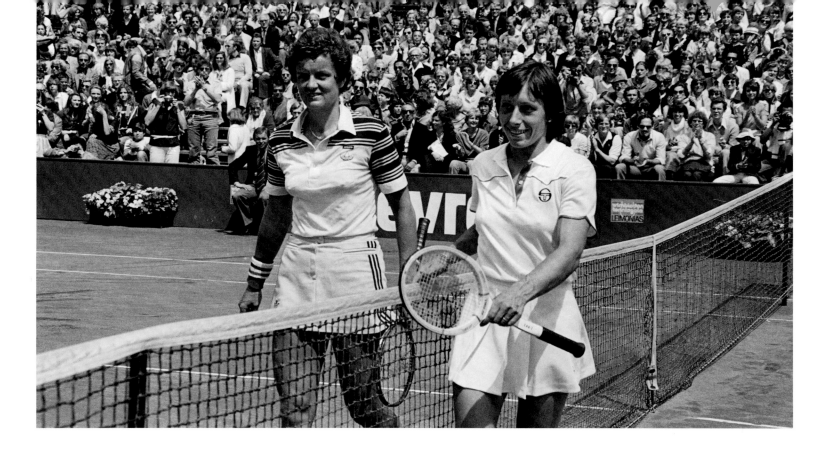

Curiously, the two faced each other again at Wimbledon a year later, again in the first round. This time Isner, the tallest of all top players at 2.08 meters (and shoe size 50), made relatively short work of it, winning after two hours. The duel almost happened again the following year, this time in the second round, but Isner was eliminated in the first round and prevented the personal triple.

Eight years after the fabulous record, John Isner was also involved in the fourth longest match in tennis history: in 2018, he lost the semifinals of Wimbledon 2018 against South African Kevin Anderson with 6:7, 7:6, 7:6, 4:6 and 24:26 – playing time: six hours, 36 minutes.

In third place among the longest matches in tennis history is a Davis Cup match between Argentina and Brazil from 2015: Leonardo Mayer won against João Souza in six hours, 43 minutes. In second place comes the 2013 Davis Cup doubles between the Czech Republic and Switzerland, in which the duo of Tomáš Berdych and Lukáš Rosol beat Marco Chiudinelli and Stanislas Wawrinka 24:22 in the fifth set after seven hours, two minutes.

2,08 Metern (und Schuhgröße 50) höchstgewachsene aller Spitzenspieler, relativ kurzen Prozess und gewann nach zwei Stunden. Auch im Folgejahr wäre es beinahe zum Duell gekommen, dieses Mal in der zweiten Runde, aber Isner schied in der ersten Runde aus und verhinderte das persönliche Triple.

John Isner war acht Jahre nach dem Fabelrekord auch am viertlängsten Match der Tennisgeschichte beteiligt: 2018 verlor er das Halbfinale von Wimbledon 2018 gegen den Südafrikaner Kevin Anderson mit 6:7, 7:6, 7:6, 4:6 und 24:26 – Spieldauer: sechs Stunden, 36 Minuten.

Auf Platz drei der längsten Spiele der Tennisgeschichte liegt ein Davis-Cup-Match zwischen Argentinien und Brasilien aus dem Jahr 2015: Leonardo Mayer gewann gegen Joao Souza in sechs Stunden, 43 Minuten. Auf Platz zwei kommt das Davis-Cup-Doppel von 2013 zwischen Tschechien und der Schweiz, in dem sich das Duo Tomáš Berdych und Lukáš Rosol gegen Marco Chiudinelli und Stanislas Wawrinka im fünften Satz nach sieben Stunden und zwei Minuten mit 24:22 durchsetzte.

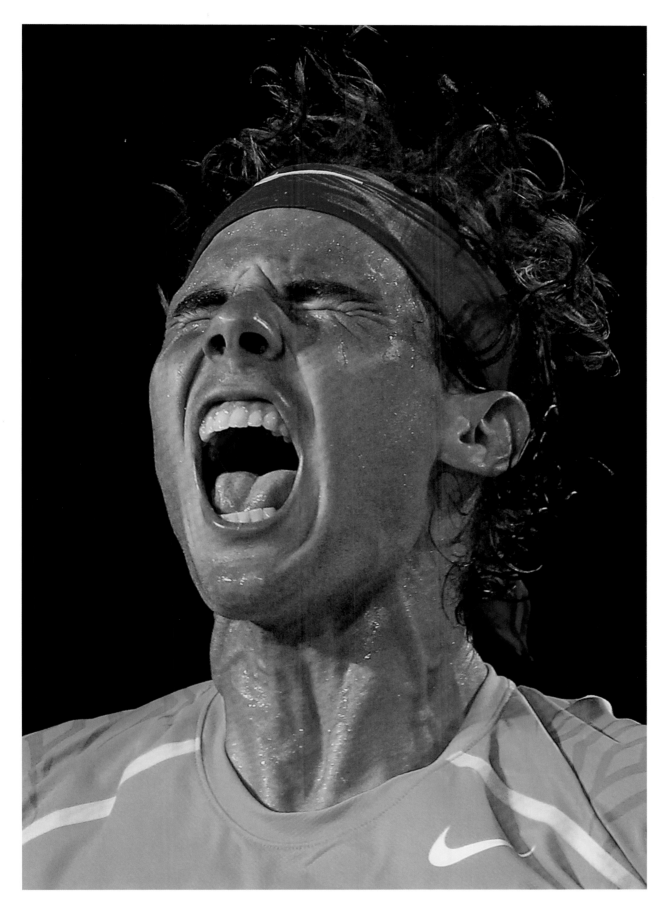

↖ Martina Navratilova (right) holds the record of 167
tournament wins. Pictured with Betty Stöve, Den Haag, 1980.
Martina Navratilova (re) hält den Rekord von 167 gewonnenen
Turniersiegen. Im Bild zusammen mit Betty Stöve,
Den Haag, 1980

↑ Rafael Nadal's record for the most Grand Slam titles
won (22) is set by Novak Djokovic in 2023.
Der Rekord von Rafael Nadal mit den am meisten
gewonnenen Grand Slam Titeln (22) wird im Jahr 2023
von Novak Djokovic eingestellt.

Faster, Younger, Older – the Most Amazing Records

Schneller, jünger, älter – die erstaunlichsten Rekorde

MEN

Grand Slam victories: Rafael Nadal and Novak Djokovic, 22
Tournament wins: Rod Laver, 198
Tournament wins in a year: 16 (Guillermo Vilas, 1977)
Matches won: Ken Rosewall, 2521
Won matches in a row: Björn Borg, 53
Youngest tournament winner: Aaron Krickstein, 16
(Tel Aviv 1983)
Oldest tournament winner: Ken Rosewall, 43
(Hong Kong 1977)
Hardest serve: Sam Groth, 263.0 km/h/163.4 mph
Youngest world No. 1: Carlos Alcaraz, 19 (2022)
Oldest world No. 1: Roger Federer, 36 (2018)
Tallest player: Ivo Karlovic, 208 cm
Shortest player: Oliver Rochus, 163 cm
Double faults in a match: Marc Rosset, 30 (Davis Cup 2001)
Aces: John Isner, 13,990
Aces in a season: Goran Ivanišević, 1477 (1996)
Longest tiebreak: 36:34 (Benjamin Belleret–Guillaume
Couillard, Florida 2013)
Most weeks at No. 1: Novak Djokovic (374 weeks)
Wimbledon record champion: Roger Federer (8 titles)
French Open record champion: Rafael Nadal (14 titles)
Australian Open record champion: Novak Djokovic (10 titles)
US Open record winners: Jimmy Connors, Pete Sampras,
Roger Federer (5 titles)
Most Masters titles: Novak Djokovic (38 titles)
Golden Masters record: Novak Djokovic
(all 9 Masters tournaments)
Most ATP titles: Jimmy Connors (109 titles)
Shortest match: Clavet–Shan at the Shanghai Open 2001
(25 min)
Best annual record: John McEnroe 1984
(82 wins to 3 losses)

HERREN

Grand-Slam-Siege: Rafael Nadal und Novak Djokovic, 22
Turniersiege: Rod Laver, 198
Turniersiege in einem Jahr: 16 (Guillermo Vilas, 1977)
Gewonnene Matches: Ken Rosewall, 2521
Gewonnene Matches in Folge: Björn Borg, 53
Jüngster Turniergewinner: Aaron Krickstein, 16
(Tel Aviv 1983)
Ältester Turniergewinner: Ken Rosewall, 43
(Hongkong 1977)
Härtester Aufschlag: Sam Groth, 263,0 km/h/163,4 mph
Jüngster Weltranglistenerster: Carlos Alcaraz, 19 (2022)
Ältester Weltranglistenerster: Roger Federer, 36 (2018)
Größter Spieler: Ivo Karlovic, 208 cm
Kleinster Spieler: Oliver Rochus, 163 cm
Doppelfehler in einem Match: Marc Rosset, 30
(Davis Cup 2001)
Asse: John Isner, 13.990
Asse in einer Saison: Goran Ivanišević, 1477 (1996)
Längster Tie-Break: 36:34 (Benjamin Belleret–Guillaume
Couillard, Florida 2013)
Meiste Wochen auf Platz 1: Novak Djokovic
(373 Wochen)
Wimbledon Rekordchampion: Roger Federer (8 Titel)
French Open Rekordsieger: Rafael Nadal (14 Titel)
Australian Open Rekordchampion: Novak Djokovic
(10 Titel)
US Open Rekordsieger: Jimmy Connors, Pete Sampras,
Roger Federer (5 Titel)
Meiste Masters Titel: Novak Djokovic (38 Titel)
Golden Masters Rekord: Novak Djokovic
(alle 9 Masters Turniere)
Meiste ATP Titel: Jimmy Connors (109 Titel)
Kürzestes Match: Clavet–Shan bei den Shanghai Open
2001 (25 min)
Beste Jahresbilanz: John McEnroe 1984
(82 Siege zu 3 Niederlagen)

WOMEN

Grand Slam victories: Margaret Court, 24
Tournament wins: Martina Navratilova, 167
Matches won: Martina Navratilova, 1442
Consecutive matches won: Martina Navratilova, 74
Youngest tournament winner: Tracy Austin, 14
(Portland, 1977)
Oldest tournament winner: Billie Jean King, 39
(Birmingham, 1983)
Hardest serve: Georgina García Pérez, 220 km/h/136.7 mph
Youngest world No. 1: Martina Hingis, 16 (1997)
Oldest world No. 1: Serena Williams, 35 (2017)
Tallest female player: Akgul Amanmuradova, 190 cm
Smallest player: Gem Hoahing, 146 cm
Longest tiebreak: 22:20 (Akgul Amanmuradova–Anna Zaja,
Moscow 2017)
Double faults in a match: Anna Kournikova, 31
(Australian Open 1999)
Most weeks at No. 1: Steffi Graf (377 weeks)
Longest time in Top 10: Martina Navratilova (19 years)
Most Grand Slam titles: Margaret Smith-Court (24 titles)
Most WTA titles: Martina Navratilova (167 titles)
Longest match (Grand Slam): Shiavone–Kuznetsova on June
29, 2011 (4h 44min).
Best annual record: Martina Navratilova 1984
(86 wins to 1 loss)
Golden Slam: Steffi Graf (1988) – wins in all 4 Grand Slams
+ Olympic gold in singles

DAMEN

Grand-Slam-Siege: Margaret Court, 24
Turniersiege: Martina Navratilova, 167
Gewonnene Matches: Martina Navratilova, 1442
Gewonnene Matches in Folge: Martina Navratilova, 74
Jüngste Turniergewinnerin: Tracy Austin, 14 Jahre
(Portland, 1977)
Älteste Turniergewinnerin: Billie Jean King, 39 Jahre
(Birmingham, 1983)
Härtester Aufschlag: Georgina García Pérez,
220 km/h/136,7 mph
Jüngste Weltranglistenerste: Martina Hingis, 16 (1997)
Älteste Weltranglistenerste: Serena Williams, 35 (2017)
Größte Spielerin: Akgul Amanmuradova, 190 cm
Kleinste Spielerin: Gem Hoahing, 146 cm
Längster Tie-Break: 22:20 (Akgul Amanmuradova–Anna
Zaja, Moskau 2017)
Doppelfehler in einem Match: Anna Kournikova, 31
(Australian Open 1999)
Meiste Wochen auf Platz 1: Steffi Graf (377 Wochen)
Längste Zeit in Top 10: Martina Navratilova (19 Jahre)
Meiste Grand Slam Titel: Margaret Smith-Court (24 Titel)
Meiste WTA Titel: Martina Navratilova (167 Titel)
Längstes Match (Grand Slam): Schiavone – Kusnezowa
am 29. Juni 2011 (4h 44min)
Beste Jahresbilanz: Martina Navratilova 1984
(86 Siege zu 1 Niederlage)
Golden Slam: Steffi Graf (1988) – Siege bei allen 4 Grand
Slams + Olympia Gold im Einzel

The Battle of the Sexes

Der Kampf der Geschlechter

The match went down in sports history as "The Battle of the Sexes": top player Billie Jean King faced Bobby Riggs in 1973. The then 55-year-old considered women's tennis to be garbage and repeatedly claimed that he could still beat the best women in the world at his age. Riggs himself had once been a world-class player, even winning Wimbledon in 1939 and being number one in the world. But would he actually be able to compete at his age and without training?

The first to react to Riggs' provocations was the reigning world number one Margaret Court. She took on the loudmouth and lost outright on Mother's Day, 6:2 and 6:1. The press called the match the "Mother's Day Massacre." So was Riggs right? Billie Jean King wasn't going to put up with the bravado. The reigning Wimbledon champion asked for revenge on behalf of all the women in the world – and in September of the same year defeated her opponent 6:4, 6:3 and 6:3. This result surprised the experts, while Billie Jean King was celebrated as an icon of women's tennis.

However, further comparative matches then again turned out in favor of the men. In 1992, for example, Jimmy Connors faced Martina Navratilova, and although asymmetrical rules applied (Connors had only one serve and had to play on a larger court), Connors won 7:5 and 6:2. In his autobiography, he later revealed that he had bet a million dollars that Navratilova would win no more than eight games.

Das Match ging als »The Battle of the Sexes« in die Sportgeschichte ein: Spitzenspielerin Billie Jean King trat 1973 gegen Bobby Riggs an. Der damals 55-Jährige hielt Damentennis für Schrott und behauptete wiederholt, er könne auch noch in seinem Alter die besten Frauen der Welt schlagen. Riggs selbst war einst ein Weltklassespieler gewesen, der 1939 sogar Wimbledon gewann und die Nummer eins der Welt war. Doch würde er in seinem Alter und ohne Training tatsächlich gegenhalten können?

Als Erste reagierte die amtierende Weltranglisten-erste Margaret Court auf Riggs' Provokationen. Sie trat gegen das Großmaul an und verlor ausgerechnet am Muttertag ganz glatt mit 6:2 und 6:1. Die Presse nannte das Match »Muttertagsmassaker«. Hatte Riggs also recht? Billie Jean King wollte sich die Angeberei nicht bieten lassen. Die amtierende Wimbledon-Siegerin bat für alle Frauen dieser Welt um Revanche – und besiegte im September desselben Jahres ihren Gegner mit 6:4, 6:3 und 6:3. Dieses Ergebnis überraschte die Experten, während Billie Jean King als Ikone des Frauentennis gefeiert wurde.

Weitere Vergleichsmatches fielen dann allerdings wieder zugunsten der Männer aus. So trat 1992 Jimmy Connors gegen Martina Navratilova an, und obwohl asymmetrische Regeln galten (Connors hatte nur einen Aufschlag und musste auf einem größeren Feld spielen), gewann Connors mit 7:5 und 6:2. In seiner Autobiografie verriet er später, er habe eine Million Dollar gewettet, dass Navratilova nicht mehr als acht Spiele gewinnen würde.

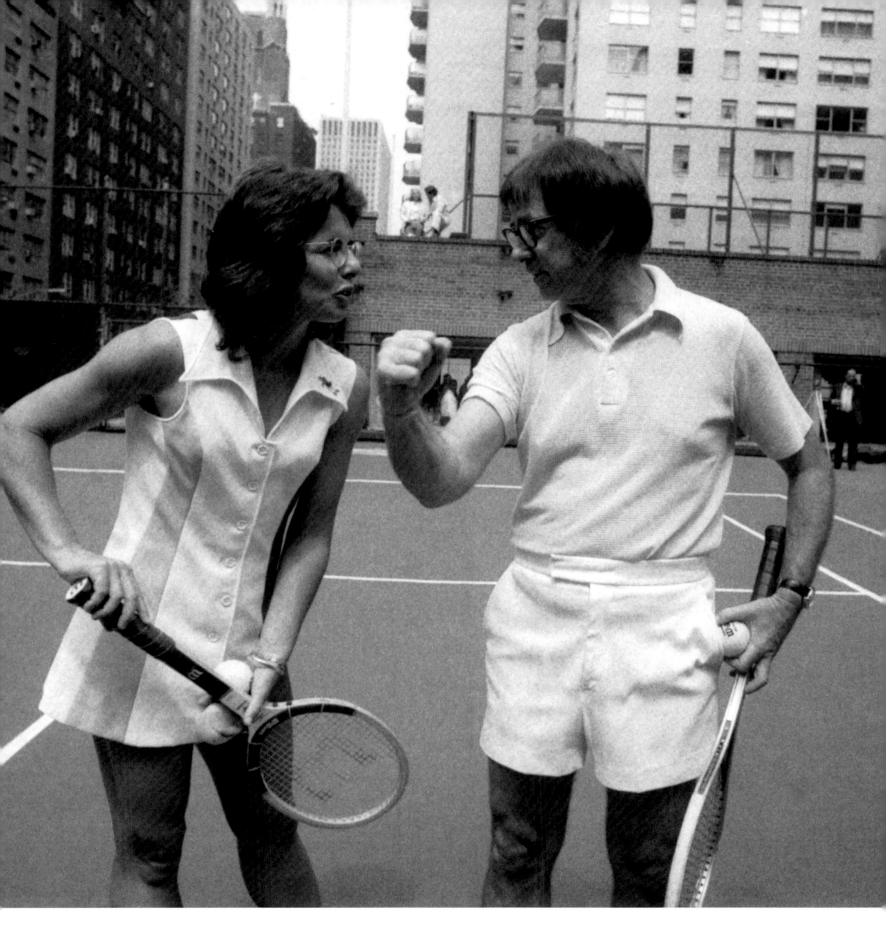

Wimbledon winner Billie Jean King faces Billy Riggs in the "Battle of the Sexes",
the winner receives $100,000, New York, 1973.
Wimbledon-Siegerin Billie Jean King trifft im »Battle of the Sexes« (Kampf der
Geschlechter) auf Billy Riggs, der Sieger erhält 100.000 Dollar, New York, 1973.

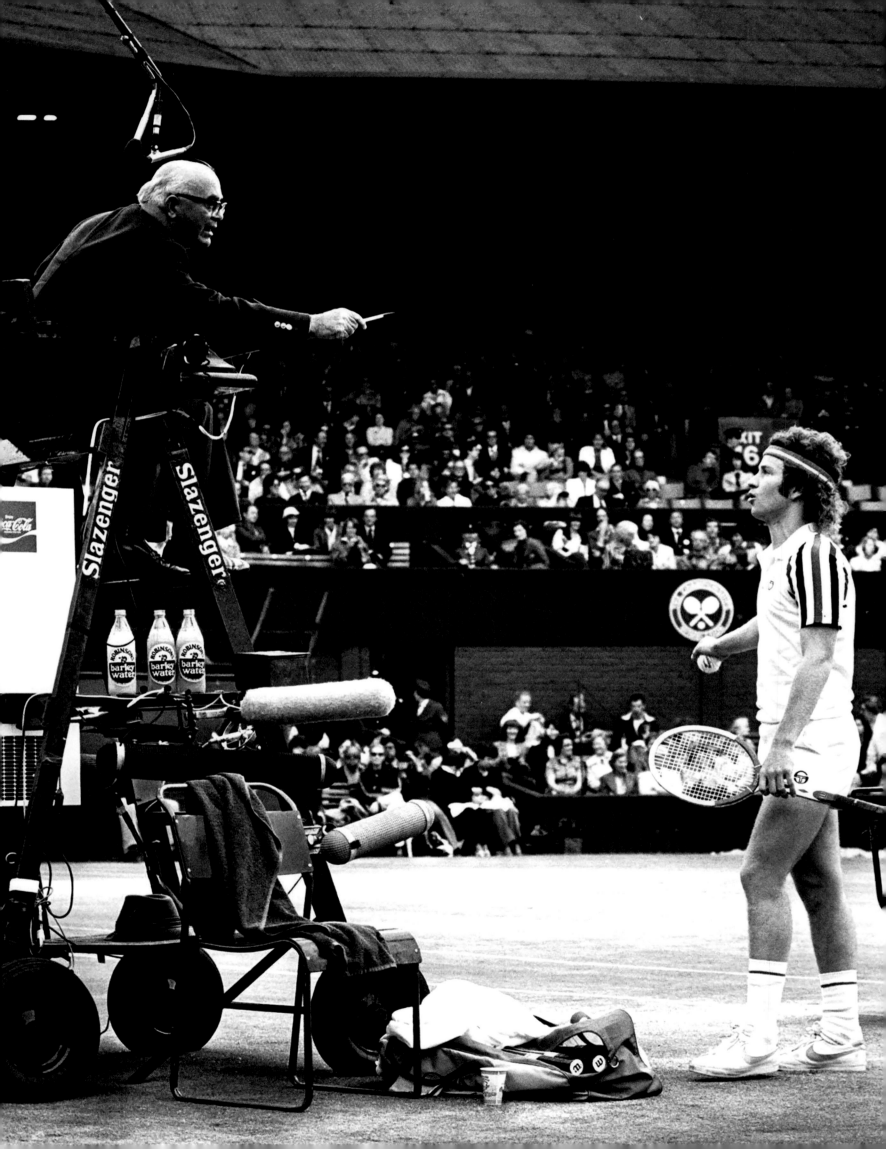

Stranglers, Dopers, Gamblers: the Biggest Scandals

. .

Würger, Doper, Zocker: die größten Skandale

It may be called "white sport" – but the players, officials and betting providers are not always innocent. There is far too much money involved, and the temptation to resort to illicit means is great, or even to lose one's temper in the heat of the moment, as John McEnroe so inimitably demonstrated. His saying "You cannot be serious!" has made it into the vernacular and is also the title of his autobiography, published in 2002. McEnroe's anger was always directed at the referees.

Direct confrontations between opponents on the pitch are rarer, but they do occur, for example when in June 2010 the Austrian Stefan Koubek went for the throat of his compatriot Daniel Köllerer during a change of sides (and was disqualified).

Corentin Moutet and Adrian Andreev were also on the verge of a brawl in September 2022 at the Open d'Orléans after the obligatory handshake at the net and had to be separated by the referee.

As in any sport, doping occurs in tennis. The first prominent victim of the World Anti-Doping Agency (WADA) was Andre Agassi in 1997, who tested positive for the stimulant methamphetamine and

John McEnroe, apart from his particular tennis achievements, is known for his noisy arguments with the referees, Wimbledon 1980.
John McEnroe ist neben seinen besonderen Leistungen im Tennis bekannt für seine lautstarken Auseinandersetzungen mit den Schiedsrichtern, Wimbledon, 1980.

Er mag »weißer Sport« heißen – doch unschuldig sind die Spieler, Funktionäre und Wettanbieter nicht immer. Viel zu viel Geld ist im Spiel, die Verlockungen, zu unerlaubten Mitteln zu greifen, sind groß, oder auch mal in der Hitze des Gefechts die Fassung zu verlieren, wie es John McEnroe so unnachahmlich vorgemacht hat. Sein Ausspruch »You cannot be serious!« hat es bis in die Umgangssprache geschafft und ist auch der Titel seiner 2002 erschienenen Autobiografie. McEnroes Wut richtete sich stets gegen die Referees.

Seltener sind direkte Konfrontationen zwischen Kontrahenten auf dem Platz, aber auch diese kommen vor, etwa als im Juni 2010 der Österreicher Stefan Koubek beim Seitenwechsel seinem Landsmann Daniel Köllerer an die Kehle ging (und disqualifiziert wurde).

Auch Corentin Moutet und Adrian Andreev standen im September 2022 bei der Open d'Orléans nach dem obligatorischen Handshake am Netz kurz vor einer Schlägerei und mussten vom Schiedsrichter getrennt werden.

Wie in jedem Sport wird auch im Tennis gedopt. Das erste prominente Opfer der Welt-Anti-Doping-Agentur (WADA) war Andre Agassi im Jahr 1997, der positiv auf das Aufputschmittel Methamphetamin getestet und gesperrt wurde. Er behauptete, man habe ihm die Substanz in einen Drink geschüttet – gestand aber in seiner Autobiografie

was banned. He claimed he had been slipped the substance into a drink – but admitted in his 2009 autobiography that he had been addicted to the drug during those years. Richard Gasquet had an even more astonishing excuse ready for his positive cocaine test: he had been canoodling with a lady in a nightclub in Miami.

Doping is also an issue in women's tennis: In 2007, Switzerland's Martina Hingis tested positive for a byproduct of cocaine and was banned for two years despite her protestations of innocence. Maria Sharapova had to sit out 15 months because

aus dem Jahr 2009 ein, dass er in jenen Jahren von dieser Droge abhängig war. Eine noch erstaunlichere Ausrede hatte Richard Gasquet für seinen positiven Kokain-Test parat: Er habe in einem Nachtklub in Miami mit einer Dame geknutscht.

Auch im Damentennis ist Doping ein Thema: 2007 wurde die Schweizerin Martina Hingis positiv auf ein Nebenprodukt von Kokain getestet und trotz ihrer Unschuldsbeteuerungen für zwei Jahre gesperrt. Maria Sharapova musste 15 Monate aussetzen, weil ein Grippemedikament, das sie regelmäßig einnahm, vom Internationalen Tennisverband (ITF)

↑ Maria Sharapova was banned for taking a flu drug which was subsequently added to the list of banned substances. Picture shows her winning the French Open in front of the Eiffel Tower, Paris, 2014.

Maria Sharapova wurde gesperrt, weil sie ein Grippemittel nahm, welches nachträglich auf die Liste verbotener Substanzen gesetzt wurde. Das Bild zeigt sie als Siegerin der French Open vor dem Eiffelturm, Paris, 2014.

↑ Switzerland's Martina Hingis tested positive for drugs, which she vehemently denied, 2007.

Die Schweizerin Martina Hingis wurde 2007positiv auf Drogen getestet, was sie vehement bestritten hat, 2007.

↑ Stefan Koubek grabs his compatriot Daniel Köllerer by the throat while changing sides, 2010.
Stefan Koubek fasst seinem Landsmann Daniel Köllerer an die Kehle beim Seitenwechsel, 2010.

↑ Corentin Moutet and Adrian Andreev also get into an argument at the net, 2022.
Auch Corentin Moutet und Adrian Andreev geraten 2022 in einen Streit am Netz.

a flu medication she regularly took was added to the list of performance-enhancing – and thus banned – drugs by the International Tennis Federation (ITF).

The biggest scandal, however, was caused by Austrian Daniel Köllerer – that 2010 strangulation victim. In 2011, he was accused of match-fixing: he apparently deliberately lost to lower-ranked players in order to pocket lucrative betting sums for himself or accomplices, and was banned for life.

Match-fixing is a major problem in tennis because it is much easier to cheat in an individual sport than in a team sport such as soccer. Russia's Nikolai Dawydenko was also at the center of a scandal when, in August 2007, an unknown person bet 1.5 million euros on Davydenko's defeat in the final against Martín Vasallo Argüello at the ATP tournament in Sopot, Poland – after Dawydenko had already won the first set 6:2. And indeed, the Russian retired in the third set due to injury. However, nothing could be proven against him.

auf die Liste der leistungssteigernden – und damit verbotenen Mittel – gesetzt wurde.

Für den größten Skandal aber sorgte der Österreicher Daniel Köllerer – jenes Würgeopfer von 2010. Im Jahr 2011 wurde ihm Match-Fixing vorgeworfen: Er verlor offenbar absichtlich gegen niederklassigere Spieler, um für sich oder Komplizen lukrative Wettsummen einzustreichen, und wurde lebenslang gesperrt.

Match-Fixing ist im Tennis ein großes Problem, weil in einem Individualsport viel leichter betrogen werden kann als in einem Mannschaftssportwie etwa Fußball. Auch der Russe Nikolai Dawydenko stand im Mittelpunkt eines Skandals, als im August 2007 eine unbekannte Person 1,5 Millionen Euro auf die Finalniederlage Dawydenkos gegen Martín Vasallo Argüello beim ATP-Turnier im polnischen Sopot setzte – nachdem Dawydenko bereits den ersten Satz 6:2 gewonnen hatte. Und tatsächlich gab der Russe im dritten Satz verletzungsbedingt auf. Ihm konnte jedoch nichts nachgewiesen werden.

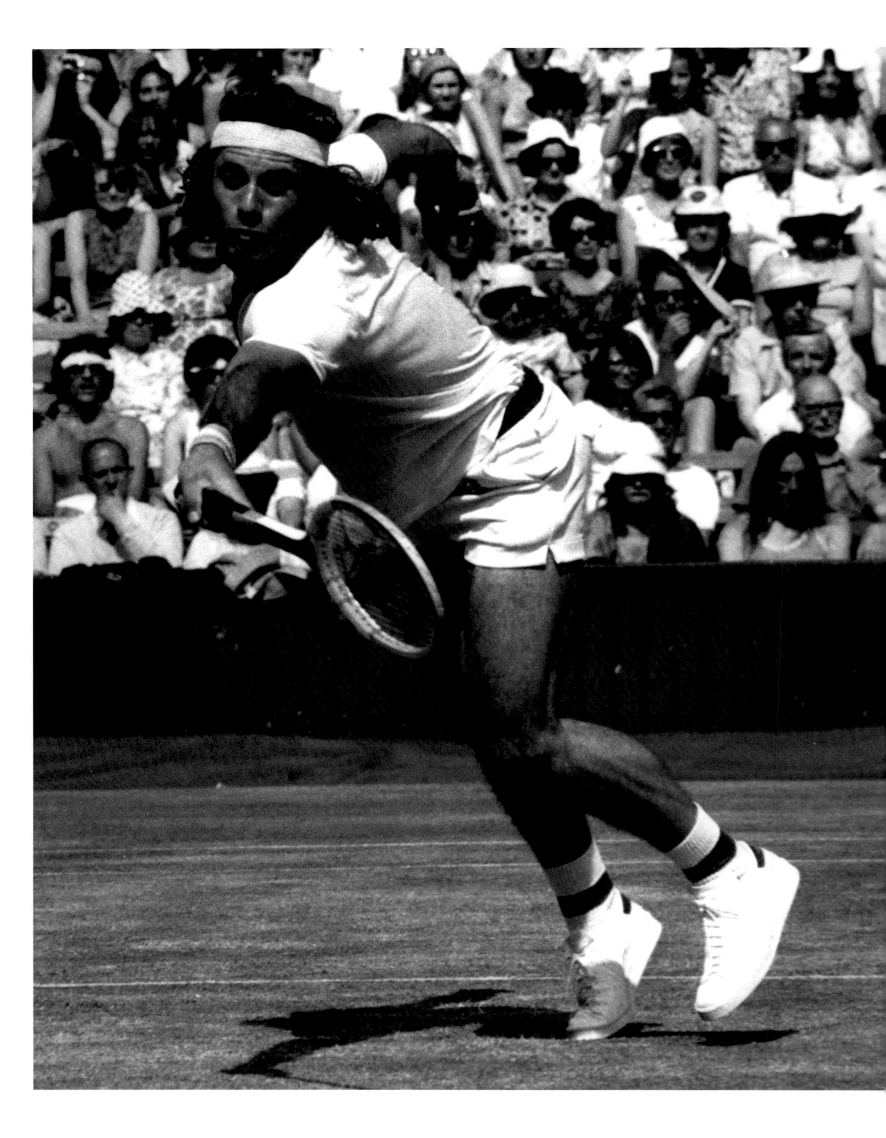

PLAYERS WHO MADE HISTORY

SPIELER, DIE GESCHICHTE SCHRIEBEN

The following players did not shape an era, but they left very important traces in tennis history, each in their own way.

Die folgenden Spieler prägten zwar keine Ära, hinterließen aber ganz wichtige Spuren in der Tennishistorie, jeder auf seine Art.

Guillermo Vilas in action during his match against Roscoe Tanner, Wimbledon, 1975.
Guillermo Vilas in Aktion während seines Spiels gegen Roscoe Tanner, Wimbledon, 1975.

Arthur Ashe was the first colored player to win the US Open and the Davis Cup in 1968 and the Wimbledon tournament in 1975. The U.S. American contracted AIDS in 1988 because of a contaminated blood bag, made the disease public and set up a foundation to help AIDS sufferers. It was also thanks to him that HIV was finally talked about openly.

Boris Becker has become virtually synonymous with tennis in the German-speaking world and still dominates the headlines today, long after his active career – not always in a positive sense, but always on the front page. And anyone

Arthur Ashe gewann als erster Farbiger 1968 die US Open und den Davis Cup sowie 1975 das Turnier in Wimbledon. Der US-Amerikaner erkrankte wegen einer kontaminierten Blutkonserve 1988 an Aids, machte die Krankheit öffentlich und gründete eine Stiftung, die sich für Aidskranke einsetzte. Auch ihm war es zu verdanken, dass über HIV endlich offen geredet wurde.

Boris Becker ist im deutschsprachigen Raum geradezu ein Synonym für Tennis geworden und beherrscht bis heute, lange nach seiner aktiven Laufbahn, die Schlagzeilen – nicht immer im positiven Sinn, aber stets auf der Titelseite. Und wer über Boris Becker redet, darf **Michael Stich** nicht vergessen, der 1991 im Wimbledon-Halbfinale Stefan Edberg besiegte, obwohl der Schwede kein einziges Aufschlagspiel verlor (das brutale Ergebnis lautete 4:6, 7:6, 7:6, 7:6 für Stich), und dann auf dem Center-Court zur

Björn Borg and Arthur Ashe have fun photographing each other.
Björn Borg und Arthur Ashe haben Spaß beim gegenseitigen Fotografieren.

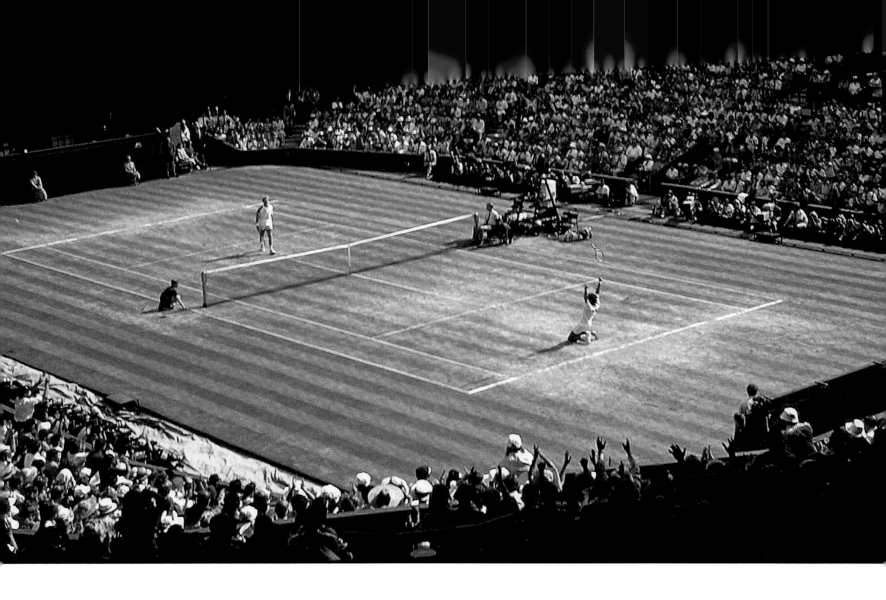

talking about Boris Becker must not forget **Michael Stich**, who defeated Stefan Edberg in the 1991 Wimbledon semifinals, although the Swede did not lose a single service game (the brutal result was 4:6, 7:6, 7:6 for Stich), and then clearly beat Boris Becker in his "living room" on Centre Court to the surprise of all the experts. The press made them out to be arch-enemies – they were certainly not friends – but they got together in 1992 and won Olympic doubles gold for Germany.

Gabriela Sabatini also caused a sensation off the court. The Argentinian and Steffi Graf's fearsome opponent launched her own perfume in 1989, which became a bestseller, and she also published a motivational book. She is still a successful businesswoman today and is involved in numerous charity organizations and Unicef.

Überraschung aller Experten Boris Becker in seinem »Wohnzimmer« deutlich schlug. In der Presse zu Erzfeinden hochstilisiert – Freunde waren sie jedenfalls nicht –, rauften sie sich 1992 zusammen und gewannen im Doppel Olympia-Gold für Deutschland.

Gabriela Sabatini sorgte auch jenseits des Platzes für Furore. Die Argentinierin und Angstgegnerin Steffi Grafs brachte 1989 ihr eigenes Parfüm heraus, das ein Bestseller wurde, außerdem veröffentlichte sie ein Motivationsbuch. Sie ist bis heute eine erfolgreiche Geschäftsfrau und engagiert sich in zahlreichen Charity-Organisationen und für die Unicef.

Michael Chang machte mit unbändigem Kampfgeist wett, was ihm an Physis fehlte: Legendär waren die French Open 1989, als der

Michael Chang made up for what he lacked in physicality with irrepressible fighting spirit: the 1989 French Open was legendary, when the U.S. player, plagued by cramps, beat Ivan Lendl in five sets in the round of 16 (sometimes playing the serve as a simple forehand) and finally won the final against Stefan Edberg, also in five sets. He was only 17 years old – slightly younger than Boris Becker was when he won Wimbledon in 1985 – making him the youngest winner of a Grand Slam tournament to date. It was to remain his only Grand Slam triumph, but he stayed in the top ten of the world rankings for a long time.

Two other teenagers made tennis history: **Aaron Krickstein** looked like a pop star, his poster adorned many a girl's room. He won an ATP tournament in 1983 at the age of just 16 and

US-Amerikaner, von Krämpfen geplagt, im Achtelfinale Ivan Lendl in fünf Sätzen schlug (dabei spielte er den Aufschlag mitunter als einfache Vorhand) und schließlich das Finale gegen Stefan Edberg ebenfalls in fünf Sätzen gewann. Er war erst 17 Jahre alt – etwas jünger als Boris Becker bei seinem Wimbledon-Sieg 1985 – und ist damit bis heute der jüngste Gewinner eines Grand-Slam-Turniers. Es sollte sein einziger Grand-Slam-Triumph bleiben, aber er hielt sich noch lange in den Top Ten der Weltrangliste.

Zwei weitere Teenies schrieben Tennisgeschichte: **Aaron Krickstein** sah aus wie ein Popstar, sein Poster schmückte so manches Mädchenzimmer. Er gewann 1983 im Alter von nur 16 Jahren ein ATP-Turnier und schaffte es mit 17 in die Top Ten der Welt – Rekorde, die bis heute bestehen. Allerdings war der US-Amerikaner schon früh

↖ Game, set and match. Michael Stich beats his compatriot and "nemesis" Boris Becker to win his only tennis major, Wimbledon, 1991.
Spiel, Satz und Sieg. Michael Stich besiegt seinen Landsmann und »Erzfeind« Boris Becker und gewinnt damit sein einziges Tennis-Major, Wimbledon, 1991.

↓ Gabriela Sabatini wins the women's singles against her fiercest opponent Steffi Graf, US Open, 1990.
Gabriela Sabatini gewinnt das Dameneinzel gegen ihre schärfste Gegnerin Steffi Graf, US Open, 1990.

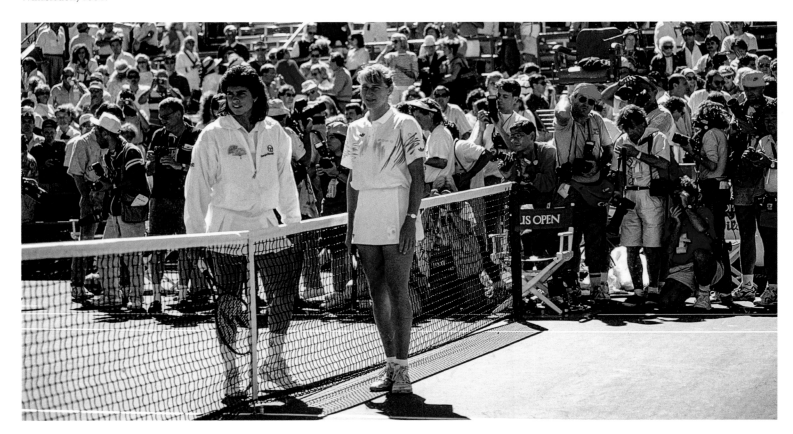

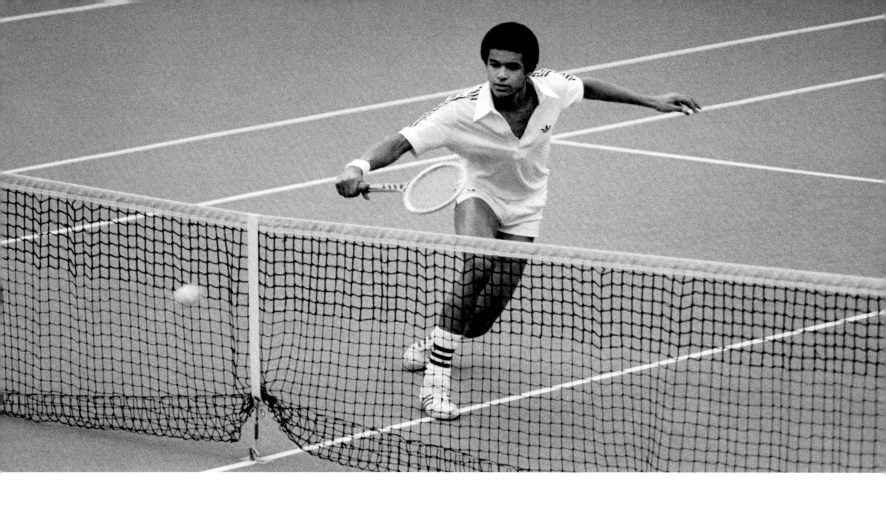

made it into the world's top ten at 17 – records that still stand today. However, the U.S. player was dogged by injury early on; the really big career eluded him.

Even younger than Krickstein, his compatriot **Jennifer Capriati** achieved fame and glory when she reached her first professional final at the age of 13. Shortly thereafter, she made it to the semifinals of the French Open, and by the age of 14, she had climbed into the world's top

vom Verletzungspech verfolgt; die ganz große Karriere blieb ihm verwehrt.

Noch jünger als Krickstein kam seine Landsfrau **Jennifer Capriati** zu Ruhm und Ehre, als sie mit 13 Jahren ihr erstes Profi-Finale erreichte. Kurz danach schaffte sie es ins Halbfinale der French Open und mit 14 Jahren stieg sie in die Top Ten der Welt auf. 1992 holte sich Capriati im Endspiel gegen Steffi Graf die Goldmedaille bei den Olympischen Spielen in Barcelona.

↑ French tennis player Yannick Noah, who is also a successful musician, during a Davis Cup match against the Netherlands, Amsterdam, 1979.
Der französische Tennisspieler Yannick Noah, der auch als Musiker erfolgreich ist, bei einem Davis-Cup-Spiel gegen die Niederlande, Amsterdam, 1979.

↗ Petr Korda skillfully returns a serve during a match in 1994. His son Sebastian is also a talented tennis player and active in the tennis circuit.
Petr Korda retourniert gekonnt einen Aufschlag während eines Matches im Jahr 1994. Sein Sohn Sebastian ist ebenfalls ein talentierter Tennisspieler und aktiv im Tennis-Zirkus.

↗↗ Aaron Krickstein has so far become unsurpassed as the youngest player to reach the top ten in the world rankings at the age of 17, US Open, 1989.
Aaron Krickstein hat bislang unübertroffen als jüngster Spieler im Alter von 17 Jahren die Top Ten der Weltrangliste erreicht, US Open, 1989.

→ Cincinnati Open, 1994. Michael Chang is the youngest man in history to win a major singles tournament. He won the French Open in 1989 at the age of 17.
Cincinnati Open, 1994. Michael Chang ist der jüngste Mann in der Geschichte, der ein großes Einzel-Turnier gewonnen hat. Er gewann die French Open 1989 im Alter von 17 Jahren.

→→ American tennis player Jennifer Capriati at the US Open, 1991.
Die amerikanische Tennisspielerin Jennifer Capriati bei den US Open, 1991.

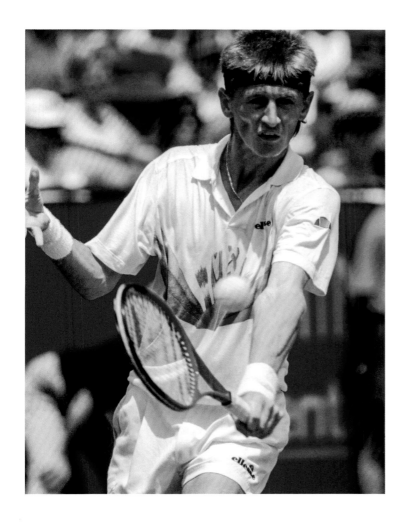
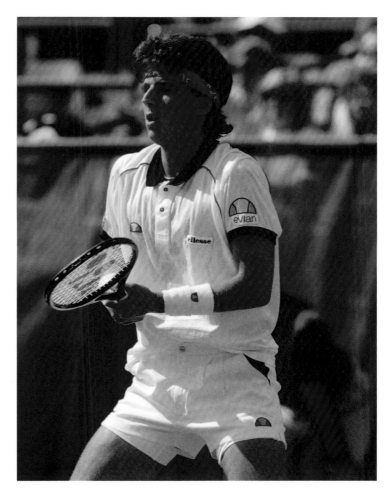

ten. In 1992, Capriati won the gold medal at the Barcelona Olympics in the final against Steffi Graf. The fame got to her, the press gratefully pounced on her escapades (shoplifting, drug possession), and her decline seemed sealed. But she made a comeback: in 2001 and 2002 she won three Grand Slam tournaments and even briefly became the world No. 1.

Thomas Muster is considered the best clay court specialist of all time. Yet the Austrian had to fight his way back onto the court for six months after a serious accident in Key Biscayne – a drunk driver had hit him. In 1996, he made it to the top of the world rankings for six weeks. Curiously, he is the only world number one never to win even one match at Wimbledon, because his love was clearly for the clay.

Der Ruhm machte ihr zu schaffen, die Presse stürzte sich dankbar auf ihre Eskapaden (Ladendiebstahl, Drogenbesitz), der Abstieg schien besiegelt. Doch ihr gelang das Comeback: 2001 und 2002 gewann sie drei Grand-Slam-Turniere und wurde sogar kurzzeitig die Nummer 1 der Welt.

Thomas Muster gilt als bester Sandplatzspezialist aller Zeiten. Dabei musste sich der Österreicher nach einem schweren Unfall in Key Biscayne – ein Betrunkener hatte ihn angefahren – sechs Monate lang zurück auf den Platz kämpfen. 1996 schaffte er es für sechs Wochen an die Spitze der Weltrangliste. Kurios: Er ist der einzige Weltranglistenerste, der nie auch nur ein Match in Wimbledon gewinnen konnte, denn seine Liebe galt eindeutig dem Sand.

Ein ähnlicher »Sandmann« war **Guillermo Vilas**, der im Gegensatz zu Muster zwar auch auf anderen Belägen große Turniere gewinnen konnte – dafür schaffte es der Argentinier aber nie auf Platz eins der Weltrangliste, was bis heute für Gesprächsstoff sorgt; noch 2020 beschäftigte sich eine Netflix-Doku (*Guillermo Vilas: Settling the Score*, zu Deutsch: »Guillermo Vilas: Eine Richtigstellung«) mit dem sonderbaren Fall. Sein Rekord von 46 gewonnenen Matches in Folge aus dem Jahr 1977 steht bis heute. Ähnlich wie Boris Becker und Steffi Graf in Deutschland sorgte der Linkshänder für einen Tennisboom in ganz Südamerika.

Und dann gibt es da noch den erstaunlichen »Korda-Slam«: Der Linkshänder **Petr Korda** siegte 1998 bei den Australian Open. Seine Töchter Jessica und Nelly entschieden sich für eine andere Sportart und gewannen 2012 und 2019 die Australian Open im Golf. Und Sohn

← Thomas Muster on his red "carpet" at the French Open, 1997.
Thomas Muster auf seinem roten »Teppich« bei den French Open, 1997.

A similar "sand man" was **Guillermo Vilas** who, unlike Muster, was also able to win major tournaments on other surfaces – but the Argentinian never made it to number one in the world rankings, which is still a topic of conversation today; as recently as 2020, a Netflix documentary (*Guillermo Vilas: Settling the Score*) dealt with the strange case. His record of 46 consecutive matches won in 1977 still stands today. Much like Boris Becker and Steffi Graf in Germany, the left-hander created a tennis boom throughout South America.

And then there's the amazing "Korda Slam": left-handed **Petr Korda** won the Australian Open in 1998. His daughters Jessica and Nelly opted for a different sport and won the Australian Open in golf in 2012 and 2019. And his son Sebastian, again in tennis, won the Australian Open Junior Championships in 2018. What a talented family!

He was the last Frenchman to win the French Open in 1983 – and a champion of hearts anyway: **Yannick Noah** not only looked like a pop star, but also became one after his active career. One of his music albums reached number one in the charts, another was awarded a Golden Record.

And last but not least, it looks like the next tennis dominator will also come from Spain: **Carlos Alcaraz** won the US Open in 2022 and became the youngest number one in tennis history after this triumph. When this book is published, he will still only be 19 years old.

↗ With his victory at the US Open in 2022, Carlos Alcaraz became the youngest world No. 1 in tennis history at the age of 19.
Mit seinem Sieg bei den US Open 2022 wurde Carlos Alcaraz mit 19 Jahren die jüngste Nummer 1 der Weltrangliste in der Tennis-Geschichte.

Sebastian gewann, wiederum im Tennis, die Australian Open Junior Championships 2018. Was für eine talentierte Familie!

Als letzter Franzose wurde er 1983 French-Open-Sieger – und ein Champion der Herzen war er sowieso: **Yannick Noah** sah nicht nur aus wie ein Popstar, sondern wurde nach seiner aktiven Karriere auch einer. Eines seiner Musikalben erreichte Platz eins der Hitparade, ein weiteres wurde mit der Goldenen Schallplatte ausgezeichnet.

Und zu guter Letzt sieht es so aus, als käme auch der nächste Tennis-Dominator aus Spanien: **Carlos Alcaraz** siegte 2022 bei den US Open und wurde nach diesem Triumph die jüngste Nummer eins der Tennisgeschichte. Bei Erscheinen dieses Buches wird er immer noch erst 19 Jahre alt sein.

Imprint

Impressum

© 2023 teNeues Verlag GmbH

Texts: © Stefan Maiwald. All rights reserved.
Captions © Anke Feierabend. All rights reserved.

Editorial Coordination by Nadine Weinhold, teNeues Verlag
Translations by Paul Melcher
Copyediting by Stephanie Iber, Christiane Gsänger
Creative Direction by Peter Feierabend, Feierabend Unique Books
Layout and typsetting by Frank Behrendt, Feierabend Unique Books
Production by Nele Jansen, teNeues Verlag
Photo Editing, Color Separation by Jens Grundei,
teNeues Verlag

Library of Congress Number: 2023932651
ISBN: 978-3-96171-443-8
Printed in Slovakia by Neografia a.s.

FSC MIX Paper | Supporting responsible forestry **FSC® C020353** www.fsc.org

Published by teNeues Publishing Group
teNeues Verlag GmbH
Ohmstraße 8a
86199 Augsburg, Germany

Düsseldorf Office
Waldenburger Straße 13
41564 Kaarst, Germany
e-mail: books@teneues.com

Augsburg/München Office
Ohmstraße 8a
86199 Augsburg, Germany
e-mail: books@teneues.com

Berlin Office
Lietzenburger Straße 53
10719 Berlin, Germany
e-mail: books@teneues.com

Press Department
presse@teneues.com

teNeues Publishing Company
350 Seventh Avenue, Suite 301
New York, NY 10001, USA
Phone: +1-212-627-9090
Fax: +1-212-627-9511

www.teneues.com

Credits/Bildnachweis:
© Wikimedia Commons/:
6 (left): Charles Hulpeau; 6 (right): Walter Clopton Wingfield; 7, 8/9, 13 (both) 18, 19: Rob Croes/Anefo; 16: Agence de presse Mondial Photo-Presse; 20, 21: Bain News Service, publisher; 22 (right): Groupe l'Équipe; 22 (left): Hugo van Gelderen/Anefo; 23, 84, 85: Eric Koch/Anefo; 24: Herbert Behrens/Anefo; 29 (bottom), 89: Chris Eason; 34, 35 (left): Koen Suyk/Anefo; 35 (right): Momovieman; 36: Francisco Diez; 42/43: Anefo; 44: R Boed; 45: Esther Lim; 46: German Federal Archive; 49: Agence de presse Mondial; 54 (top): National Photo Company Collection; 54 (bottom): Agence de presse Meurisse; 55: Photo Company Collection, 57: Harry Pot/Anefo; 58: W Stacey Warnke; 61: Lynn Gilbert; 62: National Archives and Records Administration; 64 (left): W.Punt; 64 (right): Hans Peters/Anefo; 68, 71, 204, 220: Hans van Dijk; 72: Harry Pot/Anefo; 76, 78/79, 80/81: W Edwin Martinez; 79: John Mathew Smith; 82: Joop van Bilsen; 86, 90 (left): Agence Rol; 90 (right), 93: Agentur Meurisse; 97 (top): Diliff; 98 (bottom): Carina06; 99: Frédéric de Villamil; 146 (bottom): Horacio Gomes; 167 (right): Los Angeles Times; 167 (left): HI 622; 185 (right): Alfred Nitsch; 198: Photographisches Büro des Weißen Hauses; 212 (right): si.robi; 218: Barry Shimmon; 221 (bottom left): James Phelps; 223: Yannick Jamot.

© Getty Images/:
Cover: David Cannon; 2: DigitalVision Vectors; 10: George Freston/Fox Photos/Hulton Archive; 14/15: Patrick Piel/Gamma-Rapho; 25: Dennis Oulds/Central Press/Hulton Archive; 26, 92: Central Press/Hulton Archive; 27: Roger Jackson/Central Press/Hulton Archive; 29 (top): Michael Brennan; 37: Clive Brunskill for Laver Cup; 40: Allsport/Hulton Archive; 41: Bob Martin/Hulton Archive; 52: Hulton Archive; 60: Robert Riger; 61 (bottom): SSPL/Manchester Daily Express; 65: George W. Hales/ Fox Photos/Hulton Archive; 74: William Vanderson/Fox Photos/Hulton Archive; 94: Simon Bruty/Allsport; 95, 119 (bottom), 199 (bottom): John Russell; 97 (bottom): Frank Peters/Bongarts; 98 (top): Clive Rose; 100: Evening Standard/Hulton Archive; 101: Hartwig Valdmanis/United Archives; 102: Gotham/GC Images; 103: Paul Harris/ Archive Photos; 111 (top) The AGE/Fairfax Media; 115; 116/117: Olivier Morin/AFP; 119 (top): Georges De Keerle; 120/121: AELTC/Joe Toth – Pool; 123 (top): Matthew Stockman; 123 (bottom), 184: Tim Clayton/Corbis; 124/125: Al Bello; 127, 194: George Rinhart/Corbis; 128/129, 152/153, 183, 209: Bettmann; 130: AFP; 132/133: Arturo Holmes/Getty Images for ATP Tour; 136/137: Miguel Medina/AFP; 140/141: David Cannon/Getty Images; 142 (bottom): Pedro Pardo/AFP; 143: Clive Brunskill/Getty Images; 145, 151: Slim Aarons/Hulton Archive; 158: Steve Russell/Toronto Star; 160: Istock; 161: Thomas Samson/AFP; 168, 170/171: Steve Powell/Allsport/Hulton Archive; 172/173: Jacqueline Duvoisin /Sports Illustrated; 174: Allsport; 180: Skip Bolen; 188, 189, 190, 191: Hulton Archive; 193: Vista Photos/Hulton Archive; 195: Ron Galella/Ron Galella Collection; 196 (bottom): PL Gould/IMAGES/Archive Photos; 199 (top): Suzi Pratt; 201: Frazer Harrison/ Desert Smash; 205: Scott Barbour; 216/217: Calle Hesslefors/ullstein bild; Back Cover: George Freston/Fox Photos/Hulton Archive.

© Alamy Stock Fotos:
12, 17, 28, 30, 32, 33, 38, 47, 48, 50, 51, 59, 63, 66, 70, 73, 77, 83, 87, 88, 91, 96, 104, 107, 109, 111u., 112, 139, 144, 147o., 154, 175, 178, 186, 192, 196 (top), 197, 200, 202, 210, 212 li, 214, 219, 221 (top left and right, bottom right), 222.

Others courtesy of:
134: © Singita; 138: © Il San Pietro di Positano; 147 (bottom): © Tennis De La Cavalerie, tennis@tcma; 150 (top): © La Quinta Resort & Club; 150 (bottom): © Enchantment Resort; 148,149: © Gstaad Palace/Nico Schaerer; 155: © Mercedes-Benz Group; 163, 164, 165: © Jürgen Chmiel, TC Berlin-Weißensee e.V., 166: © FALKE.

Private Archive:
142 (top), 146 (top), 156, 157.